NORTHBROOK PUBLIC LIBRARY
NORTHBROOK, IL 60062

W9-BRD-445

Northbrook Public Library

8270

the PHOTOgraphic garden

ORGANIC Gardening

MASTERING THE ART OF DIGITAL GARDEN PHOTOGRAPHY

Matthew Benson

RODALE

ಣ

For Heidi, Daisy, and Miles

Mention of specific companies, organizations, or authorities in this book does
not imply endorsement by the author or publisher, nor does mention of specific companies, organizations,
or authorities imply that they endorse this book, its author, or the publisher.

Internet addresses and telephone numbers given in this book were accurate at the time it went to press.

© 2012 by Matthew Benson

All rights reserved. No part of this publication may be reproduced or transmitted
in any form or by any means, electronic or mechanical, including photocopying, recording, or any other
information storage and retrieval system, without the written permission of the publisher.

Rodale books may be purchased for business or promotional use or for special sales.
For information, please write to:
Special Markets Department, Rodale Inc., 733 Third Avenue, New York, NY 10017

Printed in China
Rodale Inc. makes every effort to use acid-free ♾, recycled paper ♻.

Photographs by Matthew Benson

Book design by Kara Plikaitis

Library of Congress Cataloging-in-Publication Data is on file with the publisher.

ISBN 978–1–60961–087–6 paperback

Distributed to the trade by Macmillan

2 4 6 8 10 9 7 5 3 1 paperback

We inspire and enable people to improve their lives and the world around them.
www.rodalebooks.com

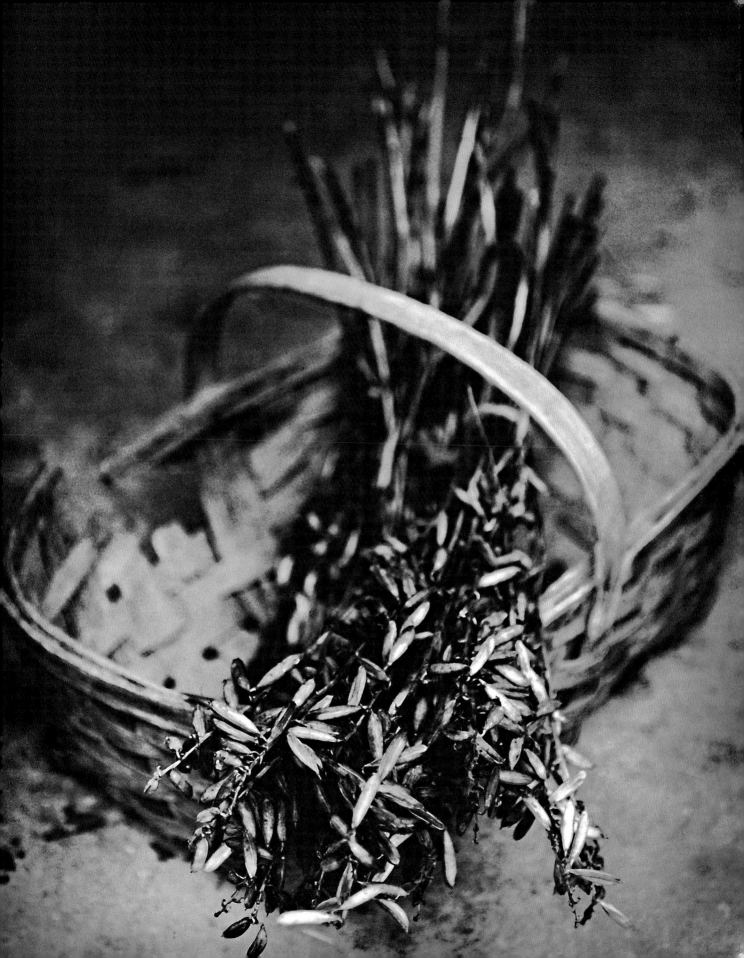

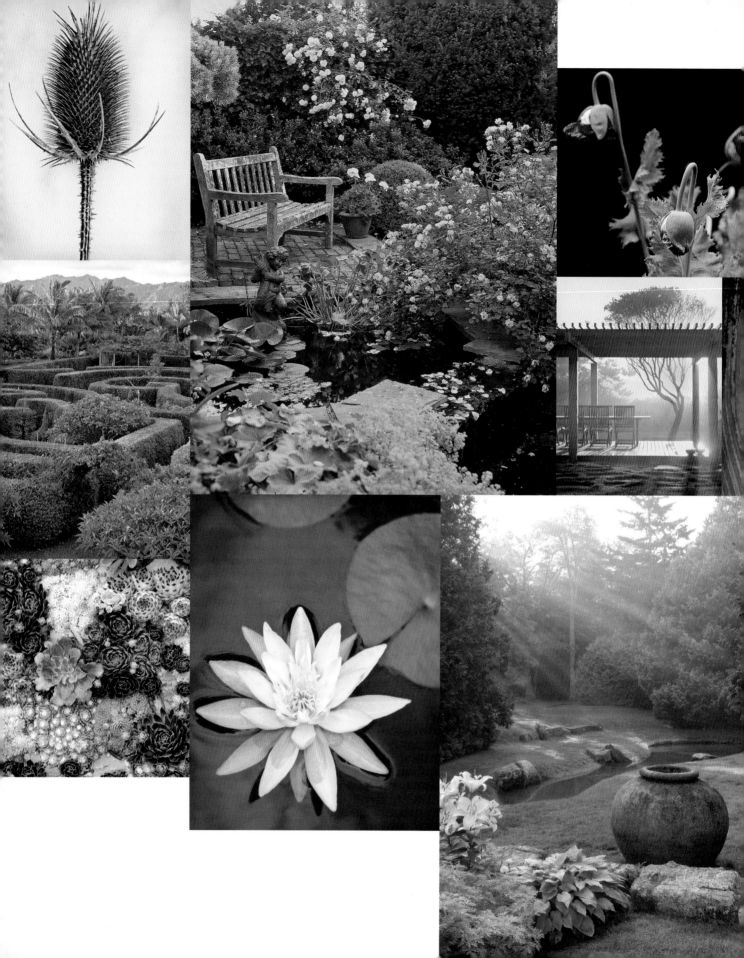

contents

introduction:
The More Beautiful Question vii

Light

1 Where to Begin
8 The Light Fantastic
11 Light and Point of View
13 When Design Trumps Light
15 How the Camera Sees Light
19 Seasonal Light
22 Light on the Botanical Portrait
27 The Still Life
34 Working with Bad Light

Design

39 Finding the Shot
43 Telling the Story of a Garden
47 The Seven Principles of Design
64 Point of View
68 The Camera's Eye
70 Shooting Through
74 Propping to Serve the Image
80 Thinking Graphically
83 Visual Intuition
86 Where to Be
88 Moving Through the Garden with Your Camera
103 Narrative Dimension
108 Black-and-White
113 Selective Focus
119 Garden Ornament
122 The Sensual Garden
126 The Garden of Compromise
128 Photographing the Vegetable Garden
130 The Water Garden
132 People and Pets in the Garden
137 Personal Style

Postproduction

139 Creating with the Computer
140 Image Assessment
141 Digital Workflow
142 Adobe Lightroom
148 Adobe Photoshop
150 Photoshop Fundamentals: The Magnificent Seven
162 Photoshop Flow

Cameras

165 The Basics
167 What to Look For
175 Smartphones, iPods, iPads, and Photo Apps

seeing is being 176
acknowledgments 178
index 179

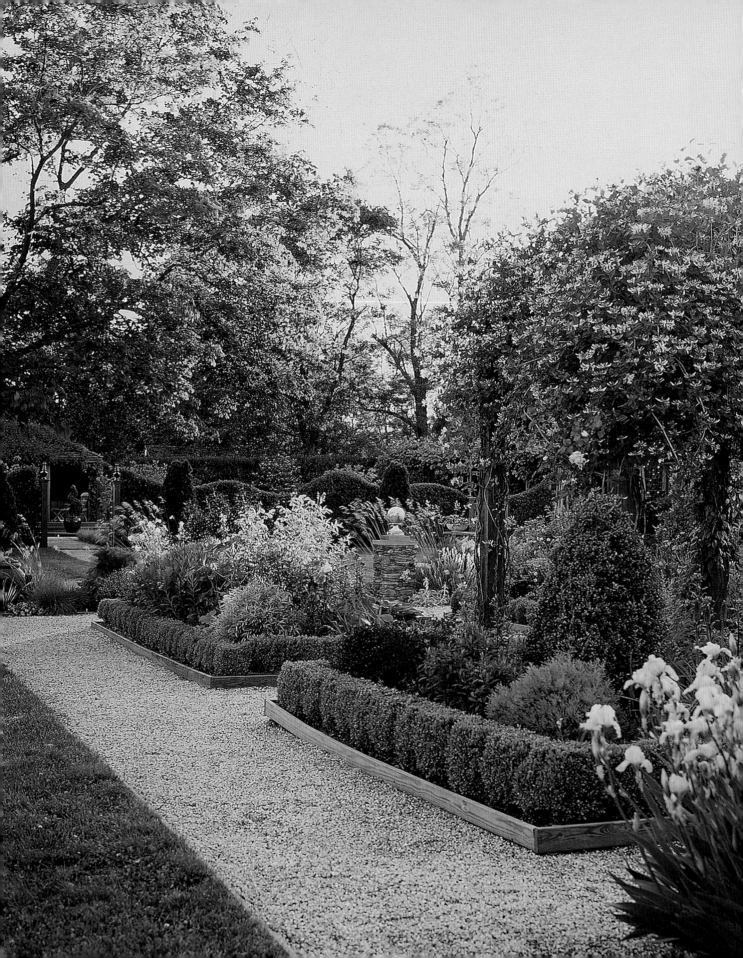

introduction

The More Beautiful Question

Instinct tells us: See a beautiful garden, a glorious blossom, a splash of perennial color—take out the camera and click. You know that this perfect light, this fragile, miraculous beauty is fleeting. Best to capture it.

But knowing how best to capture it eludes many of us. You put your camera to your eye and shoot away, only to delete the image later when your lowly pixels disappoint: too dark, too light, too much contrast, too little focus, or too awkward of a composition. All the aesthetic excitement you experienced in the garden has perished, and you're left with a pile of forgettable megapixels.

Sound familiar? Anyone who has ever walked through a garden, camera clutched firmly in hand, knows that the rich sensory imprint of color, light, and form can almost overwhelm the senses, yet the photographs we take are often a weak surrogate of the remembered experience.

So how do you rein in your impressions and bring them vividly to life in pictures? How do you create an evocative impression of the place? Perhaps you begin by editing out the distractions and extraneous information, and focus in on what matters to *you*—what tells *your* story of this garden.

The garden experience is always a personal one, and your images should reflect that understanding. While some of us are drawn to the wildflower meadow, to a bit of loose, natural chaos in our otherwise orderly lives, others respond to the strict symmetry of formal gardens, with their linear hierarchies and historical

This garden plays beautifully with light, form, and color. Its bones are strong and directional, leading the eye gracefully up, around, and through.

references, creating order and beauty in a chaotic world. Whatever your visual disposition, the camera is an extension not only of your eye, but also of your creative temperament.

The camera is a seeker, after all. Through the camera, we give ourselves the liberty to explore, to wonder, and to render the world through our own intuitive sensibility. But the camera also has a point of view. The world looks different through it; its perspective is edited and directed, focused on a singular idea.

This is no small technological feat when you consider how fully the garden engages all of the senses. Gardens are a source of great intuitive comfort; we know them in our DNA. We know the repetition of form and pattern, the way light moves through leaves and petals and sweeps across a smooth expanse of lawn, and the artful balance of color from one bloom to the next. These are familiar references for those who garden.

But how best to record the fleeting moment? Still photography seems to have its limitations: There's no movement, no sound, no scent—just two-dimensional stillness. Yet an effective image has the power of invocation; in the best photographs, all of the senses are aroused.

The most successful garden photography is a perfect fusion of technical literacy, narrative intent, and aesthetic understanding. Technology doesn't tell you what visual ideas to have, of course; it is only there to do your bidding, but

each photograph has a story to tell and a configuration of light, form, and color that makes it unique.

The Photographic Garden is a garden of visual ideas, captured and skillfully evoked by the camera. This book is meant to make you a better, more intuitive artist in the landscape, to foster a deeper understanding of design and aesthetics, and to encourage the development of your own visual sensibility.

It is not only a photographic exploration of gardens, but also an introduction to digital image-making tools, from cameras to postproduction software. Gigabytes of storage on cameras and computers, as well as remarkable editing programs, have freed up the old constraints of film.

More than ever, we can be open to not knowing, be willing to fail, be able to *ask the more beautiful question*—to look at the visual world around us and be compelled to wonder: What if I shot it this way, or tried it that way? How could I make this image *more beautiful*? The consequences of an aesthetic leap of faith will only lead your photography forward.

Though technology may have changed the tools we use to capture and render images, the fundamentals of what makes a compelling photograph or gives a photographer a great eye have not changed. Understanding light and composition has not changed. The infinitely complex and beautiful pattern language of the natural world has not changed; but how you see it is about to.

This book is meant for gardeners who wish to photograph better, and who want to learn to see the garden differently through the camera. Those who garden already have a love affair with plants and planted spaces, with the beauty and complexity of nature, with all the metaphors of what it means to garden and to care for living things. The camera in the garden both informs and deepens our understanding of the natural world and its aesthetic cultivation.

The garden holds a mirror up to us; it speaks to our conceits and frailties, to our desire for purpose and meaning. The Buddhists counsel that "if you do one thing with your life, make a garden," and we do. We plant and nurture, we imagine and design, we weed, we prune, and we falter and prevail. There is a rhythm and purpose in the garden that strongly mimics the arc of our own lives. In our efforts to be beautiful, healthy, successful, and happy, the garden is a life partner, a reminder of the extraordinary but impermanent cycle of all things.

Though the camera sees the garden differently than our eyes do, it can teach us much about color and design, about light and form. A garden considered through the camera is very attentive to composed space and to qualities of light. The camera, with its Apollonian desire for order and beauty, reins in wildness and makes it reachable. And just as you would not deliberately design and cultivate a garden absent of beauty, you should be as particular when composing through the lens. Think of the camera as a guide and confidant, there to help you see more fully and deeply. Think of the photographic garden as a sensory expression, taken in largely by the eyes, and refined by the camera.

Learning to see the garden photographically will make you a better garden designer, tuning your eye to the complex textural detail of plants, to the way they hold and transmit light, and to their posture and habit. The camera reveals archetypes of color and composition that the eye can miss, and it speaks in a pattern language all its own. With the camera you are developing your ability to see and heightening your aesthetic sensibility, all of which will make you both a better photographer and a better gardener.

The Photographic Garden is a book for the aspiring visual artist, a label that any passionate gardener can claim to own. It will teach you how to choose and use the right cameras and lenses and equipment for garden photography, how to light and compose your images beautifully, how to enhance your garden images on the computer in postproduction, and how to move beyond weak or poorly conceived visual ideas to something photographically great. You will learn how to see like a camera, how to work like a professional, and how to imagine and create like an artist.

Matthew Benson

The camera can transform the garden with its own poetic viewpoint. This Magnolia soulangiana *is in full bloom, photographed up into the canopy with a wide-open aperture so that its soft pink blossoms and branches read like visual haiku.*

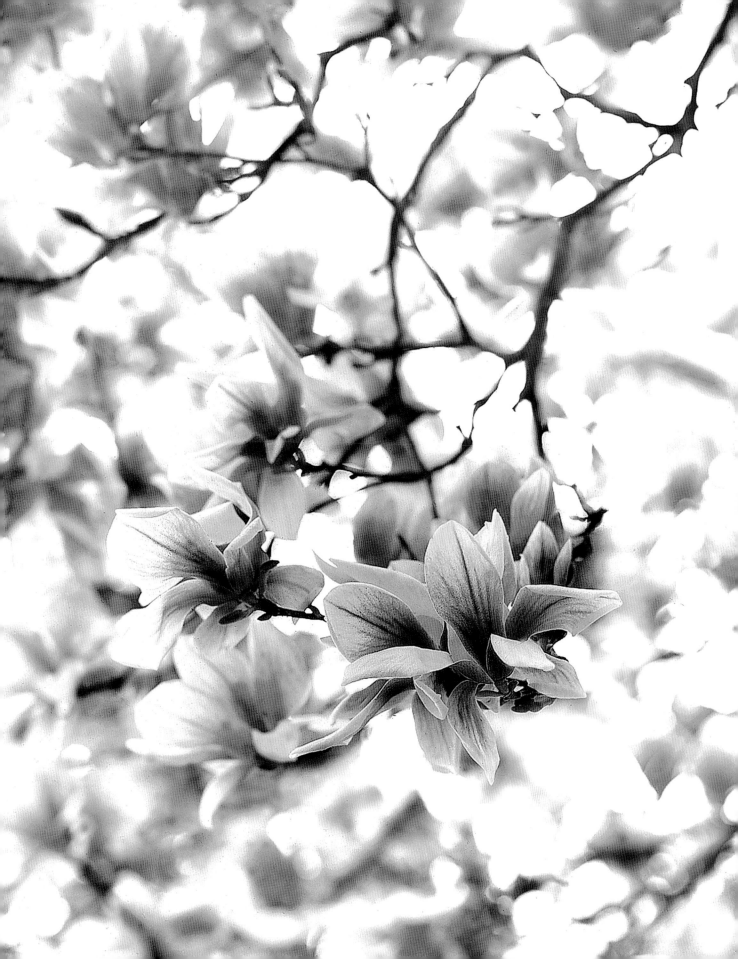

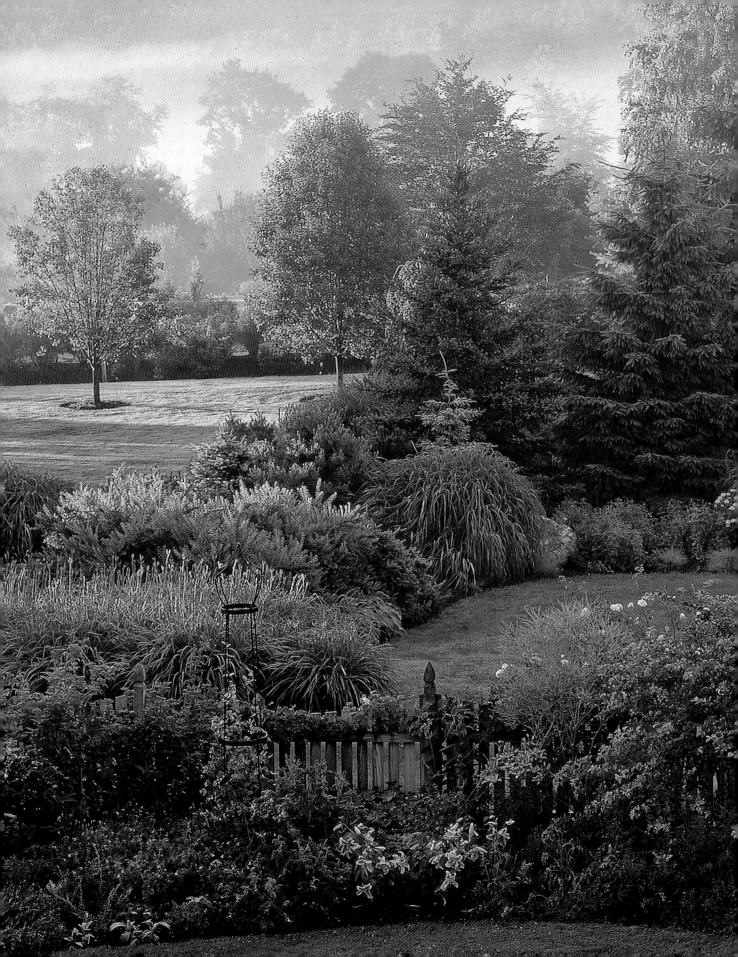

*"Light makes photography. Embrace
light. Admire it. Love it. But above all,
know light. Know it for all you are
worth, and you will know the key to
photography."*

—George Eastman

1 *Light*

Where to Begin

When I'm in a garden to photograph, usually arriving just before dawn, I'm
looking for the first signs of light: a pale filtering through a canopy of trees, a
splinter of light on a formal pool, the wink of a spider's web or an insect wing,
a perennial border beginning to glow. This is the most magical time in the
garden. When the garden wakes, plants are well rested, their leaves and petals
dew-moistened, and their unfolding colors deeply saturated. The morning
carries with it all the promise of capturing beauty through the lens.

*This backlit garden in Connecticut was shot around 5:30 a.m. as both sun and mist met on the
horizon and carried warm, soft color across the landscape. The camera was overexposed and
bracketed so as not to miss the moment. It was shot out of a guest bedroom window using a medium
telephoto lens to compress the view. The light brushing the grasses in the foreground, the diagonal
sweep of the shrub border, and the gleam of the trees in the distance are as painterly as it gets.*

1

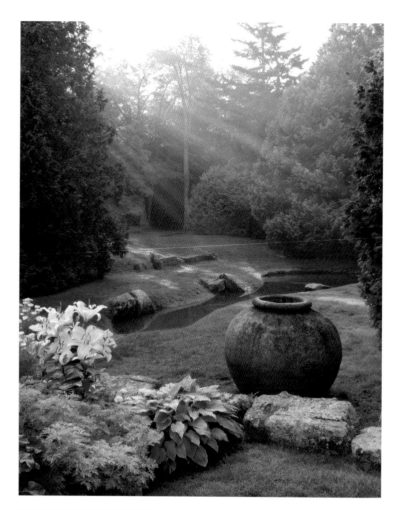

This garden in Maine, with its curvilinear pond and large, patinated urn, is surrounded by a dense northern pine forest. The light that reaches it filters through the canopy for only a moment before washing the landscape in unflattering light. The banded rays moving through the treetops and reaching down to the pool were a gift, although the composition was carefully premeditated.

But before the camera comes near my eye, I'm quickly and scrupulously taking in the scene. Where will the light break through? How will it move across the garden as the day progresses? Where should I be when the light begins? My most immediate concern is not with the garden itself, but with the quality of light that moves across it.

Some gardens are surrounded by a high canopy of trees, so that no light reaches in until the sun is up and blazing white across the borders; others let light filter through quite early. Sometimes, in wide open land, the sun comes up like a hot fist, forcing you to dash about and shoot in a manic frenzy as the garden quickly heats up and the light begins to wash out all the midtones of color and

shade, and all you're left with are blotches of hot light and dark shadows. Then there are places near the shore—coastal gardens where warm and cool air currents combine—where the sun emerges, pale and lovely, in a diffusion of mist, radiating softly across planted borders and beds.

A garden about to be photographed is defined as much by how light moves across it throughout the day as it is by the plantings themselves. A beautiful garden in bad light is only a modest facsimile of itself, whereas a more humble garden in beautiful light can be transformed, reinvented by the way the sun's rays course through it.

I have photographed gardens where the bones and hardscaping were beautifully designed, the planting schemes thoughtfully rendered, and yet the overall effect of being there was a disappointment because the light was wrong. The shade- and sun-loving plants were all in their appropriate places, the larger architectural perennials anchored the back of the border and annuals splashed their seasonal colors just right, but something was missing: consideration of the sun's unvarying path across the garden.

Gardens are usually designed around the existing footprint of the house, with a front yard, a back yard, and side yards. Unless a house and garden are designed at the same time, there's often not much leeway in choosing how sunlight will make its way across a property. But when there is, gardens should be designed to flow from east to west, so that the most beautiful light in the morning and in the evening will backlight the scene.

Early and late light is the magic you seek for the most photographable moments. Light at midday compromises the beauty of the garden, turning delicate plantings into stark shadow and glare. So for garden

photography, what matters most is where the light is when the day begins and ends.

Backlighting is a simple concept; it's when objects come between you and the light. To backlight, place your subjects between you and the sun, so that they glow with light as it moves through their structural form or gives them a radiant outline. Gardens are particularly well suited to backlighting; their leaves and petals glow and contain more saturated color when lit from behind, their stems and branches beautifully filter and fracture the light, and they radiate and glimmer.

A backlit garden glows with transmissive light. It is transformed into luminous, evocative renderings of color and form. The mind's eye swoons here, the way it does while watching a sunrise or sunset, and we are hardwired to respond; the light is serene, harmonious, and safe. Its long, warm shadows are an intuitive comfort. And the camera allows us the freedom to look into the light and linger there while the naked eye may be strained by such brightness.

We seem to be genetically predisposed to favor backlighting over all other types of light; it is ambrosia for the visual cortex. We are born moving toward the light, and we die—according to those who've clambered back from the edge—the same way. How the old photography paradigm of light over your shoulder became engrained is a mystery; it turned your back on the light, moving your camera away from it. The instinctual need of the visual psyche to look to brightness was starved.

The best garden photography understands the fundamentals of light. After all, *photo-graph* means light-drawing. The most important change you can make to improve your garden photography is to learn to shoot *into* the light. Position yourself to photograph *toward* the morning and late afternoon light, with beds, borders, and petals between you and the sun.

Once you sensitize your eyes to

Left: These bantam hens seem oblivious to the fact that they are walking in beauty, backlit and framed in the late afternoon light. Some scratch was tossed out to get them into position in the frame. As the gladioli and peegee hydrangea glisten with light, long, soft shadows reach toward the camera. The formality of this garden (my own) was conceived for the camera, with framed views and graphic perspectives arranged on an east-west transept to take advantage of light.

Right: With morning mist diffusing the early light, this Maine flower farm glows with soft, radiant color. See how the diagonal bands of color lead the eye into the frame, while the shed becomes a visual destination. In minutes, the sun will burn through and the light will change. Great photography in the garden is sometimes measured in minutes, with the best light bookending the day.

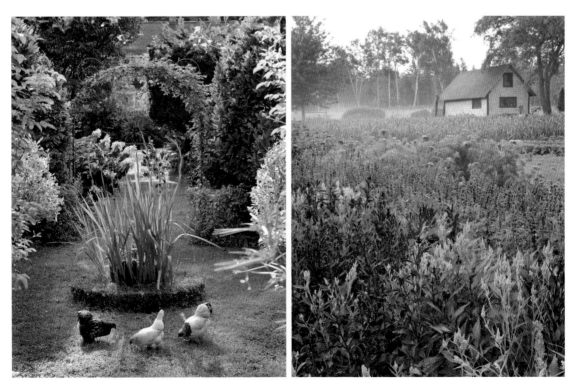

the subtleties of how light moves across and through the garden, and learn to make light a priority, your images will go from glare to glow, from brittle, stark contrast to evocative translucence. Great garden images glimmer and pulse, and they radiate warmth and welcome.

If the light is seductive, shoot; if not, be patient. Light is in constant motion, as are clouds that can filter harsh rays. If it's a particular scene you're after, but the light is wrong, wait or come back. It's worth it. I'd rather not shoot, and try to come back, than insult something beautiful with bad light.

Creating toward the light is nothing new in landscape art. The Hudson River School of the mid-19th century often painted into the rising or setting sun, their symbolic landscapes infused with radiant backlight. Their canvases conveyed an idyllic American paradise whose picturesque wildness was always perfectly lit. And the Luminist movement that succeeded it was preoccupied primarily with how light affects and transforms the landscape. Like the later Impressionists, their focus was on light and color as subjects in themselves, worthy of aesthetic contemplation.

Nineteenth-century Romantics understood the symbolic power of light, whether in the saturated landscapes of the painter Thomas Cole or the poems of Coleridge or Wordsworth, who saw meadows "apparell'd in celestial light." This wasn't the hard light of reason, but the reassuring light of all things beautiful and true.

The 21st century is no different from those that preceded it when it comes to basic aesthetic DNA. We like beautiful light. It will always take us in. As a photographer, an awareness of that collective sensibility will serve you well in your efforts to create an idealized impression of the landscape.

You may find yourself in a garden where, like the Luminists or the near-blind Monet before you, light is the primary subject. The garden may be modest or ambitious in its design, but there's something about the light at the moment you are there with your camera that commands attention.

Your camera's automatic exposure meter will be bewildered by backlighting, of course, and assume there's too much light. So set the camera on program mode, and use the exposure compensation dial to lighten the image enough to properly render the garden and overexpose the sky. Most new digital cameras, even the compacts, allow for some degree of exposure control. Learning to use these basic settings, and overcoming a phobia of barely legible technical manuals, is a giant leap toward creative freedom.

This farm garden is laid out perpendicular to the morning light so that, as the sun rises, long bands of luminous color stretch across the beds. The foreground pickets anchor the frame and set up a foreground/midground/ background progression through the image. Notice how the grasses and treetops are lit from the morning sun and how your eye moves through the plantings to the visual anchor of the barn.

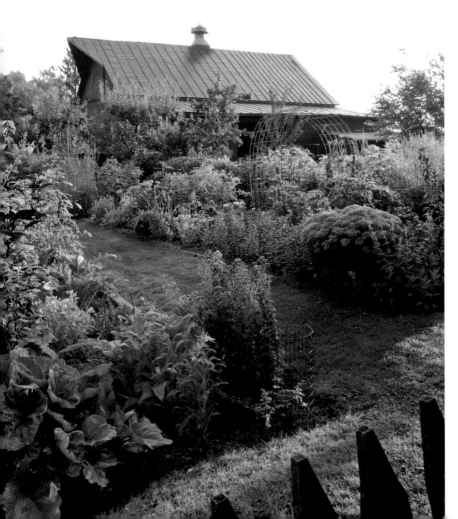

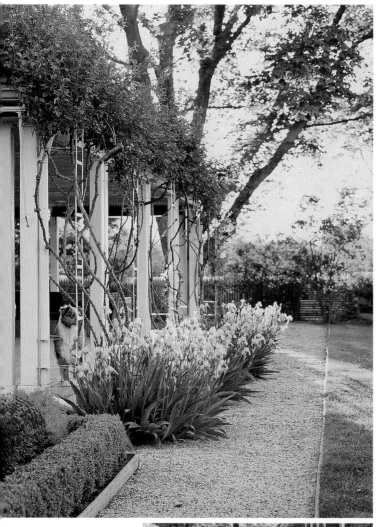

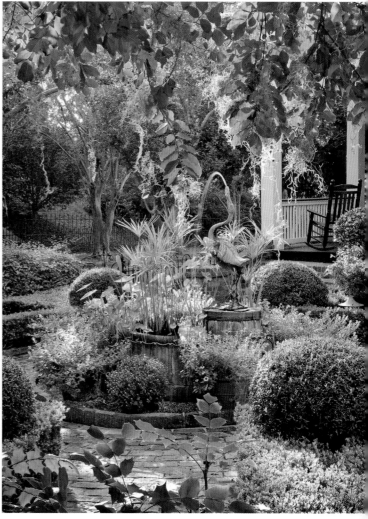

Top left: The upturned limbs of this towering maple are brought to life as the sun moves behind it, blurring the small branches and leaves. The crisp, repeating lines of the pergola and the linear progression of the pea gravel path draw the eye toward the tree's more impressionistic form.

Top right: A formal front garden in historic Natchez, Mississippi, with its background of gothic live oaks and draping Spanish moss, is a Southern jewel. The hard light has been filtered through a foreground tree as it plays off the clipped boxwood and water feature. The rocker was placed on the porch to give the eye a destination.

Left: These sculptural shrubs and lattice would appear much flatter and less dimensional without the bright hairlines provided by late afternoon backlighting. The entire scene, with its rigid architectural lines, is brought to life by light, which wraps its glinting presence around the entire garden.

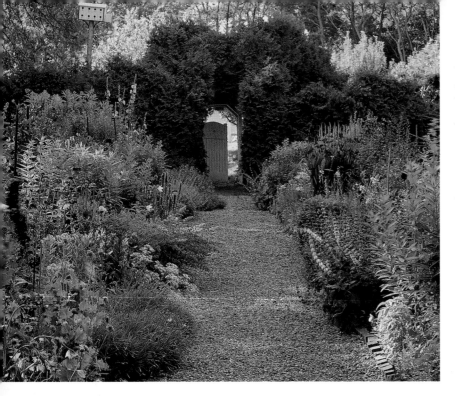

Left: This Beatrix Farrand garden in Bar Harbor, Maine, is just starting to glow and glint with morning light. The colorful looseness of the plantings invite your senses in, and the far gate is ajar just enough to lead you through.

Opposite: This image was shot hanging off a barn roof with an assistant holding my ankles. The composition is classic, with a lush, zigzagging line of perennials and annuals, ending in an oasis of garden seating—in this case, a pergola dressed in a riotous canopy of Clematis paniculata. *The dawn is lighting the background trees and the tall grasses and annuals in the border. Sadly, this garden no longer exists, but the camera was there to immortalize its perfect, fleeting beauty.*

How to Shoot into the Light

TECHNIQUE: Shooting into the light will force you to make some manual adjustments to your camera, and understanding how to make them is critical. If your SLR or compact digital has a means of controlling exposure, usually with an exposure compensation dial, this is the function you will use to trick the meter into overexposing when you're pointing your camera toward bright light.

You will have to take your camera off of its *auto-program* mode and set it to *program* in order to use this function. If you don't have exposure compensation capability, many compact and subcompact digitals allow you to fix the focus and exposure by depressing the shutter button halfway. If this is the case with your camera, find a darker part in your scene that is at a reasonable focal point as well, and lock in the exposure and focus with the shutter button. Then reframe the scene, bringing in the sky and morning light. It may take a few tries to get the exposure right, but they're only pixels, so shoot away.

Tweak your angle or move behind a tree or garden structure to block direct light from entering the lens, and wait for light to illuminate different parts of the overall garden. By waiting and watching as the light moves, new light patterns and image tones will emerge. If light flares inside the lens with bright hexagrams or hazes it, use your hand above the lens to reduce flare, keeping it just above the frame crop. If you do get a bit of hand in the image, it can be removed by a later cropping in postproduction. Keep shooting with the moving light; you'll know when you've got the shot in the bank and you can move on to the next setup.

ASSIGNMENT: Find a garden where you can shoot at first light, as well as at midday and in the late afternoon. Shoot the garden into the light and away from the light, and compare the differences in image quality. Once the sun begins to hit the garden, practice shooting through leaves or behind tree limbs to soften the direct light. Look for perennials, shrubs, and trees that are glowing, whose petals and leaves are translucent with backlight. Shoot medium and tight shots and entire plants and observe how they hold and transmit light. Find areas of the garden that are only about the quality of light hitting it at that moment, and shoot the light impression, without regard for the subject. Imagine yourself as Monet with a camera, or abstract impressionist Mark Rothko in pursuit of swaths of color. Let go of the literal and work with the idea that light alone is a subject. Try the same setups and subjects later in the day, when the light is behind you and your subject is frontlit. See how the tone and mood of your images change as the light does.

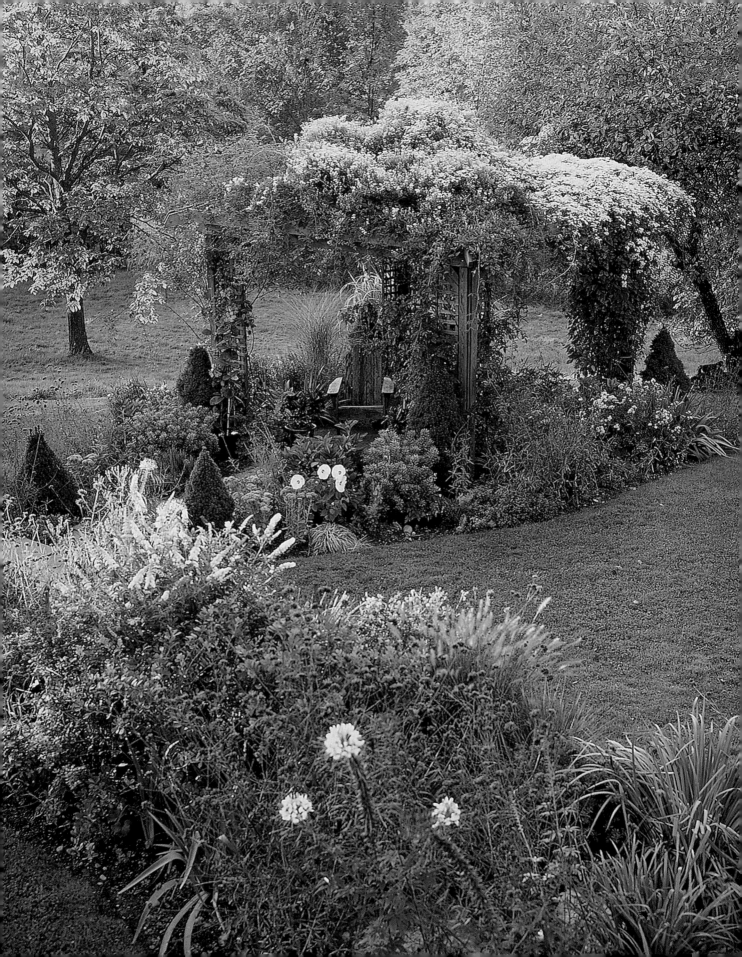

Left: This serene pool of Nymphaea *is framed only by grass, its dotted patterns of lily pad leaves contained and complemented by its circular border.*

Right: A Siberian pea shrub arcs its bough over a rill-like lap pool. The strong diagonal cutting through the frame is softened by the bough's graceful curve, which in turn frames the lounge chairs. When exploring the garden with your camera, look for ways to compose the image with strong graphic ideas in mind, such as the dynamic play of circles, squares, and rectangles.

Bottom: Simple geometric shapes, such as this bird feeder and bath, make up the bones of this garden, where the historic language of cultivated places has been reduced and modernized.

Opposite: This minimalist pergola, offset by the twisted bones of a native amelanchier, sets the tone for this coastal garden. The strong backlighting reduces the layout to graphic, monochromatic forms.

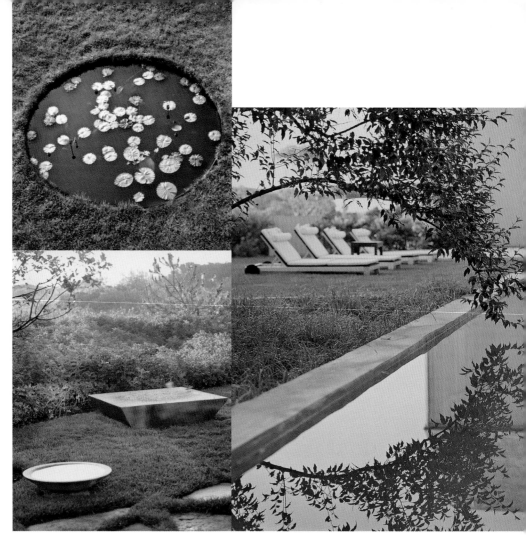

The Light Fantastic

I was on assignment in Sagaponack, New York, to shoot a shoreline garden designed by Edwina von Gal a few years back. Arriving just before dawn, with an ocean mist muting the frail, slumbering light, my assistant and I poked our way about the landscape. With the Atlantic rolling in just over the dunes and salt in the air, we searched in vain for the garden. I had been sent scouting shots of the property by my editors, so I knew it was here, but *where*? As the sky lightened, the garden began to reveal itself, remarkably: There was a long, minimalist rill of a lap pool

canopied in weeping Siberian pea shrub; a perfect liquid circle of *Nymphaea* cut into the lawn; modern sculptural pieces placed here and there; and a large, undressed arbor covering an outdoor dining area.

This garden was about understatement and modernism. Its lean, graphic bones and floral indifference were abstract and conceptual. But it somehow seemed very connected to its natural, thoroughly unmodern setting. The closer I looked, the more relationships were revealed: A pyramid of shattered automotive glass by the artist Maya

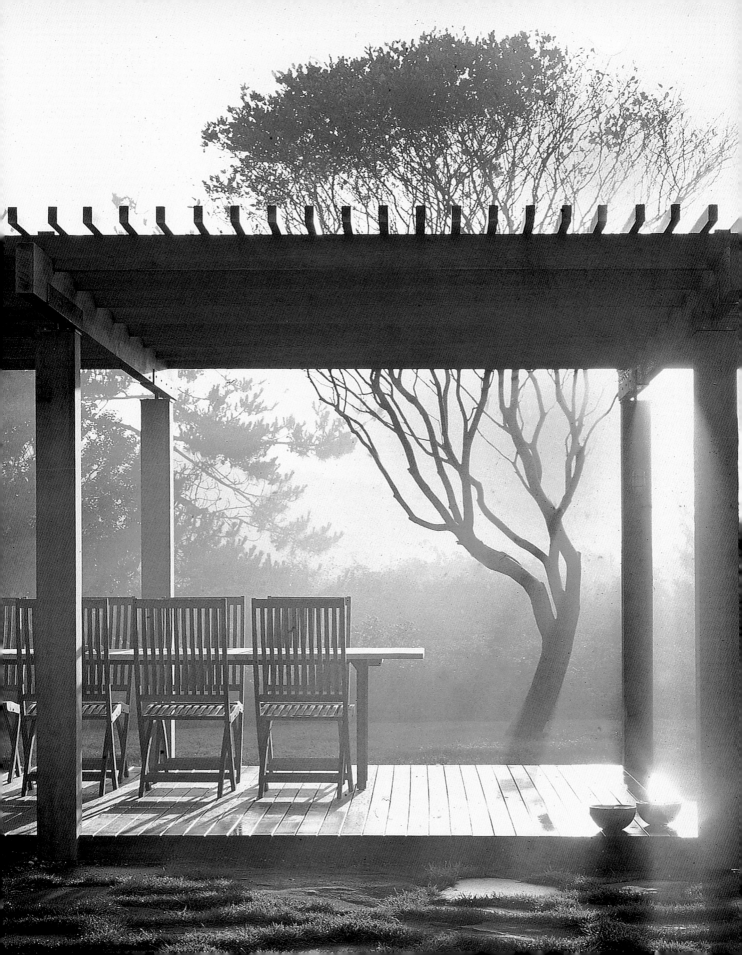

Lin mimicked the thousands of sand castles built and rebuilt on the nearby beach; the *Nymphaea* pool reflected the shape and brilliance of the sun; the wind-twisted bones of native *Amelanchier* were counterpoint to the boxy modernity of the house and arbor.

The garden was almost all bones, but what it lacked in traditional plantings, it made up for in exceptional design. Here was a thoroughly modern landscape where light would be proxy for plants, where the hardscaping that usually helps to contain and define the looser perennial elements of the garden would itself be defined by the sun. Because there were no plants per se to work with, the *leitmotif,* or theme, would, in fact, be light.

As I photographed that morning, I began to shoot the angular and unplanted arbor backlit by the rising sunlight, and beyond it the twists and turns of the *Amelanchier* trees. The warm, moist air diffused and carried light in luminous bands outside of long shadows. A solitary bird came to drink on a minimalist circle of standing water. A small bowl of rugosa roses was placed at the foot of a long outdoor table, adding a subtle trace of floral evidence and a glint of color.

The play between domestic modernism and Mother Nature was explored throughout the day. My camera and I loved this place, with its spatial haikus and Zen minimalism. The camera's own boxy, framed disposition felt a complement to the garden's geometric reductionism. Where some modern gardens can feel austere and humorless, the von

Gal garden had serenity and wit.

And because the garden was lacking in traditional horticultural archetypes, I made a decision early on in the day to let its contemporary abstractions reveal themselves through their relationship with light, with the shoreline, with the sky, with emptiness.

The von Gal garden was a surprise to me. As a lover of the lush and horticulturally indulged, a space this spare and elemental should have felt remote. I had seen a few other more luxuriant von Gal projects and this one seemed to stand on its own, a paring down of ideas. And yet, perhaps because von Gal seemed to be riffing on traditional motifs in the garden—the pergola, the birdbath, the *Nymphaea* pool, the statuary, the long rill of a pool—and transforming them into her own lyrical modernist declaration of place, the garden was accessible and thoroughly captivating.

The consummate garden designer seeks a relationship with the site and the home, and how they sit and dialogue with the larger landscape. You and your camera need to search for that same understanding. In your best work, the spirit of the place will have fused with your own artistic disposition, and something true and original will emerge. The lesson is not to come into an unfamiliar garden with your ideas or concepts fully fledged. Every garden has its own voice and distinct character. Magical, luminous places such as these are rare and challenging to render, but invested with the right kind of visual inquiry, they can be a source of photographic wonder.

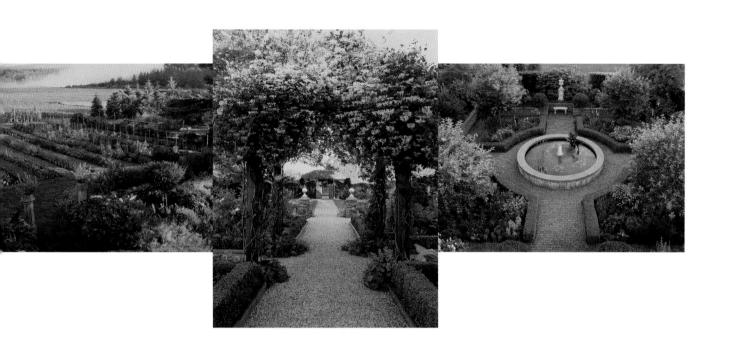

Light and Point of View

Working fully with your camera in the garden will require you to shoot from a number of points of view, namely *wide* (the overall shot of the garden, taking in most of the cultivated spaces), *medium* (coming in closer and editing the garden into smaller vignettes), and *tight* (capturing details and plant portraits). Light affects each one of these perspectives differently.

Wide: The overall, establishing shot of the garden has the most critical relationship with light. This is the point of view that takes in the garden in one eye-nourishing bite. You'll set the tone of your image by capturing how light plays off plants, arbors, and paths and how it glows in translucence through the trees. It's the scenic view, the *bella vista*, and great care needs to be taken in order to capture the light here at just the right moment.

Every morning is unique. And the effect of light on a garden's color, tone, and shape will change daily. Early morning and late afternoon light will rake across the wide, establishing shot in radiant bands of warm light. The colors of morning and early evening are mainly in the red spectrum, and include values of red, orange, and yellow. These warm colors act almost universally on the visual cortex, and we perceive them as comforting, stimulating, and energizing (even though the blue sky of midday, considered a "cool" color, is actually a much hotter color temperature than sunrise or sunset). Scientists have found that color creates physiological changes in the brain and has mood and affect, something known as chromodynamics. We're prewired to prefer certain color temperatures and, by extension, to make aesthetic choices based on the mind's neurobiological preferences.

So shooting in the red spectrum holds psychological sway over us, and the garden image, bathed in the warm light of daybreak, will always beckon and stimulate. It will pull us in. Your image needs to be an

Left: A farm garden in Connecticut wakes up to warm light and a rising bank of mist. The sun has begun to dapple the scene, punctuating the tops of the garden. Including the field in the distance illustrates the garden's relationship to its surroundings, giving the image context.

Middle: This honeysuckle arbor glows with early light, so much so that you can almost smell its sweetness. This formal garden view, topped with the arbor's welcoming wildness, invites us in. It's both intimate and establishing, which is a goal of the wide shot.

Right: A formal garden in Greenwich, Connecticut, shot from a rooftop, has a clearly defined order and geometry from above. Shot early in the morning, the light brushes through the tops of the willows, glazes the angular hornbeam hedge, and brings luminous color variations to the image. In the wrong light, this aerial perspective would flatten and dull the garden because many of the greens would be the same shade.

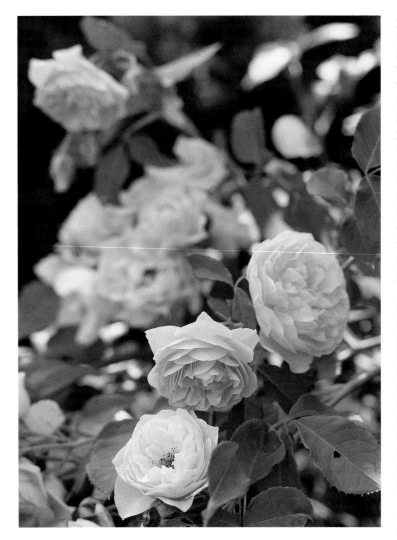

These roses delicately fold light and shadow into their multiflora petals. Dappled by surrounding trees, the light splinters through naturally to brighten various leaf sprays. If the rosebush is in an open area, use a light modifier combined with a leafy branch to get the same dappled sunlight effect.

point of view, and come in closer for the medium and tight shots in the garden, the fleeting perfection of whatever prevailing light you're working with will become less critical. The light on one part of the garden may be washed out (compromising the overall view) while the medium shot you've framed is still in reasonable light. You should time your medium setups so that they follow the path of light across the garden; you don't want to find you've missed a shot because you were paying too much attention to a single composition and not to the fleeting light.

Remember that light will begin to hit the part of the garden that is farthest from it first. Begin shooting by putting yourself as far west as you can in the morning, and shoot toward the eastern light. Reverse your positioning in the evening by standing in the eastern part of the garden and shooting toward the west. Always follow the rising and falling light, and focus your attention on how the garden changes as the light moves.

Tight: The tight point of view (traditionally called macro) will distill light down to a few highlights and tonal gradations, and allows you the most latitude and time in getting the desired shot. Save this point of view for after you have the other setups in the bank. Light modifiers, also known as diffusers, can always come to the rescue should the entire garden fall under the glare of a hot sun. Modifiers, such as scrims, screens, and filters, range from expensive to bargain priced and can be purchased in camera shops or online. While each type of modifier will soften the light to a different degree, their common goal is to allow you to shoot in bright, unflattering light.

invitation, an evocation of paradise. "We've got to get ourselves back to the garden," wrote songwriter Joni Mitchell. The overall view needs to summon up our universal desire to walk in beauty.

The lower the light, the longer and softer the shadows will be as they rake across the garden and its beds and borders. If there's moisture in the air, you may be lucky enough to capture bands of dewy light moving through the trees and brushing the plants below. This light can be used to lead the eye into the garden and establish a distinct point of view.

Medium: As you narrow your

When Design Trumps Light

There are gardens—and certain days in gardens—where light takes on a secondary role. This is not a heresy based on what I've just put forth, but rather a function of weather and garden type. An overcast day will mean more time to shoot, and the sky will act as a soft filter, muting shadows and contrast. This isn't great for the shimmer and glow that brings a garden to dramatic, heart-stopping life, but in a garden that is mostly about beautiful, shapely bones as opposed to petal power, this light is fine. In fact, even brighter, harder light falls more forgivingly on the hedges and hardscaping of a bony garden; they're never going to glow anyway.

One such garden and shoot was a sensuously carved piece of ground in New York. This garden was steeped in traditions, mostly English, but felt equally native to the south shore of Long Island. Perhaps it was the willows whimsically pruned into towering lollipops, like Truffula trees from Dr. Seuss; the Disney-like excess of flowing and undulating bubbles of yew and boxwood; or the roses and clematis clambering over very-American cedar shakes. The place was exuberant, an extroversion of its owner and designer, who was a rather retiring art director from New York.

Everywhere I pointed my lens, there were photographs to be made. The light was overcast for the 2-day shoot, so it freed me up to explore form and color alone for long stretches of time without having to worry about missing fleeting light or suffering under the unsightly glare of midday sun.

The resulting shoot, which ran in *House and Garden,* captured the remarkable spirit and sensuality of the place: drifts and waves of muted perennials; a sleek pool with Henry Moore–inspired sculptures of variegated creeping euonymus and towering purple hollyhocks; graceful, serpentine turns of hedge borders and annuals; and climbing hydrangea arcing over a privet tunnel like stars spilling across the vault of heaven—it was all a romantic's paradise. And one can hardly be a true

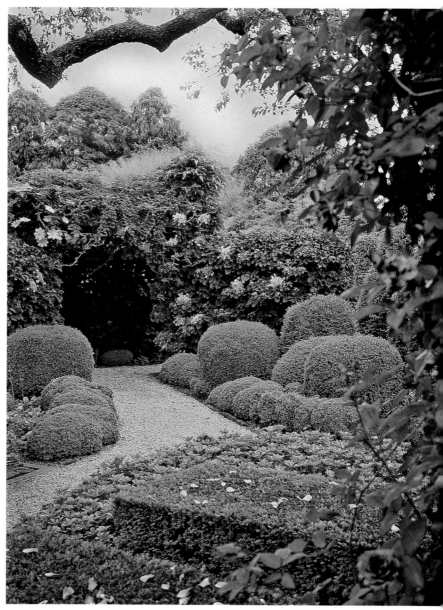

An overcast day in this garden was an opportunity to make deliberate compositions that emphasized form. The rose petals of climbing 'Zephirine Drouhin' were scattered by hand onto the boxwoods; the branch in the upper left was framed so that it echoed the curves of the distant trees. The foreground framed by roses and the path leading toward a mysterious arbor of Hydrangea petiolaris created a sense of intimacy and movement.

Left: The pale blossoms of this white Clematis lanuginosa *brighten the scene on an otherwise drab day. Choosing them as the focal point, with the garden itself only a backdrop, makes the best use of the available light.*

Middle: Emphasis on water on an overcast day will give your images some sheen. Because time is on your side in this light, your composition can be more thoroughly investigated and many perspectives can be tried.

Right: Even though light plays a minor role in this scene, the red maple in the background radiates the warmth of the morning light, while the path and shrub forms play with scale and geometry. Notice the splash of fleeting light throughout the image—on the coleus in the foreground, the tops of the hedges in the midground.

gardener, plant lover, or plant photographer without an inclination toward Romanticism, with its hunger for inspired aesthetic experience and love of the natural world. This property was as strong an argument as you can make for the cultivation of place.

Because you can't control a living garden or the light that falls on it in the same way that you can when photographing an interior or studio space, you are compelled to work with what you're given. The day your shoot is scheduled is the day the weather turns for the worse; plants that flourished only a week ago have faltered; borders that once seemed coherent are now an unsightly mess. This is the wonderful, exasperating joy of the garden and your efforts to photograph it: You are never fully in charge, and the constant *search* for photographic perfection is the only perfection there is.

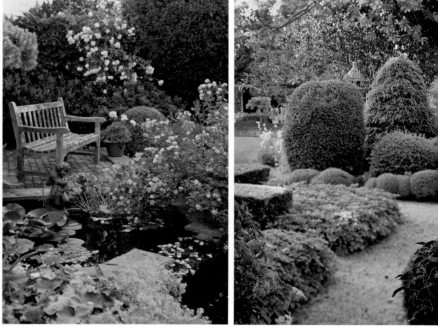

Focus on Form

TECHNIQUE: On an overcast day, you will need to seek out form and color more than light. In order for your images to have dimension, rather than appearing flat, you will need to play with scale, with contrasting and harmonic forms, and with pattern and repetition to liven up your images.

ASSIGNMENT: Find a garden scene that appeals to you and photograph it at different times of the day, maybe every hour. You can set up a tripod so that the composition is identical in each shot and only the light is changing. Observe how different qualities of light change our perception of the garden and what mood and tone the light creates. Shoot the garden on an overcast day, using form to shape your images. Then shoot the same garden in magical morning light, setting up the same compositions. What are the differences in effect from one day to the next? Which features play a starring role each day? How does light improve or flatten a scene?

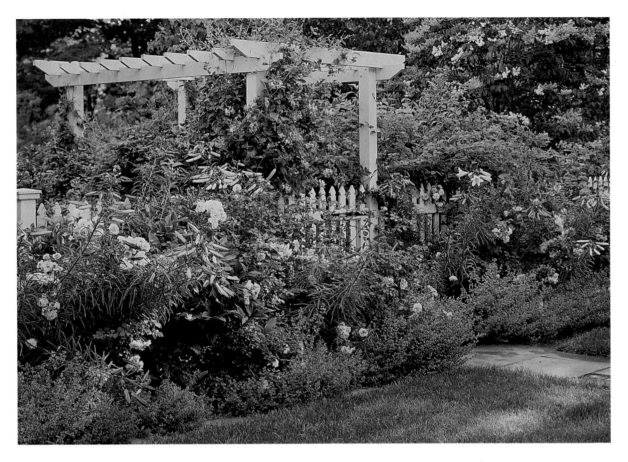

How the Camera Sees Light

The camera doesn't squint or blink. It can look directly into the sun, and it can see into deep shadows. It can conjure the world impossibly close and incredibly far. It freezes time and thaws our fixed relationship with the present moment. It sees like we do, and it sees how we *wish* we could. But the camera's most complex, beautiful, and abiding relationship is with light.

The camera's response to light is often autonomic, like a reflex. Unless we intervene, the camera responds to light the way the human eye does, always looking for the best exposure. As light levels change, the aperture of a camera lens expands or contracts like the pupil of the eye. But unlike the eye, which is always seeking the best, most deeply focused exposure, the camera lets

you control the amount and quality of light that is let in, allowing for infinite creative possibilities.

A camera's mix of controllable functions, from ISO number to shutter speed to aperture, is primarily there to manage the amount of light reaching the digital sensor. The *ISO number* is an expression of the camera's sensitivity to light; the higher the ISO, the more receptive your sensor becomes, allowing you to shoot in lower light. *Shutter speed* is the speed at which the shutter opens and closes (expressed in fractions of a second, such as $\frac{1}{8}$, $\frac{1}{30}$, and $\frac{1}{125}$). The camera's *aperture* is how wide the lens diaphragm opens in order to let in enough light to properly expose an image. Your aperture setting also controls the amount of the image that's

Dappled light and perfect plantings in this Greenwich, Connecticut, border call for a small aperture setting on the camera in order to render the entire scene with great depth of field.

Left: In order to emphasize the ornate beauty of this classical urn beneath a hornbeam arch, a wide-open aperture keeps the focus squarely on the urn, isolating it from its environment.

Right: By opening up the camera's aperture to a large f-stop, say 2.8 or lower, the foreground frame of hollyhock 'Nigra' is all that is in focus, while the background rose arbor is left to glow in soft light.

Bottom: An abundant display of Kousa dogwood blossoms is made more manageable and interesting for the eye by selective focus.

in focus, or its depth of field.

The relationship between these primary camera functions is relative, meaning that changing one function directly influences the others, and this relationship will determine the overall effect of your images. Understanding this critical interdependence is key to wresting creative control from the camera's automatic (or autocratic) functions and putting artistic control back in your hands.

For example, if I decide that depth of field—or how much of an image is in focus—is something I want to control, I will set my camera to aperture priority (usually marked by an "A" on the mode selection dial). The aperture is the size of the lens opening, and lenses have various f-stops, or apertures, from wide open (f/3.5 and under) to very small (f/16 and over). The wider the opening, the less depth of field your image will have; the smaller the opening, the more will be in focus. Photographers often say they are "stopping down" or "opening up" their lens, which refers to adjusting the f-stop. Because depth of field is a way to lead the eye and express specific meaning in a photograph, it's a setting that I always adjust manually, either opening it to have less of the image in focus, or closing it for more depth of field.

When my lens is wide open, and the camera is set at aperture priority, it tells the other two functions to step up in order to create the right exposure. Because more light is reaching the sensor with the lens wide open, the ISO will decrease (the sensor won't need to be as sensitive to light), and the speed will increase so that the wide-open lens doesn't stay open as long and the image will be exposed properly.

I also work with very fast lenses (f/1.4–f/2.8) so that I can focally isolate my subjects. Even on bright days, I set the aperture at 1.4, watch the film speed increase a thousand-fold to $\frac{1}{5,000}$ of a second, and shoot. Unless I'm shooting in the garden at slow shutter speeds to indicate movement (called "dragging the shutter"), how fast I shoot is of little consequence to my image making. The only other time it plays a part is when light is low, and I need to shoot at a slow shutter speed in order to properly control exposure.

Like the plants I photograph, I need sunlight, in all of its permutations. I tend to rise and rest according to its schedule. Cloudy, rainy weather sends me into a funk. When the barometer drops, so does my psyche. I take vitamin D supplements. I light my rooms and home with exasperating care, and spend much of my day outside, commuting between the seven buildings on my small farm, shooting in the daylight studio, or working in the orchard, greenhouse, or garden. My camera is never far from reach.

I know that in order to photograph with expression and imagination in the garden, you need to see light in all of its moods and qualities the way a camera does. You need to care deeply about light, to become a savant on the subject, paying attention to how it acts on plants and gardens, and always to be shooting. Your consuming obsession with light is the single most important relationship you have as a photographer.

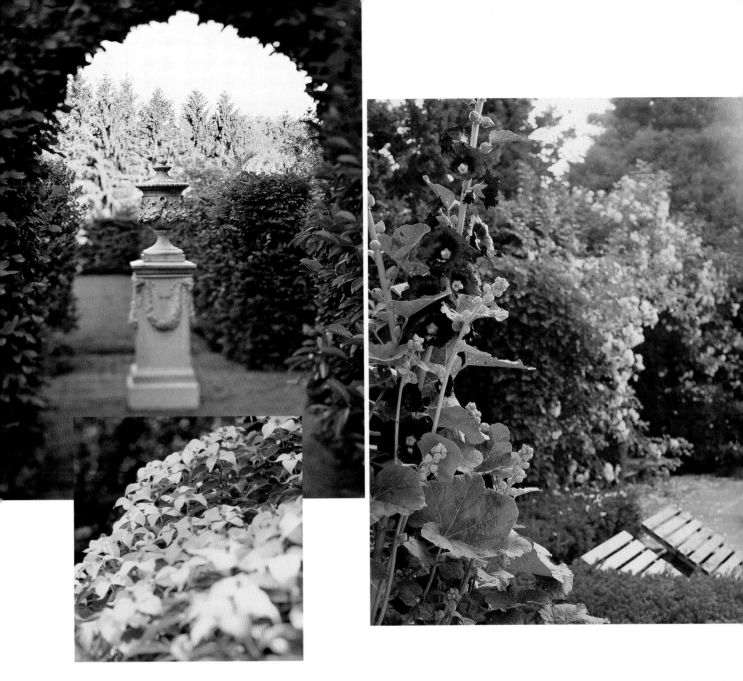

How to See Light Like a Camera

TECHNIQUE: Get familiar with the light controls on your camera, namely ISO, Speed, and Aperture. Read the sections in your manual on controlling these settings, and how to designate a manual priority or automatic setting for each. If your camera has an exposure compensation feature, or an "ISO Auto" function, study up on how to use it. The more intuitive these options become, the greater your creative latitude.

ASSIGNMENT: In the garden, practice photographing with your camera dialed to different priorities, including Auto. Choose the same setup and shoot it while varying only the settings to see how they affect exposure and overall picture quality. Keep a notebook, recording settings and examples of images, and review the notebook periodically until the information is second nature.

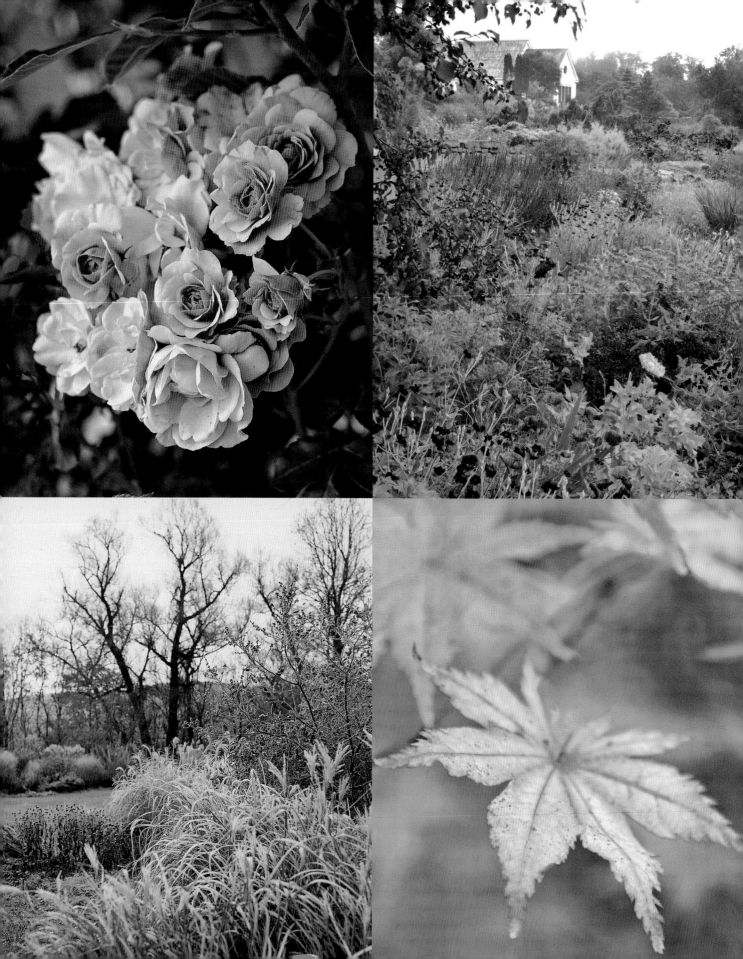

Seasonal Light

The more you shoot in beautiful light, the more you will seek it out and refuse to put your camera to your eye if the light isn't right. Just as you make discretionary choices about aesthetics elsewhere in your life, your photographs should be no exception. Learning when to put the camera down is as important as knowing when to pick it up. With iPads and Smartphones clicking away at every waking moment these days, we're being buried in a daily slurry of new images. In the garden, learn to watch and wait, and click only when the clicking is good. Most professional landscape photographers will shoot only in the early morning or late afternoon, when the light is warm and the sun's low angle brushes the scene with dramatic textural shadows.

There is also a seasonal advantage with regard to light. In early spring, when the sun is not as high and hot as in summer, the light hits the garden very early, unfiltered by the leafless trees. This light is beautiful on a slightly overcast day, but harsh and sharpened by bright contrast when hitting the garden head-on. In late spring, the light filters not only through fresh young leaves, but also through blossoms in the tree canopy. This light can be sweet and magical, as buds are freshly broken open, and seem incandescent in their glow. Colors this time of year are as fresh as they will be all season, still new and unbleached. All the attendant metaphors of birth and renewal, of the inevitable cycle, can be visually captured in the spring garden.

The light in summer is up earlier, and you will need to be, too. But there is often enough leaf cover to dramatically filter light and soften shadows. Near the shore or bodies of water, there will sometimes be mist or fog rising in the morning as cooler air courses over warmer water, softening and dispersing the light. Even atmospheric haze near cities can filter and diffuse light to your advantage. This light lends a quiet and impressionistic look to photographs.

Summer light at midday, however, is perhaps the least flattering of all the light that ever shines on the garden. Plants may crave it, fruits and vegetables may covet it, but your camera will recoil from it. I think of this light as purely physiological: necessary for plants to function, but in no way useful aesthetically to the photographer.

As summer transitions into fall, days will shorten and shadows will lengthen; colors will saturate even more as light moves through more-colorful tree cover. For many photographers, fall is a favorite season for shooting outdoors—the low light is warmer, and its long, outstretched beams create beautiful patterns through trees and across borders. As the fall air cools rapidly overnight and bodies of water retain their warmth, the soft scrim created by moisture in the morning air can cause the whole sky to glow with warmth and color. Despite the waning of plant life in the garden, fall is full of amazing opportunities to shoot.

The winter garden, though hibernating, can have its own dramatic flair. The garden's bones are the stars now: hedges, topiary, arches, and pergolas. The eye has a respite from the chromatic hum of the growing season and instead can take in the overall shape and form. Garden designs with winter interest in mind may be colonized with ornamental grasses, seed heads,

Clockwise, from top left: Roses are at their glorious best in spring, as this spray of pink floribunda blossoms proves. If the light is too bright, focus on the beautiful particulars, which are everywhere in this season.

A summer garden in full, radiant bloom, shot in soft early light. In an hour, this border became unshootable as the fog bank burned off and harsh, contrasty light ruined any subtleties of form and color.

For bright, foliar beauty, fall is the season. Here, the bronzed leaf of a Japanese maple makes a strong late-season statement. Shot with a macro lens at f/1.8, only part of the foreground leaf is in focus, leaving the rest an impressionistic blur.

Winter will reveal the garden's bones most clearly. Perennials, such as these grasses, will hold their form throughout the cold season, creating soft mounds of texture and tone.

Left: The light in summer is up higher and out longer than in other seasons. These sunflowers, though shot in relatively bright light, tower above the camera and move about in the breeze because of a deliberately slow shutter speed.

Middle: Though blossoms may be fewer in the fall, plenty of color is available to the camera. This rugosa is flaunting her jewel-like hips against a sea of soft-focused green in this seaside garden.

Right: Winter reduces the garden to its indelible bones: a boxwood ring, an arbor, a stone bench. On frozen, sunless days, you can shoot at any time, although right after a fresh dusting of snow, as in this shot, is magical. This was shot with a 28–70mm zoom lens at f/3.5.

crab apples, and hawthorn fruit. All of these add a muted, textural feel to the winter garden. Its large swaths of restrained color accented by a few bright fruits, dramatic pods, and the framed architectural lines of leafless trees, can make for strong, graphic images. With winter's cooler light, and with the occasion of reflective snow on the ground, the camera needs to be tricked into overexposing because it will interpret the snowbound scene far more brightly than you would. In order to override the camera's meter, you'll need to use the exposure compensation dial and overexpose by one or two stops, or you can meter on a part of your composition that is less bright, and lock in the exposure by depressing the shutter halfway and then recomposing. And if the snow creates a blue cast to your image, set your camera's white balance dial to "cloudy" in order to warm things up. You can also edit, accent, and improve snow-filled landscape photos in postproduction (see page 139).

In whatever season you shoot, light—in all of its transmitted, reflected, and filtered permutations—will define the feel and quality of your images.

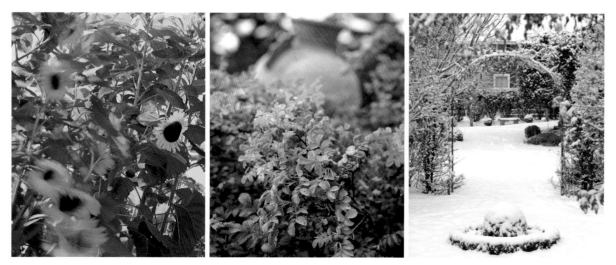

How to Photograph the Seasonal Garden

TECHNIQUE: Depending on the time of year when you're shooting, different issues will present themselves in the garden. In spring, flare and lack of leaf cover will be more of a problem, so you'll need to shoot earlier in the day. Summer will ramp up contrast with its high sun angle, so more diffusion filters may be called for. Fall will seduce you with beautiful light and color, but plants will be on the wane, so be prepared to prop up or fill in fading blooms. Winter's bones can be graphic and dramatic, but the reflected light off snow will be a challenge for exposure and color balance, so adjust your camera settings accordingly.

ASSIGNMENT: Every season will present different advantages and challenges to the photographer. Photographing your garden, or anyone's, in all four seasons will give you a sense of the changing light, color, and form in the garden throughout the year. In spring, shoot bulbs and flowering trees in combination and as botanical portraits; in summer, let the perennials take center stage with long, full medium shots; in fall, focus on the rich color palette; and in winter, shoot for form and architectural bones in the garden.

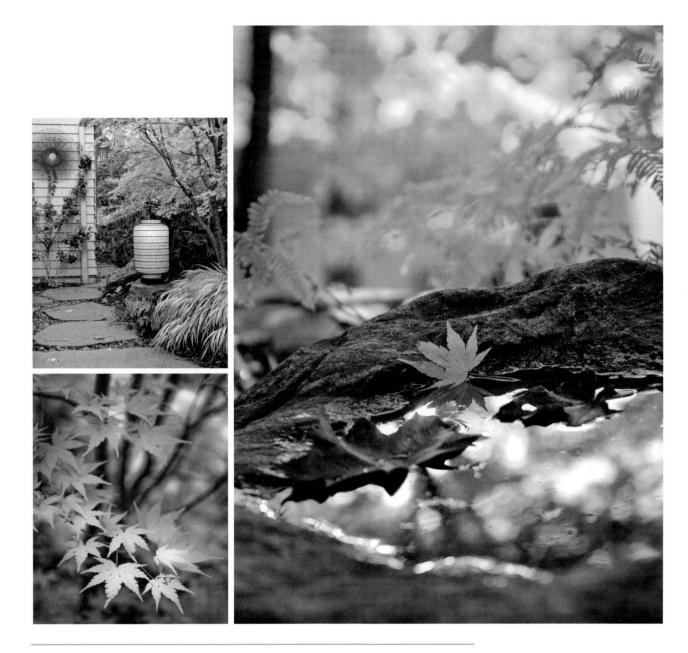

Top: The fall garden has a quiet glow to it when leaves softly radiate color. Though more hardscaping than garden, the large Balinese lantern adds a focal point in a busy setting, while the leaf-scattered path leads the eye through the image.

Right: Beautiful patterns of leaf-warmed light are at their peak in fall. Here, a water feature in a garden glows with reflected light. The leaves were added to the pooling water to break up the reflection.

Bottom: While the fall leaf colors are seductive, so are their forms. As trees turn to trunks and branches, beautiful leaf patterns emerge in contrast. These Japanese maple leaves, developed in sepia to emphasize their form, glow against a starker background.

Light on the Botanical Portrait

Left: This bright and brazen daylily was backlit to emphasize its fiery, warm colors and glowing throat. The light coming through the petals is what brings this portrait to life; the shallow focus leads you right inside.

Middle: A yellow magnolia, set against a backdrop of pink, glows in the diffused light of an overcast day. The leafless branches of this magnolia tree add strong, graphic lines to the composition. The focus is shallow and sharp on the flamelike center of the yellow blossom, while the pink background complements the pale yellow.

Right: When plant and petals are moist, as in this dewy Clerodendrum trichotomum, *water droplets will shape the petals and give them some glow on an otherwise cloudy day.*

The detail shot, or horticultural portrait, can be one of the most graphic and beautiful images you make in the garden. There is a long and captivating history of plant portraiture and for good reason: The exquisite detail and patterned forms found in nature are unrivaled for their complexity and compelling beauty.

Just as in images of the larger garden, light plays a part in the tone and effect of your botanical portrait, but because you have come in close to capture tactile detail, light's role is more of a cameo. A petal's translucence can be dramatized by certain light, its tonal gradations heightened or its hue deepened, but the botanical portrait attends to form as much as color.

Light coming from behind your subject will help to set off its inner workings and architecture: the vascular tracery in the petal and leaf of a hollyhock or magnolia blossom, seeds suspended in the red gel of a currant berry, the saturated gleam of a backlit rose. Light is the animator of form. It takes the static and turns it on with its fleeting presence.

When the light is low across the garden and moving fast, you will most likely be working on larger establishing shots, but if a bloom is provocatively lit and its form and color are glowing with beautiful light, by all means shoot it. Just keep an eye out for what's happening to the light in the wider view. Sometimes light will seem to pause for a moment on one plant in particular, singling it out for photographic scrutiny. These moments can never be anticipated, only seized upon when they arrive. So always be ready to shoot the miraculous moment. This sort of divine intercession is a gift.

Most of the time, your botanical portraits will not be dramatically lit but will, instead, be shot in filtered light, in shade, on an overcast day, or with a light scrim. The advantage of shooting your portrait in diffused light is that it evenly balances the values of form and color, creating an accurate evocation of the plant. What the images may lack in drama and flair, they make up for by revealing the sheer marvel of botanical design.

When considering light on the plant portrait, never shoot in the bright solar glare between 10:00 a.m. and 2:00 p.m. unless you have a means of diffusing the light. There are collapsible diffusers available that work extremely well, or you can always use any lightweight white fabric you have around (colored fabric will alter the hue of your subject). Any light falling outside the subject area and beyond the reach of your diffuser will be blinding, distracting the eye, so try to frame your shot within the shaded area.

Remember, too, that even when light is diffused, it is directional and always coming from somewhere, only with more subtlety. By shooting from several different angles, with the light coming from behind or from either side, you will notice quiet changes in the portrait's qualities. The closer you get to a plant and its parts, the less of a role light will play, until—at a certain macro range—you are working with abstractions of form and color, like a modern artist. These extremely tight explorations of plant form can be quite beautiful, with their non-literal lines and color-washed shapes, but also a bit alien. The whole plant is often greater, and sometimes a tight rendering of parts

Left: Shot at midday using a scrim, this portrait makes up in composition what it lacks in dramatic light. By shooting through the foreground dahlia, the subject has more depth and context.

Right: Light dapples through this rose-colored clematis planted in a bed of lavender. The complementary colors, focal point, overall composition, and twinkling early light all come together here to make the portrait feel painterly and romantic.

Left: Though the day was overcast, the colors and composition of this image make it work. A brush of beautiful light would have been nice, but not essential. The roses and clematis create a singular palate, although their form is dramatically different. The clematis is framed in the center as the star, while the rest of the blooms appear in supporting roles.

Right: A backlit strand of red currants seems to glow with sweetness from within. The interior of the fruit is subtly revealed, and its deep red color is saturated.

Opposite: These poppies seem to glow from within, their rich colors and detailed form absorbing the soft, available light. By selecting a focal point up front, but including surrounding blooms, the image says more about the plant's habit than a singular botanical portrait would.

doesn't speak to the more beautiful sum, so you may decide to take a medium view. You can always crop in to an image later if the macro view entices.

Because plants are environmental creatures, defined as much by their collective environments as their individual form, you may want to include a bit of surroundings in your portrait. Diffused light would work well for an environmental plant portrait, as would shooting a few blooms in a group that are nicely brushed with a bit of light, while the rest are in shade. A field of bee balm or Shasta daisies can create a beautiful carpeting of photographic color, but their individual form is lost. Come in tight and isolate an individual plant, while dropping the rest out of focus. This creates an illusion of the whole while focusing on the singular.

Lighting the Botanical Portrait

TECHNIQUE: The perfect lens to use on the plant portrait is a 50mm macro lens, which will allow you to shoot a standard stem-to-stamen shot of your subject, but will also give you the opportunity to come in very close for those abstract plant details. A longer lens, a 105 macro, could also work well, with the added benefit of less depth of field to isolate your subject. Flexible reflectors and scrims, or silks, are useful for shading and augmenting your shot in bright light.

ASSIGNMENT: Shoot a botanical portrait of one plant filling the frame, and another of a single plant in a group that has been isolated with selective focus. Shift your point of focus to emphasize different plants in the group, and change lenses to see their effect. Practice shooting portraits at different times of the day in varied qualities of light. Shoot in the shade and in bright light with a scrim; shoot backlit and sidelit to see how directional light affects the portrait's mood. Come in very tight on the plants' inner workings. Play with abstract form and composition, shooting partial plants or small details, such as petals, dewdrops, and leaf veins.

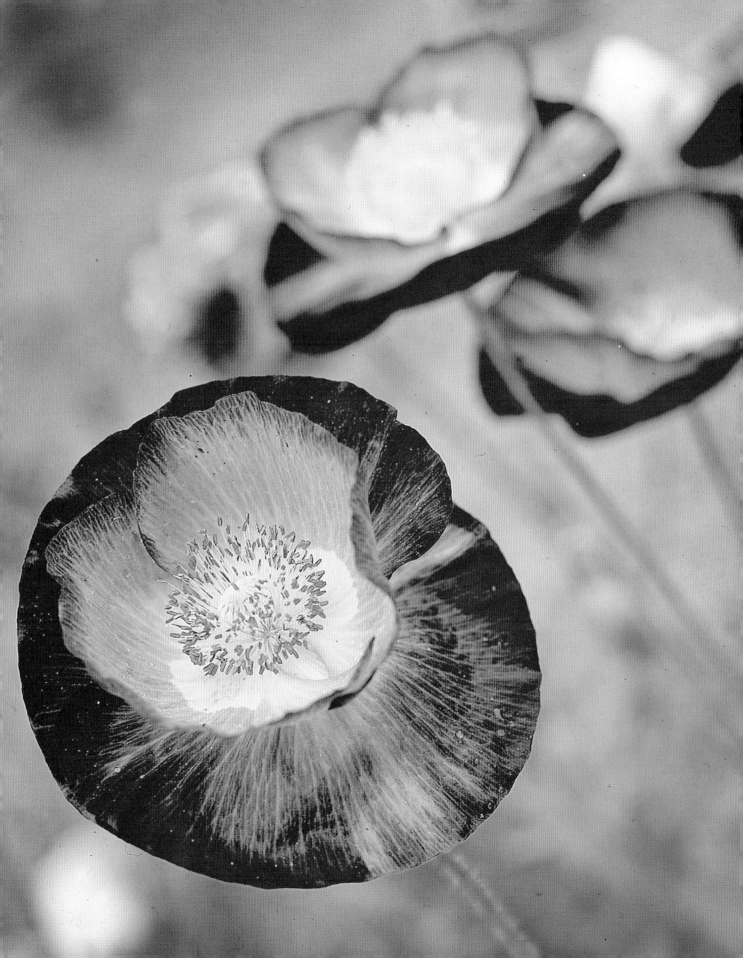

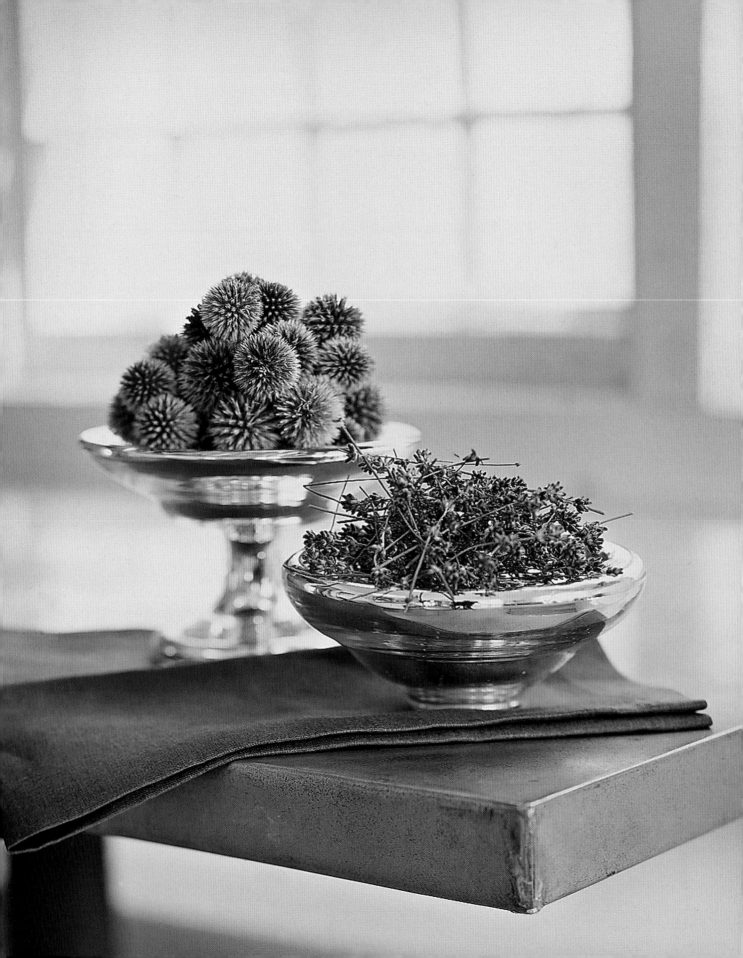

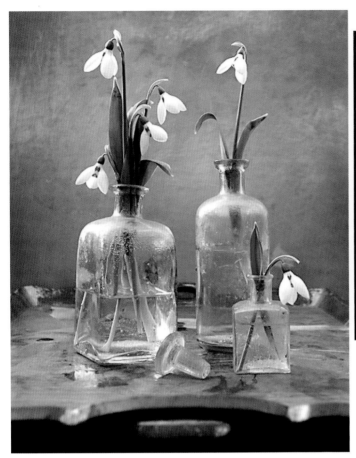

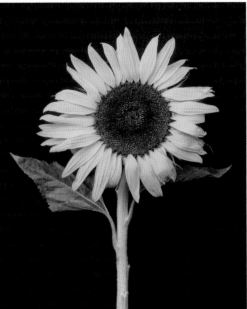

Opposite: A north-facing window, a galvanized aluminum table, mercury glass bowls, and a simple complementary fabric are all that was needed to create this serene still life of Echinops ritro *thistle heads and lavender. The mercury glass bowls add reflection and highlights to the image, and their smoothness is a counterpoint to the rough-textured thistle. Without them, the image would have had a much flatter feel.*

Left: Galanthus nivalis, *with its penchant for breaking through snow cover, was styled in cool blues and grays on brushed aluminum. The antique medicine vials help the viewer discern the plant's pint-size habit. A scrim was used over the top of the setup to diffuse the light on the reflecting surfaces.*

Right: This perfect sunflower is pinned to a background of brick-red velvet that makes its petals pop and says something about these heat-loving annuals. The light was diffused with a scrim, keeping the focus on form.

The Still Life

Much of the historical repertoire of botanical still life was painted indoors, set up in studios, rather than outdoors *en plein air* like the impressionistic canvases of Renoir or Pissarro. And much of early plant photography was created in studio as well, where conditions could be controlled and specimens chosen and edited for their archetypal form. The work of early photographers Charles Jones and Karl Blossfeldt explored botanical form under strictly controlled indoor settings.

Filling a vase or garden basket with blooms and arranging them near a north-facing window is a perfect setup for the indoor plant portrait. As you style your botanical still life, choose props that comple-ment the flowers in either shape or color and that have some narrative dimension that adds to the visual story. On a shoot about *Galanthus*, for example, I chose to style a photograph of them indoors against a cool, brushed aluminum background to emphasize their habit of poking up through the frigid snow. I also propped the image with small, beach-glass-blue antique medicine vials that emphasized their diminutive scale. These were thought-through narrative decisions, but all that glass and metal also had the effect of cooling the light and saying something about the plant's late-winter cycle.

The most flattering, dimensional light you will find indoors is near a north window. Get started with

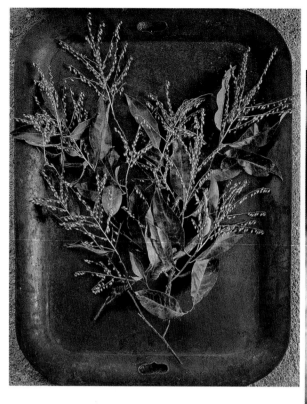

Left: These fall-gathered sourwood branches (Oxydendron arboreum), *with their deep red leaves and white, urn-shaped flowers, are a great subject for the still life. A simple tin serving tray on a cement floor was all the styling necessary. Using diffused light from a north studio window and shooting from above makes for a flat, graphic perspective.*

Right: The carefully styled still life of a basket of Baptisia australis *is lit with north light from an open door to the left of the frame. Because of the strong composition, it was converted to sepia in order to emphasize the repetition of pattern and form and play up the antique nature of the props.*

botanical portraits by setting up a small table near a north window where you can arrange your portrait; place a second small table nearby for various shapes and sizes of props.

You may also find that you want to lighten and add more detail to the shadows on the southern side of your image. A piece of white foam core or even stiff white paper will do the job of bouncing the light back into your setup. A collapsible, circular reflector is designed to bounce light and can be used indoors as well as out. If you don't have a north-facing window, an east- or west-facing window can be used at a time of day when the light is indirect. A south-facing window could also be used with diffusion (a bed sheet will do the trick). The advantage of soft sidelighting is that it will add depth to your subject through gradations of tone, and

allude to all the classical sidelit still lifes that have come before.

You can also create an outdoor studio of sorts for your plant still life, particularly when a beautiful specimen is thriving happily in the ground and you don't have the nerve, or permission, to cut it and bring it indoors. If one makes a distinction between an environmental portrait in the field, and a studio still life where a subject is separated from its usual surroundings, the outdoor studio is something of a hybrid: The plant is still *in situ*, but you've isolated it from its environment and are controlling its look by modifying both the light and the background in order to convey a particular idea. A backdrop behind your subject and a light scrim above will nicely isolate it.

On a shoot in Maine of a quirky

garden built on the bones of an old tennis court, the sheer number of gorgeous hybrid poppies, more than I'd ever seen or photographed in one spot before, tempted me to set up an outdoor studio when the light had gotten too harsh for other garden views. A black backdrop was A-clamped to a light stand with a horizontal crossbar, and a diffusion scrim was secured over that. I moved this setup around the garden, shooting poppies in various stages of bloom and blossom drop. (I'm also drawn to the architecture of the pods themselves.) My favorite image from that shoot is a hybrid oriental poppy that I had set up, who then quickly shed her soft double petals and spilled them to the base of the stem, like a model dropping her robe. I've never photographed a flower in such a provocative state of *déshabillé*.

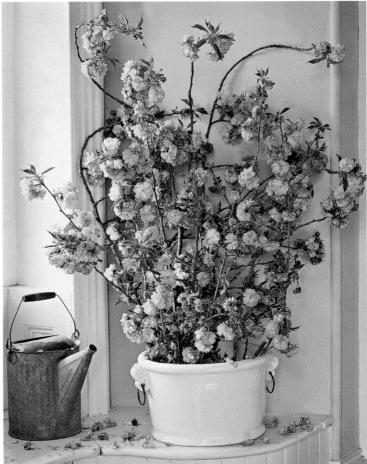

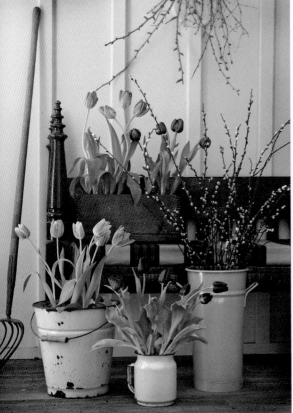

Above: Cherry blossoms, in full resplendent bloom, fill a large ceramic urn in this interior still life. The antique watering can adds some interest, and the soft sidelighting flatters the arrangement without overpowering it.

Left: This carefully styled spring image of tulips and pussy willow uses pastel-hued containers and a gothic bench for staging. The antique hay fork and ginkgo branches complete the styling, although the image would work fine without them.

Right: Even nonblooming botanicals deserve some camera time, as in these simple but elegant blue atlas cedar boughs on a wooden bench.

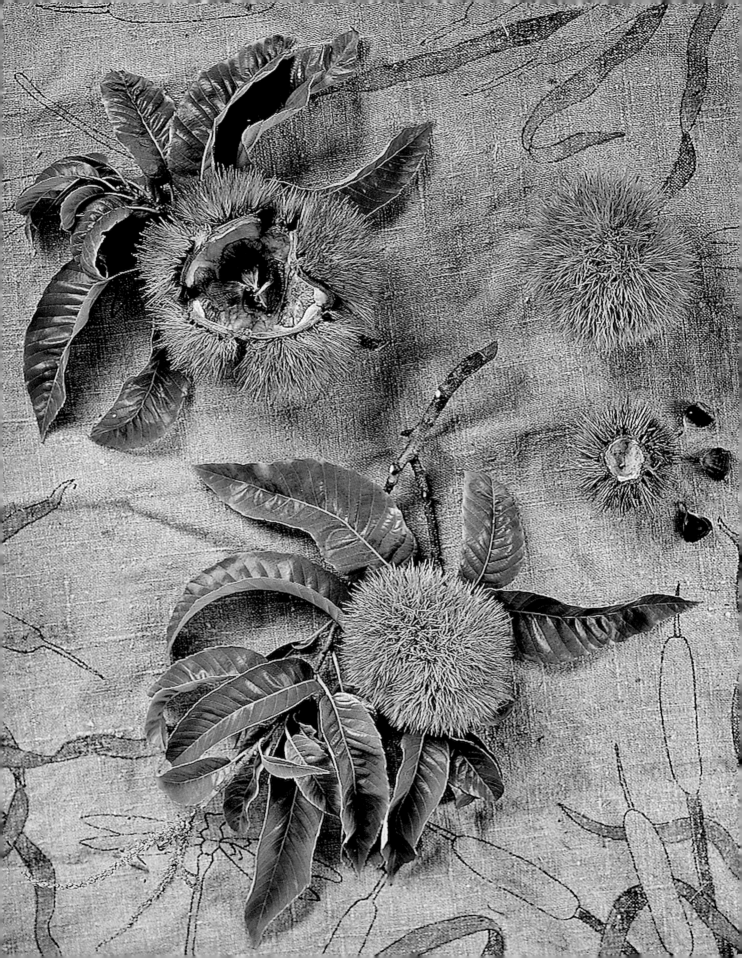

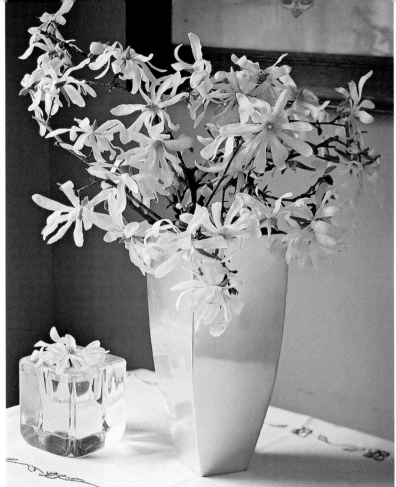

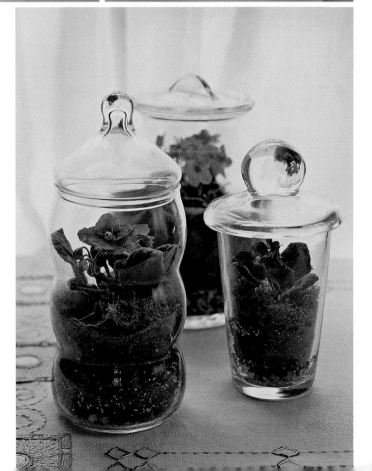

Opposite: Formally arranged chestnut seed pods and leaves on an antique linen fabric create an image that alludes to early botanical prints. Shot from above and in diffused light, the reference to historic printmaking is understated but inherent in this still life.

Above left: These *Magnolia stellata* branches were placed in a bold, brushed aluminum vase on an embroidered Art Deco linen runner, sidelit near a north window. The delicate petals counter the sturdy frame in the background, while the branches are repeated in the runner's design motif.

Above right: These stunning dahlias could seduce without much help, but the right vessel, artful windowsill, and backlight raise this image beyond the simply beautiful. Attention to the shape and color of your props is critical to a successful still life.

Right: For a shoot on terrariums, plants were displayed in antique apothecary jars and placed on a vintage Art Deco runner. The indirect light was diffused even further with a sheer curtain. Much thought and preparation went into creating and propping this image, which you have time to do with the still life portrait.

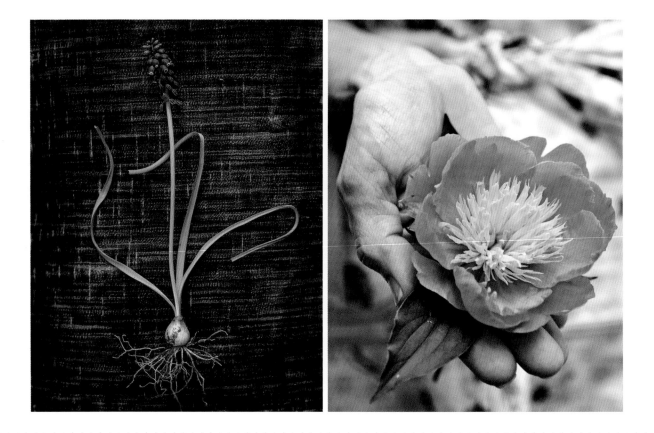

How to Set Up a Still Life

TECHNIQUE: Use a medium telephoto lens (anything between 60mm and 105mm) for a still life, just as with the botanical portrait. Use props and backgrounds that complement and animate the form of your subject. When setting up the *plein air* studio, have a number of different tones of fabric backdrops, preferably muted, to shoot against. Be sure to have enough A-clamps, duct tape, and stands to set up your backdrop in the garden, and be careful of wind taking the whole studio down. A few large stones or bricks at the base of your stand will help to stabilize it. Indoors, a north window will be your best, most diffused light.

ASSIGNMENT: Set up an interior still life, styled with a vessel to hold the flowers and whatever other props might add interest to your image (a look through a catalog of classic Old Masters' still lifes might inspire a few ideas). Then set up a studio in the garden with a backdrop and scrim at midday and photograph some botanical specimens. Add and subtract light to alter the mood of your image, then shoot your still lifes in black and white to study how the emphasis changes from color to light and shadow.

Above left: A diminutive Muscari armeniacum *shot with its bulb and tangle of roots intact on a plush velvet pillow, which highlights its color, texture, and form. The composition also alludes to historic botanical prints.*

Above right: Held preciously in the hand, a perfect specimen of Paeonia daurica *shows off all of its iconic form in sepia. The human presence conjures up our relationship with nature in this portrait.*

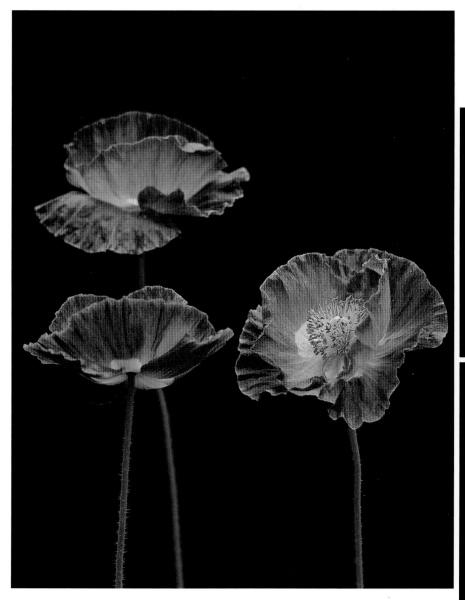

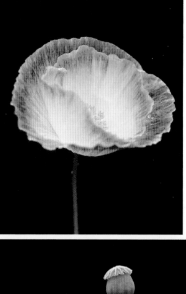

Given the right garden, permission, and the most beautiful subjects, the outdoor instant studio is an excellent way to take your explorations of plant form to the next level. If you're arriving by car, keep any stands and scrims locked away and fetch them as you need them. Never burden your adventures with too much gear; just tote the essentials. If you happen on some plant specimens you'd like to isolate, your studio is waiting for you in the trunk.

Left: For this image of poppies, a black background cloth was brought into the garden and set up with a light scrim to create an instant studio in the field, dramatically isolating these few blooms from the rest. Setting up an instant studio is always an option if plants can't be cut or moved or might wilt quickly when cut.

Right: This single, demure poppy seems to be hiding her crown of anthers behind the fold of the foreground petal made more dramatic and suggestive by dropping the petal out of focus.

Bottom: Sometimes a flower just decides to take it all off, giving you a chance to make something more provocative than planned. This poppy fell apart as I was shooting, but I kept clicking until there was nothing left but stem and pod.

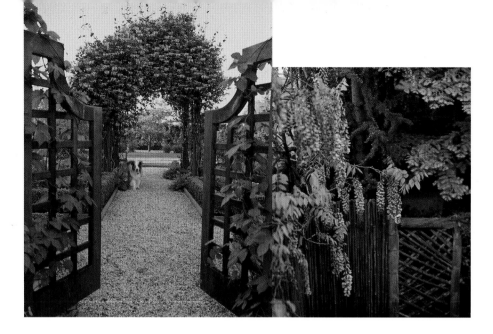

Working with Bad Light

Left: The absence of beautiful light will mean more time spent using garden elements to create strong images, as in this gate and arbor framing a view through. The appearance of the garden's mascot was pure serendipity and gave the garden's expanse a backyard quality.

Right: When the light is weak or overcast, working with strong colors becomes more important, as in this image of Wisteria chinensis *hanging over a garden gate. The image plays with patterns and tones of purple, green, and gray.*

You are always at the mercy of weather when shooting the garden. There will be days when you show up, camera ready, and the sun stretches itself in long, warm bands of light across the landscape or paints a pooling bank of fog with color—days when the light is a marvel in itself. These are the mornings you hope for, but they are by no means the norm. When the weather falters, and you're on location ready to shoot, you have to make the best of it. Gardening itself is a fateful dance with weather and climate, so why would garden photography be any different?

When the day is overcast, it not only eliminates the possibility for dramatic backlighting, but it flattens the shadows—sometimes so much so that the garden loses dimension and depth. The warm tones brought on by early light also disappear, and the garden's color palette mutes and cools. There are degrees of overcast, of course. A thin veil in the sky can soften the daylight just enough to scrim the sun without the garden going flat. Thick, gray cover, however, will shift the garden's color values and deaden the place.

On an overcast day, work at a steady pace and be sure to compose your images with a strong sense of the garden's inherent architecture. Include ornament in your images to add scale and anchor points for the eye; shoot to include and emphasize the garden's bones. What the garden lacks in light, you can augment with strong composition. If the light is gray and unflattering, you can often set your camera's color balance menu (usually found under "white balance" in the camera's menu dial) to "cloudy," which will warm things up in camera. This will give you instant color correction. I like to wait and work my colors in post-production, on a larger screen, so that I can really see what I'm doing. You don't want your crimson roses turning brick orange because you couldn't make them out on your camera's skimpy LCD screen.

If clouds turn to rain, best head for cover. Digital cameras are complex electronic visual computers that have no interest in getting wet or even damp. Once the rain clears, however, and the saturated air holds the emerging light in its grasp and every surface of the garden is trans-

piring, the scene becomes almost magical. Leaves and petals shimmer with a wet sheen; grass seems to glow; blossoms in trees hang in the still air like glass. And when a rainbow emerges, well, that's as good as it gets.

Sometimes, a garden near the sea or in the lee of a mountain or foothill will begin the day in a fog or mist that softens the light until it warms and lifts, and in the transition there are great opportunities to make beauty. This light may obscure your view at first, and you may rightfully curse it, but be patient: It's just the day unfolding. Be resourceful and figure out how to use the light you have. When the fog begins to burn off, you will have only minutes before the light makes the garden unshootable. The mad photographic dash must be part of your repertoire.

A garden I photographed for *Garden Design* magazine some years back, conceived by sculptor Jeff Mendoza for the art critic Robert Hughes, took what seemed like hours to emerge from a shoreline fog. Frustration turned to awe as the garden began to reveal itself. A small, immaculate space, standing alone along the coast of Shelter Island, New York, the garden's design undulated like surf, with rounded shrub patterns laid out in shell-like whorls. It was a marvel of interconnected sculptural layers, sensual and expressive. Even if the light had never shown up, there was enough form here to evoke beauty. Maybe it's only the most horrific light that will force a great garden to surrender its beauty.

Sometimes bad light is not a function of weather, but of the garden's inherent design and site. A garden surrounded by a high coniferous canopy will never see the beauty of early or late light, only the hard glare of late-morning and midafternoon

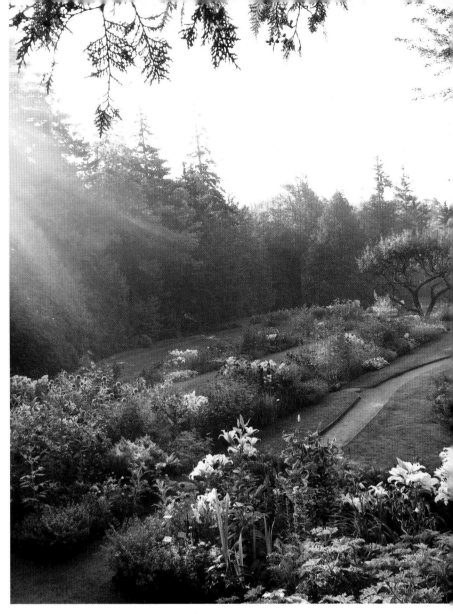

sun. The same holds true for a small back garden in an urban lot, or any garden where the low ends of the sun's east-west path are blocked by trees or structures. On clear days, these gardens are best shot early or late, avoiding the inevitable onset of hot light. Overcast days will give you more time to shoot. What these spaces lack in flattering light, they will often make up for in interesting plantings. In order to get the story of such places, find medium and tight shots that illustrate an overall theme and think about texture and senses other than sight.

This beautiful garden in Maine is surrounded by a high canopy of deciduous forest. When the light does break through, it's fast and dramatic and workable for only minutes. I was perched on a shed roof, holding down a fringe of branches, waiting for this brief moment.

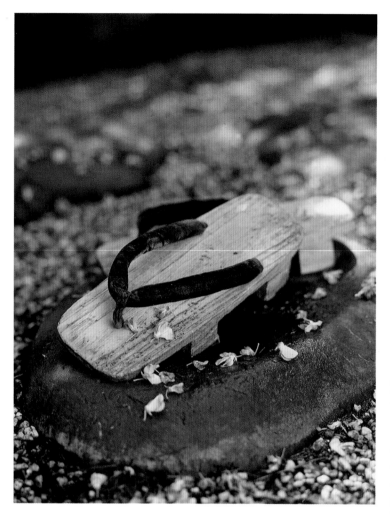

*Details, such as these
Japanese wooden sandals set
on paving stones and scattered
with wisteria blossoms, can be
made in any light, with the
right shading and placement.*

A rooftop Japanese teahouse garden in Manhattan, owned by an Internet entrepreneur, was surrounded by scrappy, tar-smeared Manhattan roofscapes, and by the time the sun reached it, it was too hotly lit to capture much more than contrast and glare. So in the morning and late afternoon, images focusing on the garden elements—a tight shot of a pair of wooden-soled sandals worn to tea ceremonies, a bamboo *tsukubai* fountain filling a stone basin, and bamboo rustling like a clump of aerial antennae— were points of focus. The light would never be beautiful, so the supporting elements of sound, texture, and detail would have to step up. I even got permission from the hotel across the street to shoot the garden in context, surrounded by less-cultivated roofs. When late-morning light hits the garden head-on, without much filtering from the horizon or a low, loose copse of trees, you'll need to work in whatever available shade there is, and scrim the detail shots you're after. If there's too much to shoot on a particular morning, you may need to come back late in the day and the following morning in order to get your shots. Whatever you do, don't shoot in the hard glare of midday light, unless you're somehow filtering the light.

A garden photographed in bad light can be partly salvaged to some degree in postproduction, but a software program adding fill light here and there and tweaking highlights can never be proxy for the real thing. That is one of the pleasures of shooting in the garden, of course: You never know what you're going to get. It's live theater—anything can happen and does. The sky opens up, the sun filters through, clouds move in, then rain, then an epiphany of perfect light. I would trade a predictable day in the studio for that capricious dance with nature anytime.

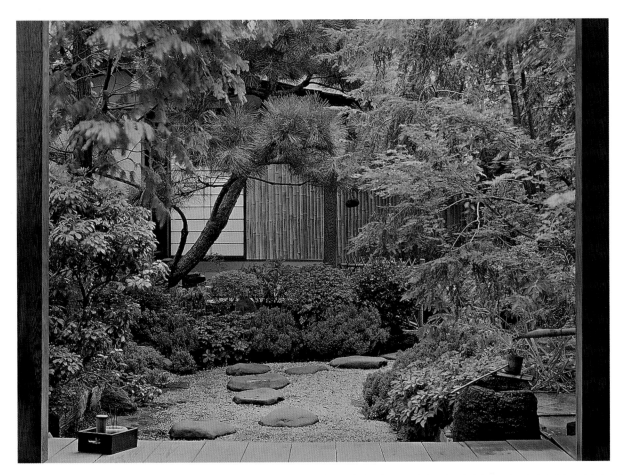

How to Shoot in Bad Light

TECHNIQUE: Scrims and filters will help you work in bright light for botanical portraits, but you'll need to be prepared to shoot the wider shots in any light (you'll need to avoid bright glare completely). Most shots can be tweaked later in postproduction to give them warmth and dimension. Locate the white balance and exposure compensation dials on your camera and read up on how to use them. The white balance function will allow you to change the temperature of the light the camera "sees," while the exposure compensation function will let you overexpose (or open up) shadows in order to capture more detail there.

ASSIGNMENT: Head out on a cloudy day and shoot a garden at a steady, leisurely pace. With the light being stable, but flat, you have all day to work on composition and technique. Alternately, shoot botanical portraits in the garden under the midday glare, using a scrim to filter light, and then shoot portraits in the shade. Compare these images to ones made in perfect morning light. Change your white balance and see how it affects the mood of your image. Change your exposure to open shadows.

Due to hot lighting conditions, this image of a rooftop Japanese garden in Manhattan focused more on formal composition and framing than on light. When you're that high up, low, soft light is not an option.

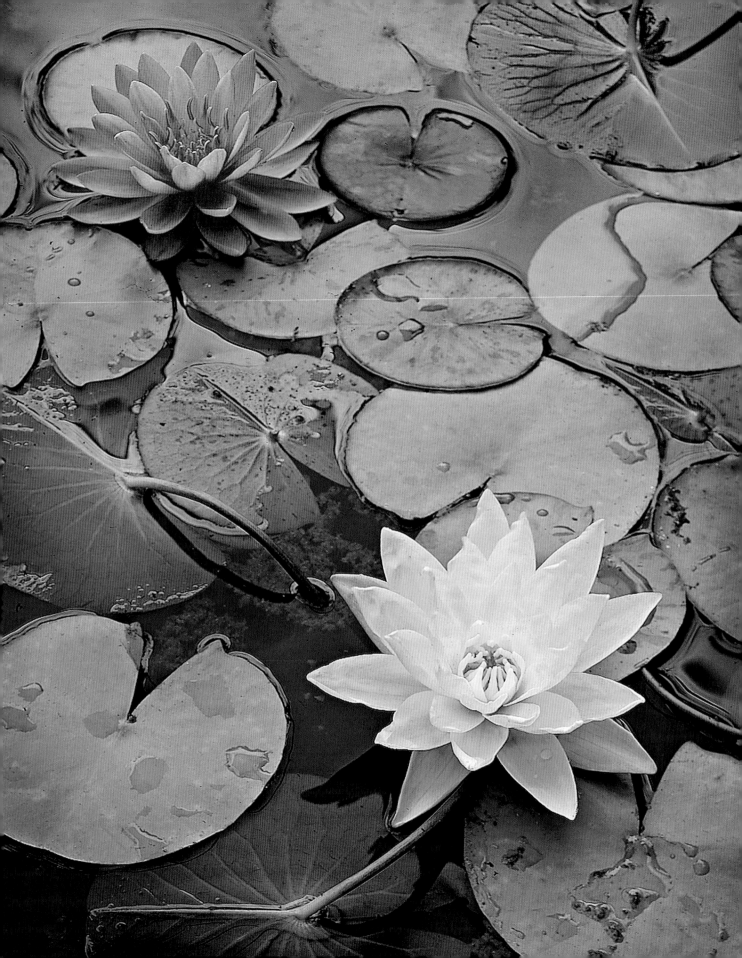

"Geometry is in everything. One finds it everywhere. It is nature's greatest teacher. One must be familiar with it, if one wants to observe and understand the things of creation."

—Eugène Emmanuel Viollet-le-Duc

2 | *Design*

Finding the Shot

Gardens are places of magical beauty and design imposed upon the landscape—an idealized, ordered portrait of nature. By extension, photography takes the order and plan of the garden and heightens it. A photographer is designing the garden again, according to his own aesthetic interests. He is creating structure and form within the rectangle of the camera, and making that space an extension of his own vision.

These water lilies were formally arranged in the frame for color harmony and compositional strength. Green leaves were turned over to reveal their purple backs, creating a subtle line of warmth through the water. The design was deliberate and carefully considered in order to create the best image.

This planting of sedums has inherent design elements, from the patterned brocade of its form to its rich whorls of complementary colors. When cropped and flattened by the camera, the plants become a living tapestry.

play, and reliable photographic techniques for finding and exploring those universals.

The garden photograph is not so much a moment in time, a "decisive moment" as French photographer Henri Cartier-Bresson used to say, but rather an idea of a place—an idealized portrait. The successful photograph is an evocation, an encounter with wonder, a visual poem that transcends time and topography and speaks to something larger than the image itself.

Distilling a garden to its essence, to its basic poetic form, in order to find compelling visual universals is always a goal of the garden photographer; and, of course, to make something simply beautiful. If I can make one honest, beautiful thing a week, then it's been a good week. In this age of quick pixels and terabytes of imagery, making something of legitimate beauty is the ultimate intent.

The best photographs have a clear and coherent design. Even the most random, loosely shot street photographs of Cartier-Bresson, Garry Winogrand, or Bruce Davidson rely on inherent design for much of their evocative power.

Sometimes a photograph will draw more attention to its photographic qualities than to its subject, and because photography is inherently interesting as a process, this isn't always a bad thing. But technical proficiency and technique alone will never make a great photograph. It may make an image interesting, even fascinating, but never beautiful. There needs to be something else in an image, something greater than the sum of its parts, a mysterious, heightened moment where we see the known for the first time, where we become aware of the very essence of *hollyhockness*, for example. Often this is an exploration of a flower's essence, its distilled, visual poem.

The origins of the word *paradise* come from the Persian *pairidaeza*, meaning "walled garden." A good garden photographer is creating his own paradise within the walls of the viewfinder, and an encounter with the idyllic becomes a possibility each time he frames a view.

What it is that makes a garden photograph a *paradise found* is the central exploration of this book. How do we discover and create our own vision of paradise with the camera? Some of this is a matter of taste, to be sure, but there are certain aesthetic universals that are always at

If I were to explore the idea of *hollyhock-ness* as a photographic concept, I would first consider its form: lanky, multifloral, incandescent against the sun. Because it usually towers above our heads, I might shoot it from way below, to amplify its height and form. Then I would come in close to its ascending, ruffled blooms, backlit against the sky, and make an impression of its translucence. Then, perhaps a macro image of its delicately veined and layered petals, its tight, light-sealed buds. Maybe even a shot taken with the camera set at shutter priority, with the shutter dragged to $\frac{1}{8}$ or $\frac{1}{4}$ of a second in order to show movement in the towering stalk. I'm after the hollyhock poem, after all. It's not going to write itself.

In order for that poem to emerge, I need to immerse myself in the creative essence of that moment, in the *here-now of hollyhock*. I need to be focused and fascinated by this encounter with the marvel of botanical form. Without a full immersion of the visual psyche, my botanical poem will be reduced to doggerel. As I drop on my knees or my back to shoot up into the hollyhock's towering height, I must be conscious only of my poetic ambitions. As soon as I begin to worry about scuffing my pants, the moment has passed.

In order to find *your* shot, be willing to lose yourself. Be a seeker. Ask the more beautiful question. Sometimes putting the camera down and being completely present in the moment for a few minutes helps you find a new or unusual perspective on your subject. Allow your intuitive eye to take over. Only then will the garden be fully revealed, and you will truly see it for the first time.

A towering tropical Yucca gloriosa *in full bloom with its spiky crown filling the bottom of the frame beneath a fragrant white plume. The plant's inherent design, and its imposing height, made this angle work.*

Finding the Shot

TECHNIQUE: The best images in the garden aren't always the ones that are deliberately sought. Sometimes they appear unbidden before your lens and need to be quickly captured. Others can be deliberated over, contemplated, and tried from many angles before getting them right. Always allow yourself time in the garden before you shoot to get the visual feel of the place. Arrive open and alert, receptive to the surprise of light and form. Look for patterns of color and light, for pleasing angles and shapes, for views through. There are always good photographs to be made—you just need to find them.

ASSIGNMENT: Go to a garden you have already photographed and only take pictures that you've never taken before. Pursue new visual ideas, look for images or angles that are fresh, for subjects that you've overlooked. Avoid the obvious and try for something unique. This is an exercise in exploration and restraint. The object is to expand your visual vocabulary and the ideas you come up with. Shoot the garden from high above (an open window) and from below (on your belly in the grass), shoot from within a border, shoot only tight details or only leaves and branches, and shoot shadows. This is an exploratory exercise.

This photograph of a single pink hollyhock, shot against a translucent sky, reveals the delicate tracery of its form, its layered petals and capillaries. Shooting up from below blows out the background and creates a seamless and evocative botanical portrait.

Telling the Story of a Garden

Every garden has a story to tell, and every time you enter that garden with a blank digital card in your camera you have an opportunity to tell a beautiful, compelling story. It will not be the definitive statement about that garden; no such thing exists because nature is, by its essence, always changing and evolving. But it is *your* story of *that* garden on *that* day.

And the garden you experience may be very different from the impression it makes on others. I've even been complimented for having created beautiful images of gardens that the designers of those gardens didn't recognize as their own. I've accepted these compliments with a caveat. While to some degree you are reporting on a specific place, the reporting must be invested with personal vision; you can't just take pretty pictures without putting them in context.

Sometimes you need to create the vision. I've shown up on many assignments where the garden I saw in the scouting images looks nothing like the disappointing swath in front of me; the roses that bloomed so prolifically last season were decimated by a late winter storm, the lily border was torn up by insatiable deer, or the clematis arbor was just a ragged tangle of blossom-less twine.

These changes in the garden are the rule. There is nothing static or certain. It is your job to be as creatively nimble as possible and to be resourceful, no matter what shape your subject is in. It's the rare occasion, although it has happened, when I fly in for an assignment somewhere and the location is just unshootable. I'm compelled to turn around and fly back, with nothing to show for the effort but some frequent-flier miles.

Usually, I am determined to make the visual silk purse out of the unsightly sow's ear. That's what I'm paid for. A half day may be spent bringing in replacement plants from a local nursery to fill in gaps in the border where perennials or annuals have lapsed, or a morning may involve wiring roses to an arbor, or filling a patio with pots of color and form. "Make it happen" is always the mantra.

I remember a shoot for *House and Garden* magazine where I flew with a crew of half a dozen editors and assistants to Pensacola, Florida, to photograph a spectacular gourd garden. The scouting from the year before had shown arbors, pergolas, and allées literally dripping with magnificent *cucurbitae*. We arrived to find that the squash bugs and vine borers had gotten to the gourds before us. After a long day of vainly trying to wire and tie the arbors with stunt gourds of every stripe, we

A magical garden in Maine, built on an old tennis court, had beautiful borders of poppies and lavender at center court. The Lunaform pot and framed view of a cove complete this unique design.

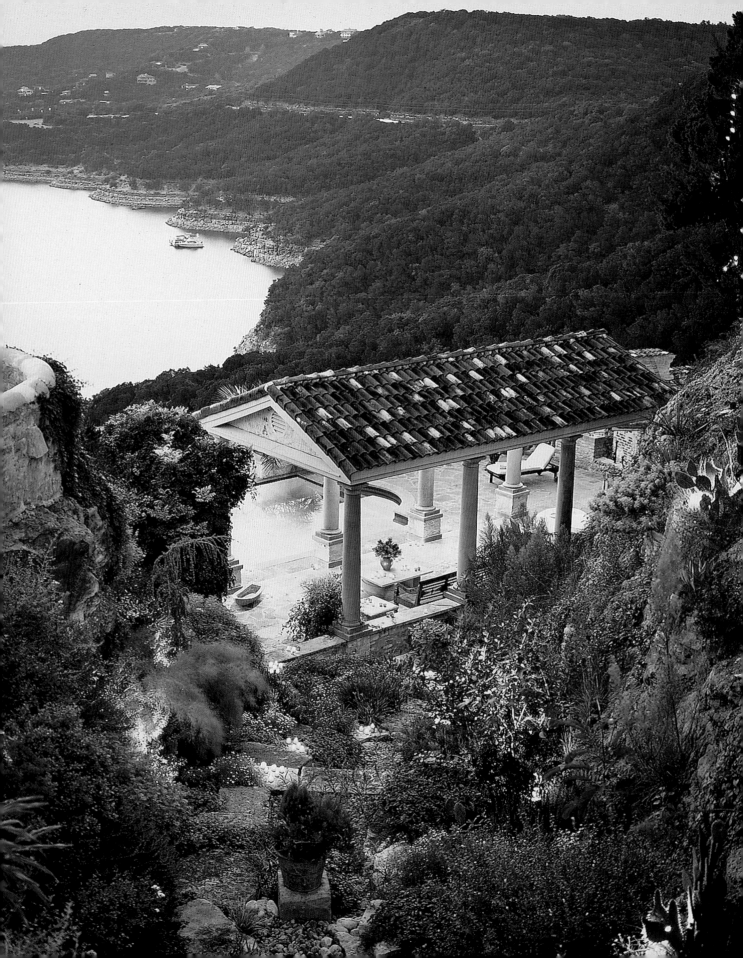

returned to New York with only wire-scuffed hands to show for our efforts, and the disenchantment that we couldn't "make it happen."

The garden shoot demands not only that you be able to make the silk purse, but also that you be resourceful and fresh with your visual ideas. The shots you ultimately find may not present themselves to you right away. Be patient. You may have to spend some time walking through the garden without even bringing a camera to your eye, only taking the space in with all of your senses. Allow your deeper creative consciousness to start flowing, to figure it out for you. Don't let your frontal lobe make all the decisions.

The garden you photograph may not be the garden that everyone else sees, and it shouldn't be. You may be drawn to the graphic bones and hardscaping, or to the statuary or physical follies in the landscape. You may focus on the palette of bloom in the borders, and spend your time rendering color. You may fall for the symmetry of hedging and trees or the arbitrary looseness of a wild-flower meadow. You may spend your time chasing butterflies and bees as they flit from one blossom to the next. But the story you find *must* be your own. You are a visual artist, not a stenographer. And gardens are too multisensual to presume they can be captured objectively.

The best photographs in the garden hope to address the beautiful on all counts, as well as all the intangible revelations of color and form. The challenge is to expose the familiar for the first time, to look freshly and with keen interest on the complex natural world through your camera's lens. Remember that you are always making self-portraits to some degree. Your best work is an act of self-evocation.

The photographer is a hunter, stalking the beautiful and the meaningful.

Opposite: The vibe of this Austin, Texas, garden was its position, high above the lake, with a desert garden descending to a templelike pergola and pool. The outdoor lighting adds to the magic of the setting.

Left: This garden's story was its unlikely placing of elements, which strayed from tradition. Without linear sightlines or design, it was just apparent randomness. This urn, sitting back against a tree, looks as though it could be waiting for a bus. Shooting through leaf cover gives its placement context.

Right: This Long Island garden, with its lush, tropical plantings and Asian influences, seemed to pulse with the sound and sparkle of water. Bringing the sky into the image in the foreground reflection adds visual intrigue. Notice how the linear composition is broken by the softness of the weeping cedars to the left, and the impressionistic light in the pool.

This carefully rendered image of a fall garden is a reduction to a few captivating elements. You know it's a garden because of the stonework, and the leaves tell the rest of the story.

We are outcasts from the first Genesis garden, after all, trying desperately to be let back in, to find purpose and meaning in our relationship with creation. The garden photograph that becomes art is one that transcends time and place and says something meaningful about what it is to be human with all of our senses awakened.

The artful photograph isn't a post-production trick in Photoshop or a clever manipulation that is an end in itself; it is at once deeply personal and universal. And because we live in a time where real experience has often been superceded by the image, and much of our understanding of life comes through a virtual filter, making the photograph that is not a counterfeit or borrowed idea is a significant challenge.

We live according to images in a way that was never possible before. Digital and social media and the Internet saturate us with such a high-def idea of life that the personal has become almost banal. If an image is to succeed as art, it needs to layer the known with what is unknowable, the material with the spiritual. It must reflect reality while at the same time transforming it beyond its literal prototype, so that the artist's vision and the real scene are both reflected in the image.

This is why you *load* your camera and *shoot*. At your most aware, you need to work with a sort of delicious intensity, at one with your surroundings. You are not only making a record of the garden's "certificate of evidence," as philosopher Roland Barthes said, but you are conjuring its spirit, the deep and elemental *idea* of the place, a universal that can stand alone.

If a garden means anything, it is a wish for beauty, for order, and for connectedness with natural things.

Becoming a Storyteller

TECHNIQUE: If visual narrative is the goal, work with all of your lenses in order to tell a complete story. Come in close, pull back, drop focus, and shoot deep. For a story to maintain a viewer's interest, it needs to have multiple points of view. Use as many techniques as you can to convey meaning, or chose a particular story line and stick to it in order to make a singular statement.

ASSIGNMENT: Choose any garden that intrigues or delights you and shoot images to explain what it is about the place that grabs you. Pick a very particular aspect of a garden and shoot that edited idea only, then pull back to tell the broader story.

The Seven Principles of Design

Photographs, like paintings, drawings, and most two-dimensional art, follow certain broad principles of design that give them form and coherence. These principles are the visual syntax that communicates, the organizational DNA, and they are concepts that clarify and direct. How they are understood and applied to your images will determine how successful your photographs are. Success, in this context, is somewhat neutral. A successful image can have all the principles of design, thoughtfully applied, yet still lack that magical, transcendent quality that makes it a work of art. But for now, let's aim for success, and let transcendence loom just beyond reach, like a persistent wish.

There are broad elements evident in almost all design; in photography, I would define them as such: *Line:* The linear is *a* to *b*. The beginning and end point in a continuum is its line. It is the path your eye travels in a photograph. *Shape*: The self-contained form of the elements in your composition conveys shape, either organic or ornamental, that creates both positive and negative space. *Direction:* Every line is moving through an image in some direction, whether horizontally, vertically, or diagonally in the frame. *Scale:* Proportions and ratios exist in every image, and scale is how one defined area relates to another. *Surface:* This is the textural quality of the objects in the frame, whether smooth, rough, soft, or shimmering. *Color:* The hues represented are the color. *Value:* Also referred to as tone, it's the darkness and lightness in the image—its exposure, luminosity, and tonal gradations.

Think of these elements as a general definition of what's in a picture, subtracting hue when you're shooting in black and white. But they are ingredients only. It's how they mix and configure themselves in your image that matters most. Those manifestations can be defined as design principles, there to guide you and lead you toward balanced and coherent compositions. As artists, we understand these principles in our subconscious and often apply them intuitively, but since this is an exercise in design theory, it's useful to pull them into the bright light of cognition for a closer look.

The seven principles of design are balance, tone, pattern, repetition, movement, contrast, and unity. Every photograph or image will address these principles to one degree or another. Their application will define the photographic effect on the viewer.

1 Balance

Balance applies to objects in the frame and how they weigh against each other, both in terms of proportional size and tonal weight (darker objects carry more tonal weight than lighter ones). A large object to the right of the frame can be balanced by two or three smaller objects on the left. Similarly, a larger, lighter object can be balanced by a smaller, dark object. Again, these balances would feel intuitively right even without principles to articulate them. But we're exploring design dogma here, not the reflexes of subconscious thought.

The arrangement of objects in your image is a balancing act, creating either harmony or tension. The way you frame or crop them will have a psychological, narrative effect: It will shape the story you are trying to tell. Symmetrical balance,

A dense carpet of ferns, moss, and roots creates an intricately designed pattern of shapes and textures on the forest floor.

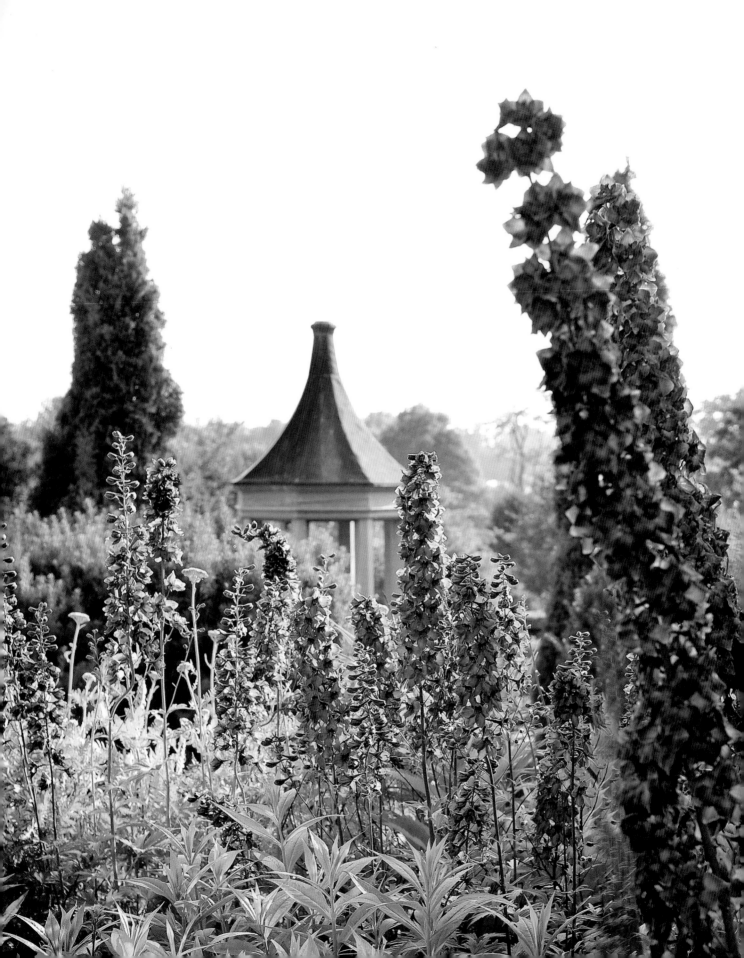

for example, has a formality to it; objects are represented with equal weight or are mirrored on both sides of the frame. Symmetry is commonly used in the language of garden design, of course. Most formal gardens employ symmetrical repetition to create patterns and organize botanical ideas. Photographs of formal settings should strive for like symmetry in their composition, ordering the arrangement of objects in the frame so that they convey the garden's idea. These photographs are rather straightforward to make: Find the formal layout, point, and shoot. They're almost made for you in the garden plan, and so can seem obvious. But even in a garden full of echoed shapes and directing lines, there are ways to bring your own sensibility to the fore. Use of light, depth of field, focal point, framing, and foreground propping can, and should, be subjectively explored within the confines of symmetrical balance.

Another type of formal, mirrored balance in the garden is in the plant material itself. Most plants are patterns of repeating parts, arranged in harmonic balance. The duplicate pleats of bloom in a rose or the radial balance in the whorls of a sunflower are marvels of design and symmetry. Perhaps it's the balanced complexity in botanical forms themselves that makes the formal garden so appealing: The orderly parts mimic the orderly whole.

Asymmetrical balance is less obvious and therefore more challenging to the photographer. Its principles can be summed up informally, as in an image *just feeling right,* or more didactically by calling out the balancing and counterbalancing elements. Asymmetrical balance leads to compositions that are pleasing and right, while unbalanced asymmetry creates tension

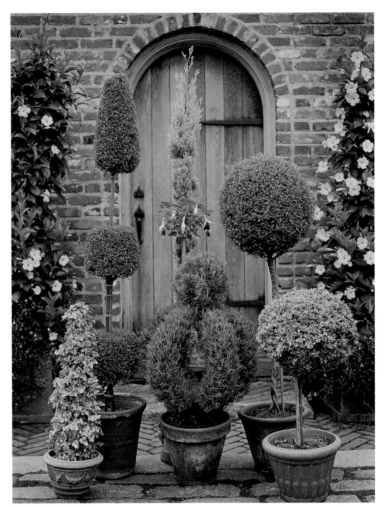

and instability—not a conventional narrative in the garden.

There are numerous ways of creating subtle, asymmetrical balance in your garden images. Color and value can be used to stabilize the composition; for example, the saturated, vivid colors of a few specimen hibiscus can be balanced by a larger mass of more muted perennials. The reverse—a sea of loud hibiscus next to a few pale, scattered blooms of *Nicotiana*—would not balance, and your image would edge toward instability.

Light can also lead the eye and balance the image, as your eye is always attracted to the brightest part of the frame. If, for example, your shot is freighted to one side with a

Opposite: These delphinium spires balance and echo the upward habit of the gothic gazebo roof and the large arborvitae. By framing the image with a delphinium in the right foreground, there is a succession of three vertical elements, giving the image depth and balance.

Above: Formal balance is created in this image not only by the symmetrical shearing of the topiary, but by staging them in front of a similarly rounded arch. The tonal balance between terra-cotta and brick adds to the effect.

Striking a Balance

TECHNIQUE: Photographic balance can be achieved either through symmetrical or asymmetrical composition, through the use of design, color, light, and selective focus. Use and arrange these elements in the frame to create the effect you're after.

ASSIGNMENT: Photograph in a garden that has a mix of plants and ornaments, and some decipherable design. Compose images that use different types of balance to achieve harmony. Use design elements, color and tone repetition, darkness and light, and selective focus to work through compositions and find balance. Pull certain elements out to throw your image off, then put them back in. Shoot a very symmetrical, formal garden in an asymmetrical way and see what happens.

Left: The asymmetry of the bent bamboo stalks makes this image work; without it, the shot lacks interest. An interruption in the expected pattern can bring an image to life.

Right: This view from the window of a Japanese teahouse is about intersecting lines, all rectilinear, except for one deviating tree trunk. Like a Mondrian painting, it arranges reality into balanced geometric planes.

mass of ornament and bloom, while the rest of the composition is relatively uncluttered, light can be used to draw the eye over and balance the image. A bright spectral highlight in the garden can hold a large amount of compositional weight. The chiaroscuro paintings of Raphael, Caravaggio, and Rembrandt all use light for compositional balance and to lead the eye.

Focal point and depth of field also play with principles of asymmetrical balance. A sharply but shallowly focused object in the garden will balance a much larger wash of unfocused detail and color. Our eyes always place more weight on what's in focus, and it will balance out the rest of the scene. An object's position relative to the rest of the frame will also balance out your shot. If, for example, you've framed a garden path obliquely across your image, beginning at the lower left and crossing to the upper right, where there's a large pergola, you may want to balance the scene by adding weight to the lower left. By having an open gate, or placing a watering can or wheelbarrow in the lower left foreground, you've created equilibrium, and the image is in balance. Your eye can move from one part of the image to the next without feeling off-kilter. If, on the other hand, the beginning of the path is left unpropped or unbalanced by selective focus, then your eye will tilt upward until it rests underneath the pergola (not a bad visual idea if the pergola is where you want to be!).

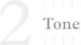

2 Tone

Tone is the dimensional shaping of objects by gradations of light and dark, by shifts in color value from cool to warm, or by shifts in scale from small to large, all of which add depth and perspective to your photographs. Tone and value are used in photographs to create emphasis and direction, to lead the eye, and to satisfy our impulse to find form in flatness.

Gradations in tone on a garden urn or rose trellis shot in low light will always tell you where the light is coming from. Those same subjects photographed on a cloudy day, in what's called flat light, won't satisfy our want for dimensional shaping, and the object will appear more two-dimensional, or flat. Our minds seem to have a congenital desire to know the direction of light, perhaps as a marker of time, or simply to satisfy our desire for dimension and shape recognition. This is why shooting in flat light, although great for subtlety, often lacks the dynamics of highlight that bring a photograph to life.

If you shoot a garden in flat light, you will more likely be drawn to strong shapes and bold lines and will need to use them to add depth and form to your images. You may want to work more intensely with gradations of scale in order to create dimension and movement. A perennial border absent of light will lack tone, and you'll need to compensate by including elements such as paths or ornaments to make the image stronger.

The backlit garden plays with tone by adding spectral highlights to plants and objects and to the overall scene. An ornament or perennial border is brought to dimensional life by an outline of light on its edges (this is known as a hairlight when photographing people). This light adds depth and form. Without it, gradation of tone is far less dramatic.

Patterns of light and dark add depth and dimension to objects as well. Objects lit from the side create

Left: This maidenhair fern against a moss background is almost monochromatic, its analogous colors blending into each other. Because the tone is flat, patterns are played up. The effect is quiet and intimate.

Right: A ruffled pink Papaver orientale *in a crowd of bright yellow calendula is offset by the complementary color relationship between the two species.*

deeper, more dimensional shadows. This is why early and late light in the garden give the photographer a much broader tonal range to work with. Strong side-lighting, with a lot of range from shadow to highlight, is a light quality often referred to as the Rembrandt effect, used by the eponymous artist to bring his brilliant canvases to shimmering life, and applied by centuries of artists since—another strong argument for the fine art museum as photographic mentor.

Color value is also a shaper of tone. As a color shifts in value, it conveys form. A constant color value looks flat; one that varies from light to dark is more lifelike. Color, of course, is a great shaper of the mood and tone of a garden, and designers use color to such ends. It's also an indicator of the time and quality of the day. Because color exists only as wavelengths that strike our eyes, and objects have no color of their own, it is always varying throughout the day based on the position of the sun. Plants can appear pallid one day and brightly saturated the next, or shifted to a cooler or warmer value depending on the quality of light.

Color value implies depth and distance: Cooler colors tend to recede, while warmer colors pop to the front. A garden scene with a distant horizon will usually cool and flatten as you move up the frame; for example, faraway mountains can appear almost blue and two dimensional in the distance. Playing with this warm/cool contrast can add welcome drama to your images. In the overall view of the garden, for example, including the surrounding landscape can emphasize the warmth and intimacy of the garden in contrast with its larger, more impersonal surroundings.

Color theory, or the relationship and placement of color elements in your composition, is a valuable design tool for creating powerful images. This is a subject worth understanding, but like harmonic theory in music, it doesn't *make* beauty: It's just a way of articulating *why* something works, but it doesn't necessarily tell you *what's* going to work.

To begin understanding color and value as a design tool, it's important to know certain fundamentals of theory. Color properties are defined as hue, or the color itself, which is interpreted in the eye as a reflected wavelength of light. White light can be broken down into seven different hues, or wavelengths: red, orange, yellow, green, blue, indigo, and violet. White light, therefore, has all of these colors present, while black light has none.

Combining colors in the garden and in your photographic frame has a particular visual effect. A monochromatic mix, namely one represented by several values of the same hue, is a subtle patterning of color intensity and depth that can be very effective. For example, a planting of a single variety of lavender in the garden is a monochromatic scheme, but the addition of highlights and shadows due to its relationship to the sun creates a fluctuation in value and gives the image dimension. Some of the gardens of Gertrude Jekyll and Vita Sackville-West are examples of brilliant monochromatic plantings whose tonal subtleties were a respite from the exuberance of traditional color schemes. Their effect is quiet and calming.

Analogous colors are located adjacent to each other on the color wheel, with hues that vary only slightly in value from one another. For example, a border of dwarf nepeta, purple salvia, and Russian

This branch of Prunus serrulata *in full bloom was propped in front of a painted backdrop in an analogous (but tonally deeper) color value. The red and pink together create a heightening effect.*

sage represents an analogous mix; the colors quietly harmonize with each other. Complementary colors are opposite each other on the color wheel, such as red and green, orange and blue, and yellow and purple. Combinations of these colors create dynamic, lively relationships that exude energy.

How does color theory apply when you're in the garden with your camera? Because you are making decisions constantly about what to leave in and out of the frame, understanding how colors balance and complement will affect your framing decisions. Including a deep red climbing rose clambering over a foreground arbor will complement an expanse of green lawn, adding energy and excitement to the image.

A foreground of 'Moonbeam' coreopsis would complement a purple beech higher up in the frame. Or analogous shades of petaled pink moving through the frame would create a harmonic travel line for the eye. Color communicates and shapes the visual experience, creating pattern and repetition.

3 Pattern

Repeating patterns and forms in the garden image are pleasing to the eye. We like the predictability of repetition and the design and order it imposes on the world. Repetition is one of life's organizing principles, from the smallest helices of DNA to the rhythmic pounding of oceans.

Learning to recognize and play with pattern is one of the fundamental steps to becoming a better photographer. Sometimes the appearance of pattern in an image is just beyond the reach of your consciousness; you know the photograph or composition pleases you, and yet you're not sure why. Getting at *why* is a way of building your visual syntax as a photographer. The *why* should never dominate the process of picture taking, but should be a part of the intuitive flow. Ultimately, you will just do it, without much cognitive forethought, in the same autonomic way that your heart sends blood to and from your body. "It is good to think, better to look and think, best to look without thinking," said Goethe, and the aim is to be able to intuitively experience the whole garden as a pattern, to see plants as patterns, and to view the entirety of nature as a play of intersecting patterns. This is how you and your camera need to exist in the world, as explorers of pattern and inherent design, sensitive to the complex ratios, geometries, and proportions that animate all life.

Visual pattern is harmonic; it sings to our longing for order and a desire for knowable things, it makes us feel safe inside the chaos of unknowns, and it organizes life. But pattern mustn't be confused with sameness. In photography, sameness can dull us into not seeing. Sameness is monotony. Our cultural disposition seems to seek out sameness, comfort, and convenience. We want it, and we want it now—the same as it was before, only supersize. The culture of sameness has been borne of convenience: endless highways ripping through the landscape and changing what was once localized culture, chain restaurants turning out their mono-flavors without any

This lush basket of pink English roses is complemented by the weathered gray bench, while the smaller diffused sprays in the background lead the eye through the frame with harmonic colors. Even the bench's lichens are part of the pattern play, echoing the roses' circular form.

Working with Color and Tone

TECHNIQUE: Use color and tone to lead the eye, use gradations of light and shade to add dimension, and always think of yourself as a patternmaker, creating a satisfying visual experience.

ASSIGNMENT: Frame up a medium shot, looking for complements of color that lead the eye across and through the image plane. If you need a color somewhere in your image, prune off a blossom that picks up a color elsewhere in the image, then use it to create a pattern. Mix warm and cool colors in the same frame and see how they play off each other. Shoot a plant or object in the garden from different perspectives and see how the angle of light affects its color and mood.

Top left: The concentric patterning of these sedum creates a harmony that is inherently pleasing. Framing them on an acute angle and limiting the composition to three makes a graphic statement.

Top right: Looseleaf lettuce, such as this 'Speckled Trout' romaine variety, has an engaging play of light and pattern when photographed with backlighting and on a diagonal.

Bottom left: The fiddleheads in this unfolding fern are characteristic of the golden ratio of proportion (or 1:1.618), which is found throughout the natural world. The eye is conditioned to respond to and seek out patterns such as these.

Bottom right: These black currants have an inherent pattern of color and form, and a grid of boxes photographed diagonally layers another strong pattern into the frame.

connection to regionality, and architecture without vision or pattern or reference to place. Sameness can bring comfort and security to some, but it can also be empty of meaning to others. It is lulling, but not truly living.

Pattern is life-affirming, especially in imagemaking. It animates and excites. It connects us to each other and to all living things. When deconstructing a particularly good photograph, you may find that a large part of its attraction lies in how well it abides by natural laws of pattern and proportion, the ratios of one part of an image relative to another. In the garden, these ratios exist not only in all of the plant forms, but also in the overall design. A well-proportioned garden, with regulating lines that imply movement, direction, and proportional repetition, is successful because of its intuitive sensitivity to underlying patterns.

There are harmonic, pattern-based universals that exist across nature and bind us together. The golden ratio of 1:1.618 is one such proportion or ordering principle that is found in nature, in the human body, and in great design. It's found in the armored petals of an artichoke or the complex whorls of a sunflower, in the chambers of a nautilus shell, the helices of pineapple fruit, the curl of a wave, or the shape of an unfolding fern. All of these natural forms are examples of golden ratios. So is the ratio of a person's height to the distance from his feet to his navel. In Leonardo DaVinci's *Vitruvian Man*, he proposed that human symmetry and proportion are echoed in the patterning of all life, and that this correlation tied humans to the working of the universe. The Greeks designed the Parthenon according to the golden ratio, and architects and designers use its proportional prin-

ciples, consciously or not, every day.

What's fascinating about these proportional laws that seem to order the universe is that they are somewhat mysterious; we don't know quite why they work, why they seem right, or why they resonate with us, but they doubtless tie us to some common, unconscious desire for harmony and order. If the anthropocentrists are right, then we like these ratios because we ourselves are made up of such stuff.

Enter the garden, and—by extension—the garden photographer. Both are seeking to organize and compose the world and to create proportional relationships that resonate. And if, as Rodin said, "nature is the model, variable and infinite, which contains all styles," then we only have to look closely and completely at nature in order to understand the possibilities of design.

You're not using the golden ratio as a measure when you go out to shoot, of course. But the very fact that there are organizing principles and patterns in the universe that are echoed in all life forms is a provocative notion. It means that the magical has meaning, that all is not random chaos, and that beauty isn't some intangible mystery but instead has its foundation in distinct and knowable patterns. This isn't to say the rendering of creative beauty can ever be reduced to formula, but rather that there are underlying principles that are worth knowing for the artist.

4 Repetition

Repetition is the presence of recurring forms and colors in an image. It is the visual beat. Repetition of subtle shape motifs is a critical design element for creating garden images worth looking at. One useful

Finding Patterns

TECHNIQUE: Looking for pattern and repetition in the garden, from the macro details of a plant's design to the garden's overall concept, is key to gaining an understanding of and appreciation for order, which the camera loves. The more you look for pattern, the more you will see it.

ASSIGNMENT: Choose a garden with some structure and photograph the more obvious pattern plays in the petals of flowers, in the rhythm of colors, or in the repetition of form in the garden's design. Then look for something much looser, where order at first seems absent, like a wildflower meadow or an overgrown arbor, and try to compose images with an eye for pattern. It may be as discrete as the repetition of a certain curve of light, a loose "S" across the frame made by a swath of golden yarrow, the twining of climbing rose canes, or layers of pebbles. The patterns are there, waiting to be photographed, and it's up to you to train your eye to see them.

Left: Graphic, curvilinear repetition keeps this East Hampton garden image strong, despite the absence of light. When the light isn't there, strong shrub forms can fill in for translucence. Here, the foreground arc of boxwood encircling smaller, rounded forms is echoed by the large, clipped willow in the distance.

Top right: Including the cosmos in the foreground of this image creates a repeating pattern with the gardener's straw hat, even down to having one circle within another. There's subtle but potent design at play here.

Bottom right: Repetition of form can take you by surprise, like when this dog ambled across my frame as I was shooting a subject in his garden. Always be ready for perfect, unplanned moments—they happen all the time.

exercise for recognizing repetition is to find a photograph that you like, and see how many repeating forms occur in that image—from the curve of an urn echoed in an arbor, to the radial wheels of cosmos repeated in a birdbath, to an armillary mimicking the globes of alliums. There are shape counterparts everywhere in the garden, both subtle and obvious, and our eye is drawn helplessly to them. Study your selected photograph by circling the repeated shapes. You will see that shapes not only mimic each other, but also that they lead you from one to the other through the frame. A curvilinear line, with its rounds and arcs of repetition, will walk you through the garden in the same manner.

Picking up these repeating forms and colors and framing them into your image is always a good place to start. Once they're in the frame, make sure that the composition rhythmically leads the eye somewhere, so that it has something *to do* and somewhere *to go*. Remember, too, that repetition is not meant to be monotonous. It is meant to engage. The forms need only suggest each other, not literally duplicate. If the repetition is too literal, and cognition is too quick, the image never engages the intuitive,

exploratory part of the brain; it's understood at a glance and doesn't hold interest.

Repetition of form and color, and the patterns they create in the garden, are a tonic for the right hemisphere of the brain. The right hemisphere is linked to our primitive subconscious, the primordial brain that has no semantic or reasoning ability. It communicates through images and is highly spatial and visual. Our primitive brain is concerned with basic needs, with the anthropological associations in images that imply shelter, food, and safety. A garden, with its rich sensual layers and nurturing allusions, abounds in these associations, and that's why we make and photograph them. They feed a fundamental part of our being. The more you stimulate the right brain with perceptual pleasure and with pattern and repetition, the more you satisfy the desire of the primitive subconscious. Remember that the brain is a hedonist, seeking pleasure and stimulation, and that it is the brain that *sees*. Our eyes merely receive light.

I have photographed gardens that seem to reach out and embrace with their warmth and envelop with their welcoming design, while others ask that you stand behind the velvet ropes, like a museum. This is a

Repeat Yourself

TECHNIQUE: Use repetition to lead the eye through the frame and to direct the viewer to a specific part of the image, but don't push. A straight avenue of trees punctuated by an urn or structure gives the viewer no choice but to scurry down the visual path. Be subtle. It's better to guide than to marshal.

ASSIGNMENT: Pick an object or ornament in the garden (a pool or fountain, a birdbath, or a gazebo) and compose as many images as you can using repetition of form or color as a means of leading the eye to that destination. Make your path indirect but certain. The viewer has to feel like he got there on his own.

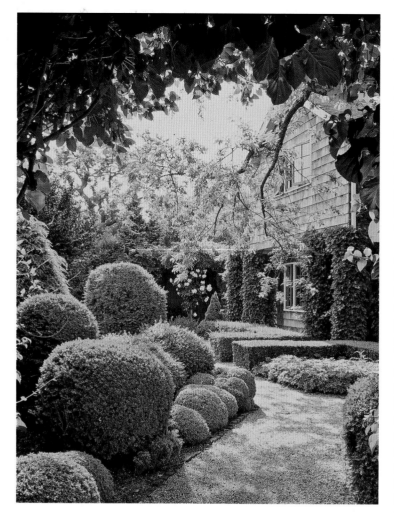

Movement is the rhythmic path on which your eye travels across an image. Sometimes an image takes your eye on a slow, rambling walk; other times, a photograph's rhythm is a fast staccato, a wild sprint of color and form. No matter what the pace, movement in an image is marked by repetitive visual beats and design motifs that define and order your experience.

As in music, visual rhythm orders a composition, but it's a beat sensed by the eyes, not the ears. All movement has rhythm, and a photograph's movement is made by repetition and pattern. It's also made by the pace and flow of a line through the frame. The linear rhythm of a winding path through a garden space is more leisurely than an oblique shot across the frame. By interrupting the flow, with a central ornament or the creation of garden rooms, we slow the rhythm and allow for a *caesura*, a contemplative pause. The more patterned repetition there is in your composition, the more the eye will flow; the more unrelated the elements, the more jarring the movement.

Remember that your eye always wants to move and explore across the visual plane, and it's looking for a rhythmic meter to follow. However you compose and pattern your image, you set the pace for the viewer.

The eye is easily compelled to move through this image, from under the arbor, down the path of patterned boxwood, and toward the light. The path's angle gives your eye direction, without revealing the entire scene beyond.

function of many parts, but often it is the comforting repetition of form, and the pleasure in the recognition of pattern, that invite you in. Your photographs should leave no one standing behind the ropes.

Creating Movement in Your Image

TECHNIQUE: Movement is indicated by composition and by how you arrange objects and lines in the space inside your viewfinder. The visual flow and rhythm in an image are as important as meter is in music.

ASSIGNMENT: Work on different types of movement in your images, from slow, aimless saunters to purposeful strides. Create movement by framing in just the right lines and forms to design the movement you're after. A cottage garden will move at a leisurely, indirect pace, for example, while a formal garden will take on a more deliberate rhythm. Shoot both types of gardens at their intended pace, then switch the intent and see what happens.

6 Contrast

By calling out the differences between an object and its environment, we create emphasis through contrast. We generate contrast through dissimilarities in color, shape, texture, or scale, all of which draw our attention to a particular focal point. Contrast in the garden is achieved by juxtaposing plants that are opposite on the color wheel or by combining elements that are light versus dark, curved versus straight, vertical versus horizontal. The wending of a garden path through the frame is in inherent contrast with the rectilinear crop of the image. If the same photograph had curved or amorphous edges, the contrast—and visual stimulation—would be less. Too many contrasting elements in an image, however, can lead to chaos and can be as dulling as no contrast at all.

Contrast is meant to define a point of focus by its difference, by what it's not. For example, focal length is definition through contrast: The chosen point of the image that's in focus separates out from all that is not in focus.

Color creates contrast by opposition as well: A few bright purple spires of delphinium in a field of black-eyed Susans will vie for all of the visual attention. Any color that's opposite the varying shades of green (which is nature's dominant backdrop, after all) will pop in the landscape: A red dahlia almost dances with chromatic exhilaration off a garden's green background.

The oblique line through the garden creates tension within the contrasting upright frame, drawing our attention, just as the curvilinear line does. When three objects dominate in the frame, they create a triangular contrast with the four-cornered rectangle. When composing your image, always choose odd over even object clusters; this creates contrast and linear tension (sometimes referred to as the Rule of Three).

Bright highlights in a backlit tree line will contrast with the deeper receding shadows of its silhouetted trunk and branches, and the darker

Left: The upright trunk of the tree forms a centerline in this image, while the sinewy twists of the vine behind it are a contrast to both the tree and the rectangular frame.

Right: A playful contrast in scale makes this image of tomatoes come alive. The odd number of large tomatoes follows the Rule of Three and makes the image more dynamic.

edges of the frame will contrast with its lighter center. These contrasts are there to help us define space and understand its components. They can be strong or subtle and comprised of tensions created by form or tone, but they are essential to the design of successful images.

7 Unity

In our quest for perceptual pleasure, the visual climax comes when an image has achieved harmonic unity, when its parts become less apparent and the whole experience comes to the fore as a beautiful, singular idea. Unity ties all the design elements together into a coherent whole, with pattern and repetition being the integrating force. Unity is achieved when you stand back from an image and sense that it is done.

Unity can be achieved through proximity, where objects in the frame are united by their closeness or grouping; by repetition of pattern, color, or shape; or by the continuation of a line or visual idea from one part of the frame to the other. The clarity of your visual ideas, and the strength of their conveyance in your image, are all a product of its unity.

It's important, however, not to photograph to a preexisting formula of rules or principles. Doing so may satisfy a theoretical set of design ideas, but your images may be dead, lacking the spirit that comes from intuitive flow. Understanding design principles is invaluable—and so is *forgetting* them. By forgetting, I mean delegating them to your subconscious, and going from visual forethought to creative invention.

When you are told that someone has a good eye, it never means that he has studied and aced his design principles homework. It means he has developed and nurtured a strong intuitive eye that just *gets it*. He has unified all of the elements of design into his way of seeing and composing. It's the syntax of principles fluidly meeting personal vision that makes the difference. Without the individual behind the camera there is no vision, only formula. And without the psyche, a digital image becomes little more than a binary sequence, a set of algorithms for creating beauty that could be written by computers. Thankfully, the human creative imagination is far too complex and nuanced to ever be mimicked by the machine. Artists will always be necessary to help us understand and articulate life.

When you photograph the garden, you are a garden designer, responsible for how that place is rendered, and answerable only to yourself. For your photographs to stand up to the rigors of aesthetic scrutiny, they must intuitively understand the design principles they chose to follow or ignore. The best photographs are always pushing beyond principle. Good photographs answer, but great photographs ask.

Definition by Contrast

TECHNIQUE: Contrast is defining a part of the garden by the visual opposition of its surroundings. It creates visual tension and engages the image-hungry brain. Use contrast as a way of adding dynamic energy to your images and as a way of defining priorities within the image.

ASSIGNMENT: After you've shot a garden and edited your favorite images, look through them and notice the contrast of color, line, scale, or texture. In the best images, there will always be one element (or more than one) that opposes another one visually and makes the image better. Now take those insights and apply them to the next garden you shoot.

Finding Unity in Your Images

TECHNIQUE: Look for clear, articulate meaning in your images. Don't try to say too much, and thereby say less. Your ideas and execution should have a coherent design and intent. True unity of visual ideas is imperceptible; if it stands out too much, then it's not in balance with the whole.

ASSIGNMENT: As you shoot in the garden, keeping all of the design principles somewhere in your collective subconscious, aim for images that are rhythmic, flowing, balanced, and harmonic. Think of yourself as a composer, creating a symphony of color and form. Accept only the best images, and learn well from the ones that don't succeed.

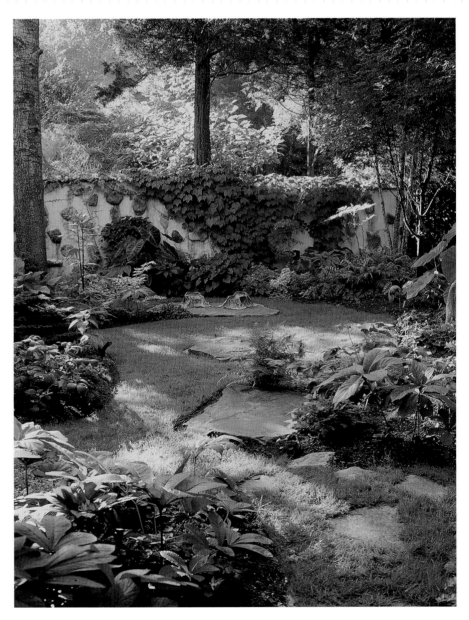

This image is successful because its composition and design have unity: The green path leads you indirectly through the frame and toward the light, which also brushes the path. The wall breaks the image into thirds and leads you to somewhere unknowable beyond. Balance, tone, repetition, pattern, movement, and contrast are all at play here to create unity.

Point of View

Always be open to a new way of seeing. Never just stand square-footed and click, and have that be your point of view. Change your perspective so that you're shooting from below, from above, from in between, and from the side. Surprise yourself with a new way of seeing the garden by taking chances. Many of these photographs will disappoint, but for every dozen or so that don't work, one will capture something fresh that you hadn't anticipated. Allow the camera to see for you; it has its own point of view, after all. Take advantage of its perspective on the garden.

Digital photography allows you the freedom to explore possibilities, to make mistakes, to reinvent images after the fact in postproduction. The only constraints present are a lack of technical understanding and weak visual ideas. Every individual will develop his own way of seeing, his own affinities for color, light, and form. Just as gardens themselves differ according to the tastes and style of the designer, your garden photographs need to evolve out of your own visual interests. You may be passionate about color or pattern or close detail. These predilections will evolve the more you shoot in the garden and the more familiar you become with technology and the fundamentals of light and design.

The running joke with me is that no matter how grand or spacious the garden, I always find myself backed up into a thorn-armored rose hedge, or flattened against an uncomfortable wall or fence. The best shots always seem to demand some physical compromise, but it's a price I'm willing to pay. I'm even willing to hang off the edge of a roof (assistant clutching my ankles!) to get a shot, or climb atop a high ladder or precariously perch myself up in a tree. The image you're after is all that matters now, and you're willing to do what it takes to get it. This is often what stands between a good shot and a great one: your commitment to being in the right place at the right time, no matter where or when that is.

If the story of a garden is as much about structure as anything else, you may want a high vantage point to help articulate the design. Once when I was on a shoot in Hawaii, a vast coastal garden on the island of Kauai seemed at first to be almost too large to capture. Its structured rooms and grand designs were as large as football fields. My camera seemed a completely inadequate tool. The centerpiece of this garden was a fantastic tropical maze—the

Working with Point of View

TECHNIQUE: If point of view is not only where you are when you shoot, but also your disposition toward your subject, then you need to remain flexible (visually and physically) in order to find images that work. It's your job to convey something specific about a garden, not just generalized loveliness. The more personal you are, the more universal the appeal.

ASSIGNMENT: In the garden, chose a single planting and change your perspective after each shot. Shoot from above, from the side, and from below. Shoot tight as well as pulled back, assessing the effect of each point of view. Every plant has an ideal photographic perspective that should be sought out, one that speaks to its character; your point of view should explore those ideas.

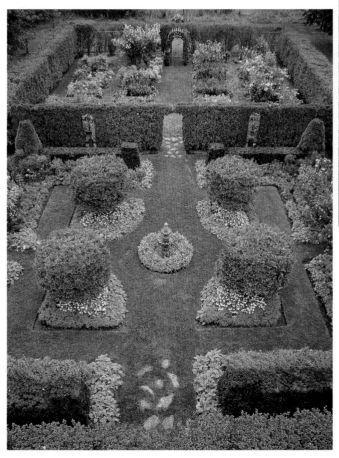

Left: This lush border of roses, daylilies, and nepeta looked as good from above as from below, with the fence, pergola, and path forming strong diagonal lines through the image.

Below: This formal garden, with its strong bones and carefully defined planting areas, was best seen from above, so a 40-foot cherry picker was hired to hoist me aloft.

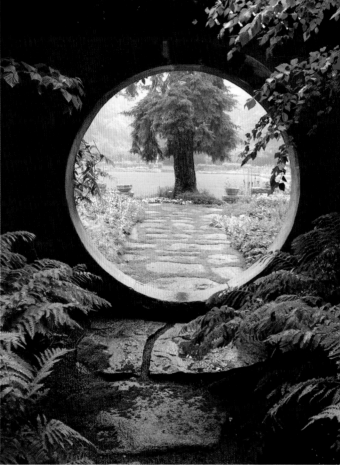

Above: Many gardens propose their own points of view, such as this one glimpsed through a Chinese-styled moon gate. These formal perspectives should be photographed, as they're part of the design, but always look for other viewsheds that are your own invention.

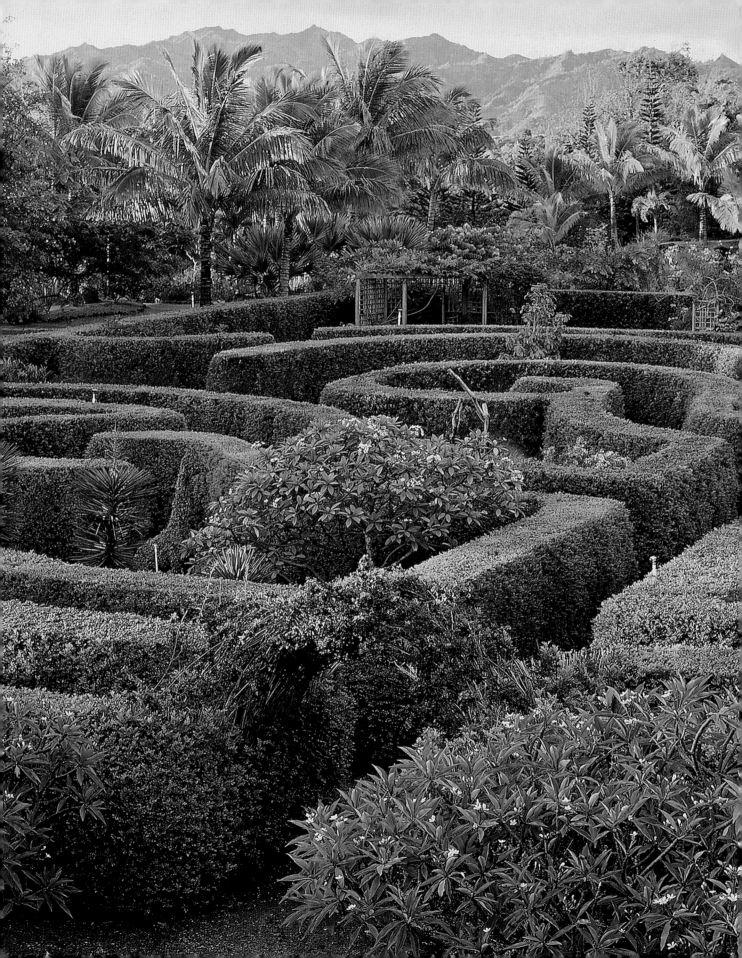

first I'd ever seen—made up of mock orange hedging, with accents of bougainvillea and frangipani. It was a magnificent sight, with snow-capped volcanoes on the horizon and towering palms. This was clearly a garden that needed to be seen from some height (mazes were always designed to be viewed from an upper terrace, after all).

As an enthusiastic New York editor stood by, we commandeered a large bulldozer on the property and I was lifted 25 feet with tripod and camera to get the shot. It worked quite well, with a compelling maze of mock orange bones backlit by an early morning sky and pink light reflecting off the low clouds.

But getting even higher, pulling the rim of the Pacific into the shot, really would have told the whole story of this place. As I thought out loud, the editor suggested that I hire a chopper. I've shot out of helicopters before, but never to take photographs of a garden. The idea at first seemed ludicrous, but the more I considered it, the more sense it made. So within the hour I was hanging out of a Hughes 500 with heavy film cameras slung around my neck, clicking away. The images paid off; seeing the garden in context—with the Pacific framing one edge and the peak of Kawaikini binding the other—gave it all the dramatic sway I was after.

Did I mention I'm terrified of heights? But with a camera between my eye and the subject, I've always felt safe, protected by the lens's habit of altering reality, by not seeing the world as it is, but framed, focused, zoomed-in or widened by the trick of fine optics. This can get photographers into trouble, of course, but usually it means you're thinking like a camera, streaming in your subconscious aesthetic, unaware of yourself. This is where the best images come from, after all.

With a few exceptions, however, there's something disorienting about the garden viewed from too high above, because it's not how we experience it. Height flattens out perspective, and strips away our more sensual understanding of a place. It can be fascinating, but inhuman somehow and remote.

I once worked with an aerial photographer who was quite successful circling over cruise ships in a chopper or capturing golf courses from 3,000 feet, but on the ground he seemed less in his element, less able to make close connections. He would wear funny-colored suspenders and bright shirts to make up for his modest people skills.

Shooting from above also lacks intimacy, movement, smell, touch, and delicacy—all sensations we expect from a garden. Being in the garden at eye level with your camera, putting the viewer right inside the experience, is ultimately the most satisfying point of view.

Opposite: This establishing shot of a tropical garden in Kauai, Hawaii, shot from the bucket of a bulldozer, brought the distant mountains, palms, and mock orange maze all into the shot. The mountains are cooled and flattened by distance, while the morning light has just started to light the maze.

Below: An aerial view from a helicopter reveals this Hawaiian garden's remarkable maze of mock orange, frangipani, and bougainvillea. But there are distracting elements in the image that could have been cropped out when shot from a lower perspective. Shooting a garden from the air may mean that rules need to be broken.

The Camera's Eye

In order to capture this tropical lotus and the underside of its architectural leaves, the camera was held at water level on autofocus and the image was made without looking through the viewfinder.

I've always been compelled as much by how the camera sees the world as by how I see it. When I was a graduate student in journalism at Columbia University, the South Bronx was our beat. In the late 1980s, this was no place to be wandering about, carelessly pointing a camera into the run-down urbanscape. But I was studying photojournalism and needed to report on this place. So instead of holding my camera to my eye to shoot, I would shoot discretely from my hip, never looking through the viewfinder. I would set my manual camera to a reasonably broad exposure and chose a stopped-down aperture that—with a wide-angle lens—would render most of my subject in focus. I came back to campus with the most technically challenged negatives, but came out of the darkroom with the best images. I had given my camera its own voice. Even though your point of view must be just that, *yours,* the camera is always a partner in that process.

By letting the camera make some choices in the garden, you're opening yourself up to possibility and surprise. I'll often hold my camera way down below a plant and shoot up into it, with the camera set to autofocus and autoexposure, never looking through the viewfinder. I may end up with a lot of useless pixels, but something magical can also happen: I get a unique perspective that makes for a compelling image.

Monet painted better as he went blind, after all.

I had an Olympus Pen Split Frame camera once that shot 72 exposures on a 36-exposure roll, meaning every frame had two separate exposures on it. I would shoot without thinking about sequence, and print the negatives that worked best together as diptychs. The camera's split format determined the pairings, and I made the final edit. This was a camera that was given its own voice and a chance to harmonize with me.

A deep, codependent relationship must develop between you and your camera in order for significant work to proceed. You need to understand it intimately, and cocreate together. In *The Keepers of Light,* William Crawford wrote, "Formal order is not imposed but discovered . . . the look comes from allowing the machine to do the seeing. The photographer's genius at least partly consists of making sure that the machine has plenty of good opportunities."

When you're photographing the garden, then, be there with all of your senses alert and tuned in. Allow your camera to take part in the creative process. It's often the case that the camera will see something you didn't, framed or focused in a way you hadn't imagined. The camera isn't just a tool that responds to input and deliberate choices; it can also free you up visually.

Letting the Camera See

TECHNIQUE: Set the camera to automatic and choose a wide lens or lens setting on your camera. Or, with your camera on program or aperture (A) priority, set a wide-open aperture (f/3.5 or less) and allow the camera to choose a focal point.

ASSIGNMENT: Shoot around the garden without ever looking through the viewfinder or at the LCD screen. Hold the camera high and low, behind, and under. Find a point of view that you wouldn't normally pursue and shoot without looking. Go through the images on a large screen in postproduction and see if the camera created any intriguing images on its own. You may be surprised.

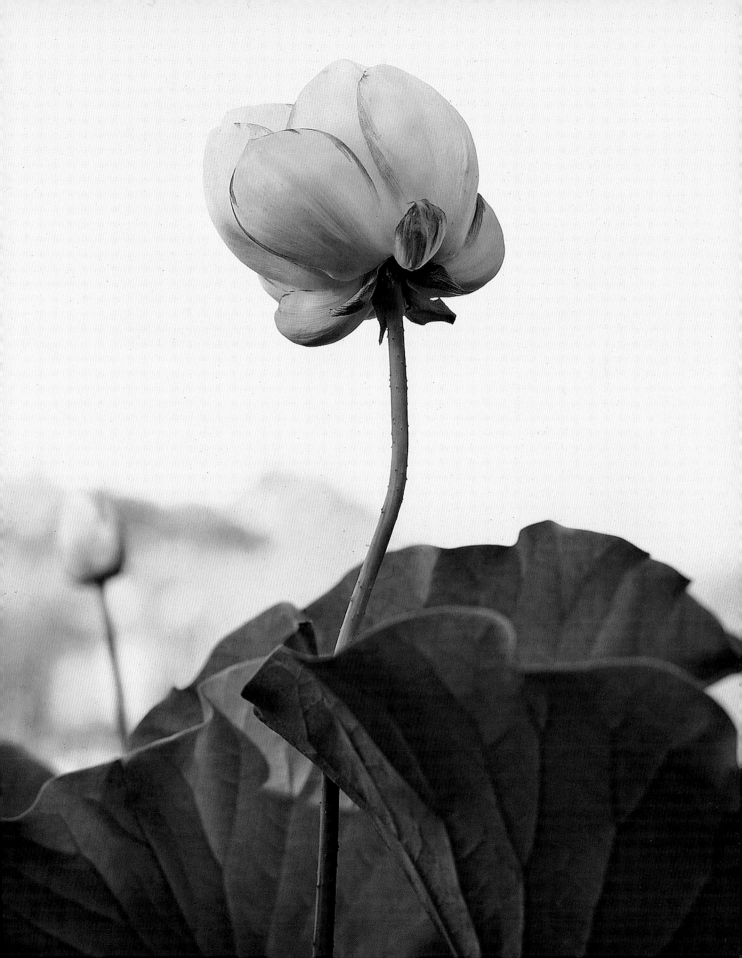

Shooting Through

Left: This lush tangle of Shasta daisies was shot using a wide-open aperture, with the lens selectively focused on a few specimens in the center of the frame. Shooting through an unfocused foreground to a point in the midframe adds to the image's depth and its sense of abundance.

Middle: This dense carpet of Coreopsis is only in focus in the foreground, leaving the rest of the plant as a soft wash of color. Playing with shallow points of focus in the frame is a way to lead the eye and convey meaning.

Right: This lily's portrait was shot through a dense planting of purple Monarda didyma. The composition and shallow field are what make the image work.

Opposite: This explosion of magnificent color in a grove of magnolias is almost too much to take in one visual bite. Shooting through and softening the foreground yellow with selective focus adds dimension and framing to the image and makes it easier to digest.

Like an unfolding seduction, a beautiful garden shouldn't reveal itself all at once. Its delights should play out slowly—glimpsed through a break in a hedge or arbor or beyond a half-open garden gate. Just as garden rooms divide visual space into distinct viewpoints, creating successions of interest, your camera can suggest and reveal as much or as little as it wants. What's left untold in a photograph and only alluded to can be as powerful and evocative as what's clearly seen. Everyone loves a good mystery.

Shooting through means framing the image with foreground, so that the photograph creates the illusion of moving through dimensional space, moving through the frame from foreground to midground to background. By shooting through a foreground, your images will deepen and become more dimensional.

There are a number of ways to use foreground to create a stronger image. The most obvious is to use the garden's inherent design elements to frame your view. If there is a lush perennial border lying just beyond a

pergola or arbor, use that structure to frame the view. The depth of field can be either deep (f/8 or higher), rendering both the framing structure and border in sharp focus, or that sense of depth and movement can be amplified by allowing the foreground to fall out of focus by opening the lens to a wider aperture (f/3.5 or smaller). Your field of view in the camera is constrained to the rectangle anyway. By varying the framing elements in that rigid form, your photograph can become more successful.

Another workable possibility is to shoot through plants themselves toward a focus point. This will deepen your image and make it more compelling. To that end, find a garden ornament and situate yourself so that the view is partially obscured by plants. Find plants that have an appealing splash of color or a form that is graphic and shoot through them toward your focus point—in this case, an ornament.

Try shooting stopped down in order to render the framing foreground in focus, and then wide open

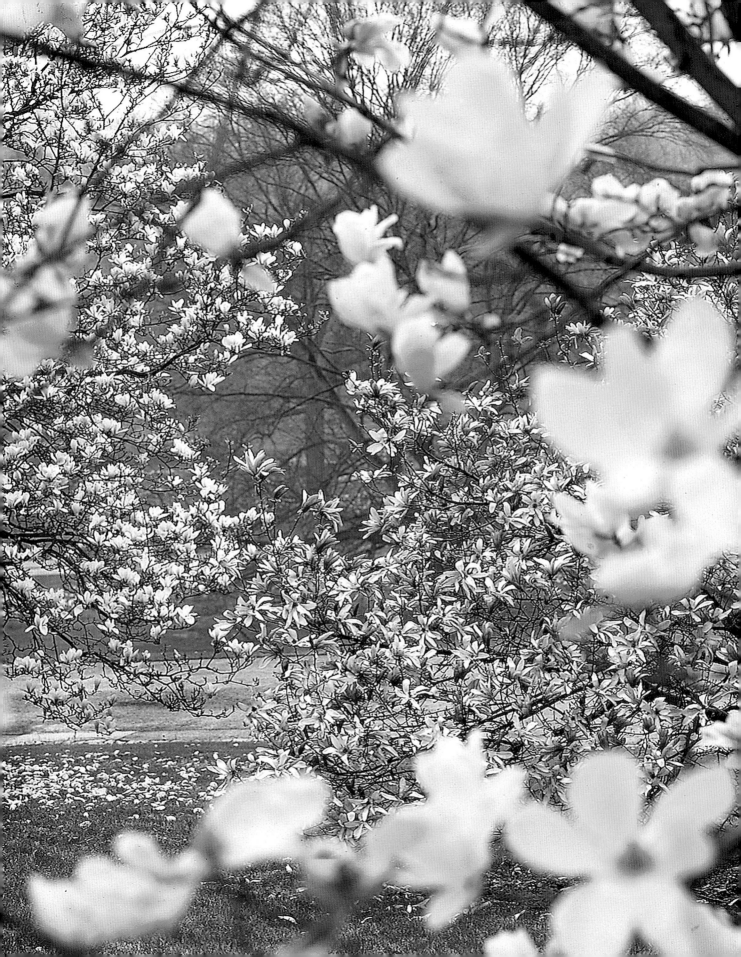

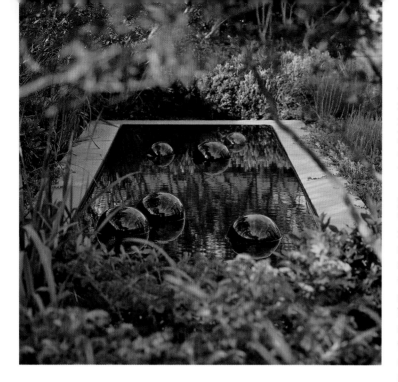

This serene, secluded pool was photographed through a foreground of shrubs and grasses, as though being discovered for the first time. The floating glass balls add to its quiet mystery.

To create this image, I would shoot with a longer lens, or use my zoom fully extended, in order to flatten the field of view and drop focus. A longer lens (80mm on up) will have less depth of field at wider apertures, and will create a more graphic perspective.

Shooting this way is a form of photographic impressionism, where the literal is exchanged for more intangible form and color. We don't experience the world literally, after all: Each one of us interprets it through a subjective filter. The camera should be no different. The rose-bush's lushness, fragrance, and exuberance is, in fact, amplified by the shallow field: What's out of focus creates a powerful and almost subconscious sense of abundance and color, even fragrance. The story you tell about that rose will have more impact if you don't give it all away, but let the viewer fill in where you've left off. We can always perceive much more than we can see. Imagination is a powerful thing, and too much literalism in the garden photograph can dilute its power.

Numerous experiments in the applied physics of optics have shown that much of what we see is not conscious. Most dramatically, experiments at the University of Geneva demonstrated that even the blind had a form of "blind sight," where they could perceive objects and forms without vision at all. Because the complexity of vision, both overt and implied, is great, and perception is so

(f/3.5 or less) so that the foreground is an unfocused blur. You will find that the wide-open attempt has enough information to suggest what it is, but not so much as to distract from your focused object.

You can also try shooting through for the tighter botanical portrait. Find a more perfect blossom among many in a group of perennials or annuals, and rather than setting your camera to macro mode, shoot through several blooms to your subject blossom. Shoot as wide open as possible to drop foreground focus. A lush floribunda rosebush photographed in all its literal sharpness is less evocative than one shot at a wide-open aperture, rendering much of the rose as soft blotches of color.

How to Shoot Through

TECHNIQUE: To shoot through, you will need to position yourself behind a foreground object or plant and have it frame the intended view while dropping it out of focus. This will create a sense of depth and optical intrigue in your shot, as though the scene were being newly discovered by your camera.

ASSIGNMENT: Find a view through to the garden that is indirect and bordered on either foreground side by an overhanging branch or plant cluster, or a dramatic bit of ornament, and shoot through to the garden. Shoot both vertically and horizontally, varying focus and depth of field. Find as many points in the garden as you can where the foreground can be framed with a view through, such as through the lattice of a trellis, the ribs of a tuteur, or the spires of Culver's root.

nuanced, we should always allow our cameras the freedom to explore.

I gave a talk once for the Archives of American Gardens project at the Smithsonian. One of their stipulations for photographing gardens for the project was that there could be no interpretation of the places, only the objective fact. While I understood their position, I had to remind them that by simply taking a photograph, you are altering the fact of the place by putting a garden into the camera's framed view. There is no such thing as a truly objective photograph simply because we don't see the world through a rectangle; we see it in a 120-degree field. The framing itself crops, edits, and interprets the view.

I will occasionally find myself in a garden with an expansive sweep of beds and borders in front of the lens, and my images can seem to drift in open space, unmoored from any intimate sense of truly being there. Broad garden views such as these are grand and stirring in the right quality of light. But they can miss when trying to visually invoke why we garden at all—which is for the intimate connection gardens grant us to beauty of the natural world.

So given our disposition toward intimacy in the garden, I often will draw foreground plants close to the lens and use them to anchor the view. By shooting through this plant-framed view, a sense of being there is implied, scale and distance are revealed, and the photograph quickly becomes more interesting. Finding a tall plant (sunflowers or verbena, for example), shrub, or tree to frame with works fine. Your eye will move through the image. By opening up the lens to a wider aperture, the framed foreground will drop out of focus, and the sense of depth in the image will deepen further. A stopped-down lens (f/11 and above) will render both the frame and distant view in greater focus, making for a more literal portrait.

A successful photograph in the garden should have visual momentum; you should move through it with your eyes the way you would with your other senses if you were there. Remember to mix up your approach to shooting through. When in the garden, shoot through borders toward a subject or through several blooms to get to one. Shoot through ornament to frame the view or shoot through a window or arbor to articulate an image. Vary your depth of field and choose your favorite amount of field later when editing.

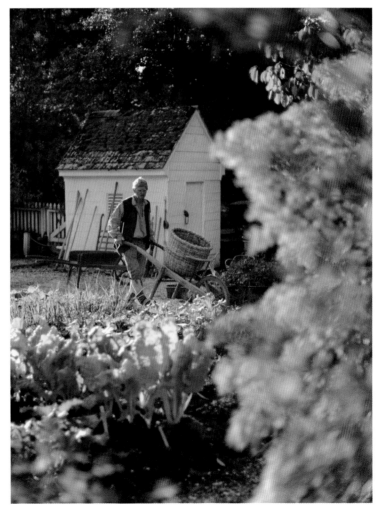

By framing this historic garden in Colonial Williamsburg through a blown-out foreground of warm orange leaf and blossom tones, the image gains depth and momentum as the gardener's outfit picks up the color.

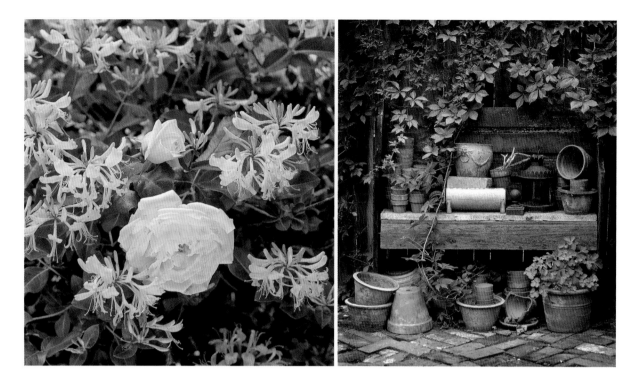

Propping to Serve the Image

Left: An arbor of climbing 'Golden Showers' roses and honeysuckle needed to be tweaked for this photograph. We took roses from another part of the arbor and wired them in for the shot.

Right: These antique terra-cotta pots on an old bench were arranged to make them look like they'd been there for years. The vine was pulled around the front to add a sense of authenticity.

I'm always giving the camera creative dominion over the garden, even if it means tucking or tying a limb back to get a better view, or bringing in a leaf- or blossom-heavy branch to frame the image. I also carry a small pair of stealthy German hand pruners in my back pocket to trim off a dead leaf or obstructing branch or stem. The image must be served, even if it means making alterations.

I've tied limbs back to get them in the right spot or out of the shot altogether, and I've clipped blooms and inserted them where there were none, to make a better image or to repeat a color pattern in the frame. I've had assistants hold large branches over an area I'm shooting in order to give me some dappled light. I've sprayed perennial borders with a mist of water to add sparkle and bling to a shot, and I've tied, wrapped, wired, stuck, taped, and pinned whatever I've needed into the frame in order to get the composition I'm after. This is visually compulsive behavior, to be sure, but in this case obsession is serving the pursuit of the better image.

I'll even bring my own props if I know ahead of time that there will be an opportunity, and a need, to style some still lifes or botanical portraits. I had an assignment to shoot a pretty comprehensive magazine piece on sunflowers, in all of their varietal splendor, and I made sure to arrive at the shoot fully prepared. The first consideration was how I imagined the images: What was my visual idea for the shoot, and how would I convey "sunflower-ness"? I thought of August, of heat, of looming velvet blooms. I thought saturated and rich. So I headed down to my favorite furniture showroom and spoke to a salesman about a couch. I said I was interested in a very expensive camelback sleeper, but wanted to get the color just right for my apartment. Could I take some swatches home and try them out with the rest of my decor? Certainly.

For a sunflower shoot, velvet upholstery fabric was stretched over foam core boards, and the blossoms were pinned in place. The fabric colors were carefully planned to complement the petals.

The variations of blueness in the shirt, box, and blueberries make this image effective. Be sure that your props have the look and feel you're after to complement the subject.

How to Prop an Image

TECHNIQUE: Carry pruners, wire, duct tape, string, and a light stand with A-clamps—anything you can use to secure props into your images. Just knowing that a shot can be improved through propping can be all the equipment you need. By being resourceful, you'll find ways to serve the image and your visual idea.

ASSIGNMENT: Find a shot of a garden that could benefit from some propping, from added foreground interest to subtle framing, and then practice creating an altered view with props. Think about strong compositional shapes and harmonies and about balance and flow in your image. Shoot a lot. Vary the composition and the props.

I showed up at the shoot the following day with a pile of rich, brushed velvet fabric swatches, each about 16 x 20 inches, that I pinned to foam core, then shot portraits of every sunflower variety against its velvety complement. I got exactly what I wanted, and apologetically returned the pollen-dusted swatches. Apparently, my "girlfriend," who's very particular, couldn't make up her mind. Remember, the idea and the image come first; they matter most. How you get there is incidental.

If you imagine ahead of time some of the images you may want to pursue, that gives you the advantage of being prepared and of propping with forethought. If you're going to shoot foxgloves, choose pastel backgrounds that won't dominate your subject; dahlias or roses could handle a richer complement; and ferns may look best against something discreet and earthy. Your prop choices always have to make sense. The more you understand a plant's habits and peculiarities, the more fitting your props and styling will be. This is where the gardener's sensibility and knowledge serve the photographer.

If you're propping your image in the garden with people, be sure that they are wearing colors and cuts that also complement. I've never encountered a subject who wasn't willing to change out of a clashing outfit to serve their image. Allow vanity to prevail. And beware of propping the "vaporized" subject—the garden bench or table that's set out with a glass of iced tea and a book but no one to enjoy them (because the subject has been abruptly beamed up to a galaxy far away). This is a habitual practice on many garden shoots, and I try to minimize or avoid these scenarios. I once asked a local stylist to add some color to a chaise under a gazebo, and turned around to see the strange unveiling of a draped blue blazer and a can of Diet Coke! Always know what you want and—more

important—what you *don't* want when you're behind the camera.

I suggest carrying small pruners, green garden wire or twine, and a small misting bottle with you when you shoot. I can't think of a single shoot I've been on where I didn't reach for one of these tools at least once. You can always improvise (I've used fingers as pruners and grasses or stems as twine and whatever I could find to moisten), but being prepared saves you a lot of time when the good light is fleeting.

Sometimes you'll have a beautiful establishing shot in your viewfinder, where the light is perfect and the

For a story on bulbs, an antique bulb dibble and fork were formally arranged on heavy paper. The tone, feel, and placement of the props add credibility to the scene.

An antique watering can brings a nice splash of color to this bulb shot, and the shallow depth of field makes the composition interactive without seeming forced.

Opposite: Old garden trugs are a perfect prop for garden shots, such as this one with freshly harvested beets.

entirety of the garden is in the frame, but there's something remote about the composition. One way to bring the garden closer is to prop the foreground of your composition with plant material and shoot through it, adding dimension to the scene. This may mean cutting a few hydrangea blooms, for example, and wiring them to a foreground shrub (another hydrangea would be best) and having them be a blur of color and form in the foreground. Yes, you are altering reality, but you are not in the garden with your camera to serve reality. You are there to serve beauty. And you will know when the line has been crossed between artful propping and pure fabrication. At its best, foreground propping just means cutting a few of the best blooms from a plant and placing or wiring them into the shot on the same plant but in a position that better serves the photograph and your framing.

If you're shooting from underneath a tree newly colored with spring bloom, but the branch you're including in the shot is still in bud, find a branch with blossoms and have someone bend it down into the shot for you, or prop it down using another stiff, fallen branch. You will need to be resourceful when an idea for an image pops into your head and you're figuring out a way to realize that idea.

Anything that's reasonably moveable can be used to prop a garden image—whether it's a few terracotta pots filled with annuals, an urn, a chaise or bench, or a clutch of antique garden tools. Whatever you imagine would serve the photograph and your idea of the place can be propped in. I've even propped and planted entire beds when there was more dirt than daylilies, or when the bright red mulch was too much (when isn't it?). I've sent art directors scurrying off to the nearest nursery with plant lists to fill in where the garden is faltering. We're always sensitive to the existing plant scheme, stocking up on cultivars that are in the garden but may be languishing or altogether gone.

It's your job to get the best possible images. Just be sure, after all of your meddling, to leave the place as you found it, unless, of course, the owners like what you've done, and aren't opposed to having a few new plants in the garden gratis. I've always tried to imagine a propped garden after I'm gone; not because I've ever left the place a mess, but because of the amount of snipping and wiring and bending that goes on. A week later, all the floral imposters would be dying on the stem, the cut flowers stuck into dirt would be keeled over, and plants tied together or staked into a shot would be craning their blossoms back toward the sun—all of this clearly marking my trail of photographic make-believe!

Thinking Graphically

Left: This palm frond fills the frame with its radiating form, creating graphic patterns of light and shade with perfect, spokelike leaves.

Middle: A photograph of a farm harvest is made more interesting by cropping the image in half and on the diagonal, then shooting from above with a long lens to flatten the effect. The colors and shapes play off each other, while the strong angled cut across the rectangle creates movement.

Right: This bed of ferns was photographed from above using a medium telephoto lens and was transformed into a graphic pattern of interlaced fronds.

To think graphically is to see the world as patterns, as distinct and interconnected parts that create a sense of visual harmony and balance. It means putting the *graphic* back into photographic by seeing the garden as design elements, and plants as a kind of ephemeral architecture. It means paying close attention to shape, detail, pattern, weight, and play. It means finding vivid expression in the particulars of botanical form, and to work with the camera to create complex and beautiful ideas.

To be a better photographer, you must also be a graphic designer. You must use the viewfinder's rectangle as a template and counterpoint to your image content. As you shoot, always think about pattern repetition and balance, about color harmonies and linear flow. You are training your brain to see and your camera to react. When your photographs improve, and burdensome left-brain attention to technique and design principles has become intui-

tive, then you enter into a state of almost preternatural creative flow, where you just get it, and it comes out of you. This is a consummation "devoutly to be wished," as Shakespeare said, and is the persistent ambition of any artist.

To think graphically is also an act of reductionism. The visual world is far too rich and varied for us to see its graphic parts outright. Our brains are interpretive, and they always want to make the whole and sum up the scene. We're wired that way. We live in the present moment, in the flux of time. Our visual world, unlike that of the still camera, morphs constantly. In order to understand and compose our images, we need to make a deliberate effort to get at the parts—the graphic bones—and figure out what works and why.

An interesting exercise is to single out a number of images in a favorite garden book or magazine and go through them, one by one, and try

A colorful basket of farm-fresh eggs becomes almost abstract when photographed from above. The concentric, radiating circles of the wire basket, the unfocused hand, and the jumbled roundness of the eggs play nicely off the fixed rectangle of the camera's frame.

Making It Graphic

TECHNIQUE: Even without a camera, you can compose in the garden. A black piece of 80-pound card stock with a rectangle cut from the center like a picture mat can be used to frame images. You can also create a rectangle with your hands, using your extended thumbs and flat palms. Graphicness comes out of relationships between shapes—complementing, pushing, pulling.

ASSIGNMENT: Go through the garden with a sketchbook and look for graphic, patterned form, for pleasing overall views, for appealing still lifes. Sketch only the broad shapes and lines that emerge. Don't embellish with detail. This is a reductionist exercise, meant to help you see graphic form and design that would otherwise be missed. Don't pick up your camera until you have thoroughly explored the garden with your eyes.

Colorful salad greens and brassicas, shot with a medium telephoto lens, become graphic diagonal bands of color when tightly cropped. A longer lens will flatten your image and compress its content.

reducing them to their basic graphic patterns and compositional style. Use a marker to make a schematic diagram of the compositional elements. What lines and shapes are complementing or counterpoint to each other? What part are colors and light playing in the success of the image? What patterns are repeated or echoed? This critical assessment of the work that pleases you, and the breakdown of its basic graphic elements, is a great learning tool. With what you find, you'll begin to speak a visual language that is fluent in its understanding of compositional design and its impact.

Once you've begun to take apart pictures and to figure out how and why they work, you need to apply those principles in your own photography. You can begin by an honest assessment of your own work. Gather the pictures you've taken and choose the ones that you like best, then apply the same critical eye you used with other photographers' work. Some subjectivity will enter the mix, of course, as we all have our own tastes, but there will also be general consensus on the images that work best. Photography, or any art, is an act of constant creation and assessment. You need to toss out as much—or more—as you keep. The best photographers are also great editors.

Another ongoing exercise that will consistently sharpen your skills with shape and pattern recognition is to look for graphic form any time you are in the garden. Look for texture and design in plants that have a strong pattern or form, for combinations that seem particularly strong, and for shapes that jump out and captivate. If they're strong with your eyes, imagine how they would compel when framed and flattened by the lens. As artists, we're always in training, just like athletes. In order to stay in shape, we need to be constantly scrutinizing the visual world, assessing and appropriating its parts, imagining how they would play in our creative work. In a sense, you are never *not* making photographs; sometimes you just happen to have a camera with you.

Visual Intuition

The best photographs of place are easy to recognize. They play with light and with form; they imply without telling; and they are masterful in their understanding of balance, tension, and contrast. They are an evocation. If one were to deconstruct a successful image, many of these elements would reveal themselves. But the magical effect of the mix, and of their proportions, relies on a deeper, more elusive understanding. It relies on intuition. And it's something you continually develop as you delve into the various aspects of imagemaking.

To work intuitively behind the camera means to allow the subconscious visual brain to play freely with light and shade, with color and form. It means photographing without prototypes or preconception. The intuitive brain wants to organize space into harmonic patterns. It seeks something, somewhere in its primitive DNA, that surpasses the frontal lobe and connects with deeper consciousness. It longs to come closer to the intangible.

The *intellect* knows all about digital technology, camera equipment, and optics; *intuition* knows about beauty. Creative intuition puts aesthetics on a wire: balanced but not static, clear but not obvious.

Working the intuitive high wire is a necessary place for photographers to be; when a photograph is too deliberately considered, too mapped out or conscious, it often lacks the magical *otherness* that transforms it into a work of art. The paintings of the Renaissance are works of technical mastery, and yet they would not be iconic masterpieces without something else in them, something *beyond*.

The works of Monet or van Gogh are personal, intuitive, and emotive. Lilies in a pond or sunflowers in a vase are pleasant enough, but when infused with the artist's subtext and his subconscious longing, desire, and fragility, they become larger than the subject itself. Monet even said he painted better once he started going blind, and perhaps van Gogh's mental illness freed his brush from the constraints of literalism. The famous garden designer and painter Gertrude Jekyll had very poor eyesight, allowing her to be more evocative with color and form.

Just as a poem can be deconstructed into a pattern of discernible internal rhyme, meter, and alliteration, its true enchantment always lies elsewhere. The lines from one of Pablo Neruda's sonnets, *"As the sad wind / goes slaughtering butterflies / I love you / and my happiness bites the plum of your mouth,"* say so much

Finding and playing with patterns and visual ideas in the garden will deepen the effect of your photography, as in this impressionistic take on a planting of Nymphaea *in a water garden. While the swirl and cool blue tone were added in postproduction, the idea to escape from the literal was conceived at water's edge.*

Working Intuitively

TECHNIQUE: There is no technique for intuitive play, except to try to reach a state of creative consciousness that is unaware of itself, that isn't judging or capitulating to the right brain. Visual intuition sings to itself; it hums in the mind's eye and finds comfort in not knowing.

ASSIGNMENT: Sit in the garden with your eyes closed and do nothing. Listen, feel, smell, meditate if you can. Then from that place of sense-awareness, pick up your camera and flow through the garden, adding a visual complement to what your senses have already taken in. Don't look at your LCD screen or assess what you've done; you don't want to detour your intuitive journey. Only after the moment and the exercise have passed should you sit down and scroll through your images.

more about love and desire than the mechanics of the poem would imply. The visual poem is no different. A photograph can easily be deconstructed into the particulars of the camera lens used, aperture, speed, and ISO, but the formula for its real effect is much more elusive. I have known many photographers who are technical masters, but whose visual intuition and poetic understanding are limited. They may be able to beautifully light even the most hackneyed ideas, but they are hobbled in their poetic ambition. The poet William Carlos Williams insightfully said that *"It is difficult / to get the news from poems / yet men die miserably every day / for lack / of what is found there."*

These towering sunflowers were perfectly lit only for a moment in the late afternoon as the sun settled behind the trees. They were shot from below, into the light, with a wide lens to emphasize their height.

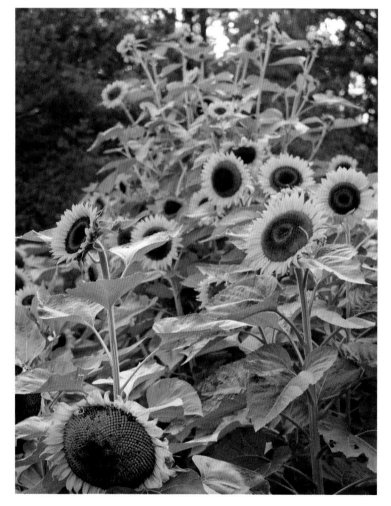

I spent years working with large- and medium-format film cameras in the garden and was often constricted by a cumbersome technology that imposed a more deliberative approach to imagemaking. But now there is almost no excuse for not *asking the more beautiful question,* seeking further and deeper and with less deliberation to discover the transformative image. Pixels are quick and plentiful, digital storage is prodigious, and postproduction software is more powerful than ever. You are limited only by your imaginative range and creative ambition.

But the facility of digital technology, along with its speed and ease of distribution, has created other challenges for the photographer, namely familiarity. It may not breed contempt, but it might breed indifference. So much imagery streaming at us all of the time might make even the most visually turned on and astute among us put on thick filters. Our brains can process only so much. The mediocre image, or one wielding timeworn clichés, will surely end up on the digital scrap heap.

You have to learn to see with strong personal vision in order for your images to make an impression. You have to rise above the clamor of digital noise with a singular point of view. In my studio I have a quote printed and pinned to the wall: "Out of such chaos comes the dancing star," from Nietzsche's *Thus Spake Zarathustra.* It reminds me to stay open, available, and aware at all times with my camera; to be a warrior against chaos and noise, and persistent in my pursuit of visual ideas. I want the dancing star to prevail.

Patterns are everywhere you look, some more banal than others. The repetitive monotony of a chain-link fence is less interesting to the pho-

tographer than the patterned complexity of an autumn leaf because the former is just dull, manufactured repetition, while the leaf is delicate, transitory, and variable. We see ourselves in its unique life cycle.

Good photography draws on the proven patterns and nuances of light and form found in the other visual arts, be it painting, filmmaking, design, or architecture. The bones underlying and supporting all of these disciplines are not new; their newness lies in building on those iconic bones, infusing them with our own ideas. Just as there are only seven notes in the diatonic scale, infinite combinations continue to create new music.

Intuitive consciousness can make beautiful order out of chaos. Good photographers tune in to this place all the time. Every time they pick up a camera, they seem to find design, pattern, and play within the frame. They make decisions quickly and with instinctive judgment. They find the ordering of light and color and form to happen intuitively, somewhere in what psychologists have begun to call the adaptive unconscious: a form of rapid cognition that is often more perceptive than conscious deliberation.

The first roll of film I took as a graduate student contained a frame that sealed my future as a photographer. I was just outside of the journalism school campus at Columbia University, camera in hand (a borrowed Nikon FM2), when a woman passed me in the low afternoon light wearing a knee-length black skirt and black patent leather pumps. As she moved quickly past, her skirt swung like sailcloth over the hard and fixed shadows of a wrought iron fence. There was something magical in the play of fluid motion across the hard, static lines. I cropped her in the camera from the waist down,

focusing on the skirt and shoes and linear shadows. When I developed and printed that black-and-white frame, the image had all of the elements of design, light, and visual play that I can now articulate, recognized in $\frac{1}{60}$ of a second. After my professor saw the print, he gave me the borrowed Nikon FM2 and three of his own older lenses. Fate sealed.

In order for your photographs to move beyond the ordinary, they need to embrace an uncommon vision and imagination, such as this photograph of a garden reflected in a mirrored orb. In order to find images such as these, you need to work intuitively, freely, and without constraint.

Where to Be

As light moves quickly across the garden, knowing where to be is imperative. You have to map out, often subconsciously, how the light will move across the place as it rises. Will it linger behind the trees? Will it be blocked by a structure? Do you have a place to shoot from that will filter the direct light, so that you can shoot through?

Do not find yourself firmly planted anywhere; be thinking about where you will be next and where the light will be going. Get on your knees, get underneath, get on top of, get inside of, get behind, get up against, and move things around. The photograph is all that matters. If something is in the way of your shot, and it's moveable, move it; if it can't be moved, change your idea or your vantage point. You are creating a world within the frame of your own making, not just accepting what's there.

Look for pattern in everything, find graphic form and play with it, and create *graphic-ness* where it's lacking. The camera loves to arrange objects in space; it loves the dance of geometry, and the courtship between line and curve. "Art is the imposing of a pattern on experience, and our aesthetic enjoyment is recognition of the pattern," said the English philosopher Alfred North Whitehead.

The deep, intuitive action you take inside the rectangle is an exploration. Reduce your images to line and curve; blur (defocus) your eyes so that you are aware only of the overall structure of the image and not its specific components. Sometimes we are unaware of the patterns because we are distracted by content. This is why black-and-white images can have more graphic power. They filter out the distrac-tions of color and force us to see the world the way that a camera does, outside of our reality. The camera must challenge your way of seeing the world.

Jon Kabat-Zinn said in his meditation on everyday life, "Wherever you go, there you are." In the garden, the more present you are in each moment, the more your images will express that intimacy. Only by leaving all the day-to-day stresses and distractions at the garden gate, which the very nature of a garden implores, can you begin to be visually present. The best images come from that attentive place.

I had a wonderful, amusing assistant for years who also happened to be a yoga instructor. When the stress of weather or uncooperative plants began to get in the way of a shoot, we would stop for a few slow and deep sun salutations in order to redirect our energy. Sometimes we'd even begin the day with a salutation or two, facing east in the near darkness, invoking miraculous light. Then we'd untangle our yoga-twisted selves and set off to make images.

In Mihaly Csikszentmihalyi's provocative bestseller *Flow: The Psychology of Optimal Experience*, he explores the nuances of perception and consciousness. His premise is that happiness comes from mindful challenge. "The best moments usually occur when a person's body or mind is stretched to its limits in a voluntary effort to accomplish something difficult or worthwhile. Optimal experience is something that we *make* happen," he notes.

Every shoot I've ever been assigned has been presented to me as a challenge: Here's the location, these are the dates, and this is the shot list. Despite the vagaries of weather, flight delays, and tempera-

mental gardens or equipment, you need to rise to the compromised occasion and *make it happen,* as I would often implore myself and others to do.

Where to be, then, is not only a physical requisite (you need to be in a garden to photograph it, after all), but a psychological one as well. In order to truly see, to discover and create images that you perhaps never thought you could, you need to invest your photographic goals with deep, sensory consciousness and effort. Optimal experience in the garden will not be handed to you; it needs to be passionately sought.

I hung out of a top-floor window in order to get this early morning shot as light began to rake across this lovely herb and cutting garden. In minutes, the light was too harsh and I had to move on to making other images.

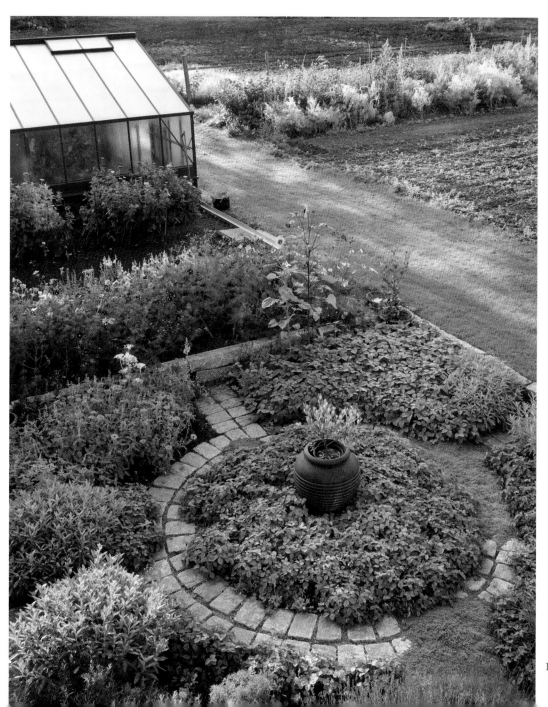

Moving Through the Garden with Your Camera

Planning and organizing your equipment and ideas will ensure you have a successful garden shoot, whether imagemaking is for a single moment in time, an hour at daybreak, or a full day.

The Establishing Shot

One of the first rules of garden photography is to show up ready to shoot. Because the sweet light can come and go so quickly, you need to hit the ground ready to record. Have the lens you plan to use mounted on the camera body, have the batteries fully charged, and have your media card empty with plenty of storage available (at least 2GB). Turn off your cell phone, your iPod, and your availability to the outside world. You are here, *now*. Don't arrive in the garden with your ideas fully fledged and plotted. Yes, you will need a loose plan to take shape once you arrive, but stay open to first impressions and peripheral ideas. Remember that the creative eye doesn't require the intellect in order to see. Much of what you conjure, design, and visualize will arrive unbidden in your imagination. The visual flow needs to run its course freely, without the ego or even consciousness. Often the best photographs will seem to find you and catch you unaware. Not to sound too transcendental, but I have had moments of visual enlightenment that came not through active pursuit, but through simple openness. This is why allowing yourself time in the garden before you photograph is so important. Make the time to take in the spirit and genius of the place. Look

Left: This photograph, taken through an ornate gate, frames and heightens the view. The longer lens has flattened perspective, bringing the house and garden elements forward.

Right: The formal balance of this small garden makes an establishing shot more obvious. Shooting it in the best available light and framing it well are your main variables.

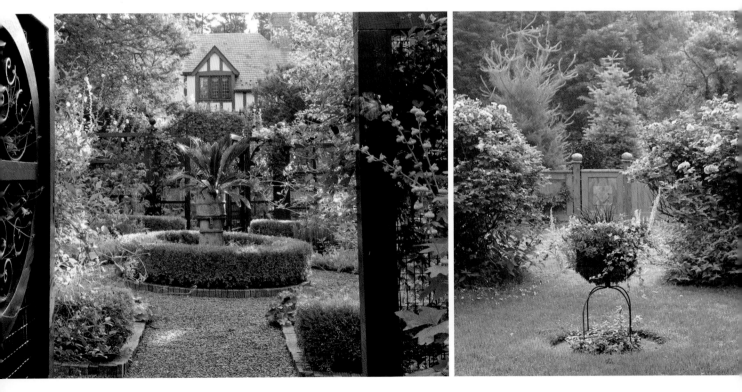

at it from all points of view; crawl behind and over and beneath. Get off the trodden path. Your subconscious will be actively creating images that you can then turn into pixels.

I carry a pack with four lenses in it: a 28–77mm 2.8 zoom, a 50mm 1.4, an 85mm 1.4, and a 55mm macro 2.8. These lenses will cover 95 percent of my shooting needs. It's the rare exception on a garden shoot that you will need a lens longer than 200mm. If you do, maybe you're not allowing yourself to experience the garden close enough. Remember that standing at a distance separates you from the intimacy of being there. The more all of your senses are engaged, the more visual ideas will flow. If you find yourself tangled up in plants or pots or crawling under a hedgerow to get the shot, so much the better. This is often just where you want to be, never mind the discomfort. The more you push yourself in the pursuit of great images, the sweeter the rewards.

I also always wear long pants and comfortable shoes that I am willing to get dirty. If a good photo opportunity is lost because you don't want to sully your Dockers or scuff your Manolo Blahniks, then you'll have cleaner clothes but fewer great pictures.

With my zoom mounted on my camera body, I then carry one other lens (usually a 50mm 1.4) in a belt pouch, so that if I want to put the heavy backpack loaded with other lenses down, I still have a basic rig with me. My gear used to always include a tripod, as shooting early and late in the day meant long exposures in low light. But the tripod has a way of staying packed away in the car or hotel room lately; it's just less critical with the speed of today's lenses and the noise-reducing capabilities of modern digital sensors. Nowadays, you can photograph at ISO speeds of 640 or more and retain amazing sharpness of detail.

Left: Photographing this formal garden's axial paths and colorful backlit shrubs and perennials sets up the scene; it's an invitation to walk through.

Right: A whimsical faux bois gate says it all about this exuberant Miami garden.

If you want to shoot at tiny apertures (f/16 or higher) for maximum depth of field in low light, then a tripod is essential. But I tend to shoot at more open f-stops, and I love the freedom and exploratory liberties I can take with a camera when I'm not dragging it around on three legs. There are even small, flexible tripods available now, capable of gripping around the post of a pergola or a fence (Gorillapod is one brand), that are very portable.

My first shots will most often be wide, overall beauty shots of the garden. The best light should be used for these. Medium and tight shots can often be worked in less than ideal light, but the full, establishing shot of the garden, the shot that says "you are here and *my God*, is it beautiful!" should be made in the sweetest light of the day.

Go through the garden at dawn and find the best vantage point to shoot into the emerging, early light. There may be several possibilities. Choose the best one, but be ready to move to the next as the light changes. You should be looking for an establishing shot that is dramatic and evocative, but do not try to make a literal garden plan. We have garden designers and landscape architects for that.

You need to evoke the whole, the aesthetic feel and sense of the place diluted into one potent photograph. Pulling back and trying to get too much in one shot can actually weaken an image. Instead, find a view through that is graphic and light-perfect. Maybe it's a feature in the garden that you find particularly beautiful or evocative as a design element, or perhaps it's not the form or design itself, but rather the way light is moving through and creating a compelling view.

Keep shooting and looking and *becoming* the camera. That state of visual flow (what philosopher Roland Barthes called the "*camera lucida*," when you're seeing through the aesthetic temperament of the lens) is critical to the creative leap

Making the Establishing Shot

TECHNIQUE: You will need to draw on everything you've learned thus far to move your apprenticeship in garden photography forward. Remember to show up at the location with everything you need, or might need, for the shoot. Begin early, take a break or siesta at midday when the light is harsh—the way Matisse did—and resume in late afternoon when the light is low and filtered by trees. Use a mix of lenses if you're shooting with a DSLR, or vary your zoom if using a compact digital. Remember to always shoot into the light, blocking lens flare by putting your hand out above the lens until that annoying hexagram disappears. Use low-hanging branches and leaf cover to frame and filter the light. Try to shoot from where the garden would normally be experienced, from a terrace or the garden's interior. Climbing up onto a rooftop may give you an interesting sense of the garden's geometric plan and relationship to the broader landscape, but it will also alter scale and make the place more remote.

ASSIGNMENT: Find a garden where you will be able to spend the day shooting from dawn to dusk. You can certainly show up in a group, but I like to work alone, rather than troop around in a gang, so that I can get into a good state of creative flow and lose myself in imagemaking. Upon arrival and before you shoot, find east—either with a compass or with your iPhone's GPS app—and begin to find the most compelling, east-facing overall view of the garden. If the light is moving quickly, this may turn into a mad hunt for the best spot, but your effort will be rewarded. Find a perch where you can shoot through ornament or plantings in the foreground to a broader view beyond. Change depth of field, shoot both vertical and horizontal, shoot high and low. Mix it up.

you're after. The more you explore *as* a camera, and see the garden world through its optical viewpoint, subjectively framed and focused, the more successful your images will be.

Remember to always be aware of what the light is doing, and follow its course. Anticipate its plan, what will be lit first and last, and what will be better shot at the end of the day with the light coming from the opposite direction. The quality of light, not the subject, is often the distinction between good and great. Vermeer and Rembrandt knew this, as did the Impressionists. If the light is flat and overcast, you will have a reprieve from the mad dash of trying to keep up with the sun's arc, and you can concentrate on color and design.

If you can't get up high enough to get the image you want, set your lens to autofocus and hold the camera over your head; if you can't get low enough to a groundcover's view of the garden, set to autofocus and position the camera at ground level. Sometimes these images will deliver exactly what you were after. Because you're not looking through the view-finder, it may take a number of tries, but the results can be wonderful.

Take a grove of towering *Silphium,* for example. Maybe you'd like to emphasize their looming form over the garden. Why not set your zoom to its widest focal length and shoot up into the floral canopy? You'll need to compensate for exposure, and aim well as you hold your camera at ground level with its glass eye to the sky, but the resulting image would surely please and engage the viewer.

You may want to follow the same course with a groundcover, or something sensual to the feet like moss or thyme, shooting from a low aspect to emphasize the connection between plant and person. Maybe have some-one walk barefoot through the shot to heighten the connection.

Exploring visual ideas and narra-tive possibilities with the camera will always lead to something new and provocative. The more open you are, the more available and aware you are of all the creative possibilities in the garden.

As you continue to explore and photograph with a large establishing image in mind, make a mental note of possible medium and tight shots you will be after next. The early light moves quickly, and it will soon leave the low horizon and harden its edges, beginning its brightening arc across the sky. Turn yourself 180 degrees from where the sun first appeared: This will be the direction you'll be shooting in during the late afternoon.

If, while chasing the overall view (or opener, as we say in the publish-ing world), you trip across an image possibility that's tighter and per-fectly lit, take it. The light may change and you may never see it the same way again. If you decide not to shoot it, make a mental note of the idea (or an actual note, which I often had an assistant do) and come back to it when you have time. You'll begin to feel the flow of intuition as you shoot, so let light and beauty lead you through your shots.

If a large view is lacking fore-ground interest, and you want your image to have more depth, bring objects or plant material closer to the camera. If you're lucky, there will be a perfect overall view in the garden that can be made stronger with the foreground framed by a tree, bloom, or ornament. But if not, take out your pruners and clip a blossom into the frame. You can even wire it to a branch so that it stays just where you want it (just be sure that the plant you're hijacking flowers from matches the one you're

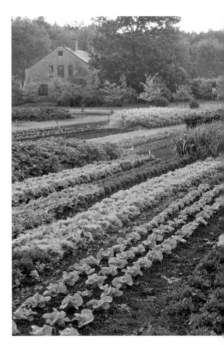

You're present in this shot: It's morning on a beautiful, ornamental farm. The light is just coming up over the distant trees, and the greens and reds of the vegetables create a strong diagonal travel line through the image.

affixing them to). By bringing a garden element into the more immediate foreground, the large, establishing shot becomes both comprehensive and intimate.

At this point, you may want to switch lenses and try an establishing shot using an alternate optical viewpoint. A medium to long lens with a fast, wide aperture—say, f/1.4 or f/1.8—will allow you to play with a very shallow field, dropping foreground and background focus and isolating your subject. You can work with the same establishing shots you used with the zoom, only the fast prime lenses will see the scene differently.

Every lens has its own optical personality, depending on its length, aperture settings, and design. The glass, or elements, inside the lens barrel have a distinct point of view, the same way that everyone's eye sees the world a little differently. The longer the lens, for example, the flatter the field, meaning distances between objects are compressed into optical flatness. The wider the lens, the more it pulls objects apart, distorting the edges of the frame (an optical aberration called barreling). Learn to use lenses not only for how much or how little they take in, or for how close or far they see, but for their more subtle optical qualities.

I like to work with very fast prime lenses, for example, because they dramatically isolate my subject area, creating almost surreal selective focus. One of my favorite lenses is a Nikon 50mm 1.4. This lens, considered a "normal" focal length, is so fast it can shoot in near darkness, but that's not its real allure for me. What I love is how, even in broad daylight, I can set my camera to aperture priority and choose this lens's widest setting (f/1.4) and, while my camera might be shooting at speeds of $\frac{1}{5000}$ of a second or more (!), I'm able to work with very shallow depth of field. This dramatic shallow field is so independent from how we see the world, and so focused on its narrowly selected subject, that it's almost a new way of seeing. Remember, the visual brain wants to play and be provoked.

Making the Medium Shot

TECHNIQUE: Use your zoom set to about midrange, or choose a fixed 50mm to 105mm lens for these images. Compose carefully, but don't crop the image too tight. Frame with some extra room left for cropping out later. Remember that framing is reductive, first when you decide what to put in your viewfinder, and later when you tighten the crop in postproduction. You can always take more out and tighten the image later, but you can't add what was never there.

ASSIGNMENT: Shoot an entire garden without using a wide lens or setting your zoom to its widest setting. This will force you to edit the view and make tougher decisions about what to keep in and what to leave out. You are training your eye to edit the scene and say only what needs saying and what makes the most compelling shot.

The Medium Shot

The medium shot is the image that takes in a more selective view by focusing on an area of the garden that can stand on its own and by only referencing the overall. Sometimes this shot is used as an opener because it speaks so well to the complete design and tone of the place. I often prefer a tighter, more edited image of the garden because it implies more than it tells, alluding to the whole rather than giving up the entire story in one broad view. The wider you shoot, and the more you try to pull in, the more the viewer pulls out of your image, and the smaller he or she becomes in the relative scale of the garden. If the view is tighter, you put the viewer there, right in it, brushing up against the *Buddleia*. In the best images, you are intimately *there*.

Often, the medium shot is a view through to the garden beyond: an open gate leading in, a view toward an inviting bench, a composition framed by an arbor or pergola, a path moving through, a perennial border punctuated in the foreground by garden ornament. This image should be made with a medium lens or with your zoom lens extended in order to compress

it. If you shoot wide, the scene will pull apart and loosen, making it less graphic and less dramatic. This view should be flattened so that all of the garden elements come to the fore to create a flatter scene. Medium to long lenses are the optics of choice for graphicness, as well as the best lenses to isolate points of focus. When seeking out this shot, you can also look through only one eye, as this will create a flatter, more two-dimensional view of your composition.

Once you find a shot, make sure to pursue several possibilities and angles of a single view. Shoot as much as you can, changing aperture to control depth of field, changing exposure, changing your point of focus. Always shoot both vertical and horizontal compositions, and plenty of each. They're just pixels, and you have thousands at your disposal. If you don't use, you lose. Carry at least two memory cards with a minimum of 4 gigabytes of storage combined. By not having all of your work on one card, you reduce the risk of losing an entire shoot to a damaged or misplaced card.

The medium shot is also a place to explore plant combinations or relationships between hardscaping

Diane Benson's first East Hampton, Long Island, garden was expressive and moody and highly stylized, as these medium shots illustrate: A massive sculpture of an open hand reaches hauntingly out of a bed; white Hydrangea paniculata *and a weeping cedar frame a view; a broken amphora and a taro plant against a stone and plaster wall; a portrait beneath an evergreen bough draped with orchids.*

In these medium-view images, the garden's individual design elements come to the fore: The elegant fence line and gate, which was propped open to reveal its design; exuberant, multicolored dahlias dominate an entire border; a formal fountain, shot in glinting backlight; and a pretty birdhouse and planting of Asian lilies are fronted by an English rose.

and the garden's softer constituents. Perennials or annuals that complement each other or are artfully grouped make perfect color-composed images. If you see a group that is particularly pretty, shoot it. Shoot garden ornaments anchoring a view, shoot a bench under an arbor, and shoot a tree in blossom draping over a chaise. The medium view is an invitation to visit; it is intimate and welcoming, and it must invite the viewer in.

With medium shots, there are also opportunities to photograph parts of the garden that are particular and specific to that place alone. Every garden has something—a view through, a defining ornament, or an overall design. Find those elements that say something singular about the garden's personality or style, and find a way to beautifully photograph them. With sensitivity and careful design, the successful medium shot can say much about a place.

It can be a challenge for a garden to be defined by its plantings alone (although regional and zonal disparities are always a clue—you won't

see rosemary trailing wild over walls in New Hampshire), but there are always elements that clue you in. Sometimes a garden's gates or fence lines have a defining quality, as they do in the long side gardens of Charleston, South Carolina, where intricate local ironwork has a strong tradition; in Maine, Lunaform urns and amphorae are like sensual cairns in the landscape, marking place. The best gardens connect to their surroundings and reference local idioms and traditions.

I've shot gardens that seem to have landed fully formed from other parts of the world, like horticultural aliens, with very little connection to their surroundings. One such property, in Greenwich, Connecticut, was conceived by a famous English garden designer and, though impressive and grand, fell flat. All the formal English archetypes and traditions were in place, but there was no personality, no soul, no *there* there. Some effort to incorporate regional herbaceous elements was made, such as a hedgerow of American holly and a formal allée of

native dogwood, but these came across as almost patronizing. The rigid allée of dogwoods, in particular, missed the mark: A tree whose informal habit belongs on the woodland's fringe is misplaced in a marshaled, linear row. Then there were the hornbeams. I went back to shoot this property in winter, and the absentee owner had decided the lingering, bronzed foliage on the extensive hornbeam hedge made it look dead, so she had her help take off the leaves, one by one. This was a proprietary garden, owned, but not understood. My camera did its best to connect (I was being paid, after all), but the disaffection took its toll: I made a lot of pretty, dispassionate pictures.

Other gardens pulse with soul and personality. Writer and designer Diane Benson's (no relation) first East Hampton garden is one such place. References to her travels in Southeast Asia and her eccentric, moody design sensibility fused to create a beautifully stylized garden of complex, expressive plantings and ornament. Every shot was a medium shot. There was no overall view, and that was the point; this garden's lush, secretive layers were not meant

to reveal themselves in one bite. When she appeared for her portrait in slim capris and tiger stripe flats, Felco pruners artfully holstered to her hip, my camera and I were smitten. Why can't every garden (and gardener) have this much consummate style?

Listening for a garden's voice takes time, and sometimes it's only a whisper. But listen you must, otherwise it's just you imposing yourself on the place. A visual conversation should develop, where the garden is allowed to express itself, answering your questions and surprising you with the beauty of its ideas.

The Tight Shot

Now that you have taken in the large and medium views of the garden, it's time to start thinking about coming in close. Not so close yet that you're into pistils and pollen, but close enough to isolate single plants and elements. This is where we begin to move in on texture and botanical form, on the design and pattern language of individual plants.

The tight shot is a narrower exploration of the garden itself and sometimes a greater opportunity to create iconic beauty. Because the tight shot

Finding graphic elements that stand on their own is one of the goals of the tight shot. A backlit paperbark maple peels and glows in this garden; a modern stucco wall fronting a grove of bamboo is brought to life with splashes of light; a simple birdbath on a stone plinth says something about this garden's refined aesthetic; ornamental glass orbs in a bed of euonymus.

Making the Tight Shot

TECHNIQUE: You can use any normal to mid-telephoto lens for this shot. You want a lens that flattens perspective, and ideally one that's fast and merciless with depth of field. The narrower the field available for you to play with, the more visual options you'll have. Shoot these images vertically.

ASSIGNMENT: Go through the garden and find plant specimens that stand out for their color or form or textures (like bark, leaf, or ornament). Find individual subjects that interest you and your camera and shoot them from different angles. Locate a subject that can be approached from varying focal points, such as a tight cluster of blossoms, and vary the subject point from front to midway to back. Then look for plants that could be rendered in black-and-white and shoot them both with and without color.

Shooting tighter means coming in and filling the frame with the garden's details. Clockwise from top left: Pink and purple dahlias are selectively focused and misted with water to add lushness; Althea nigra is a marvel of color and form; these poppies are a beautiful complement of pink and yellow; and a yellow shrub rose clambers sweetly over a picket fence.

is unmoored from the larger anchoring visual ideas of the garden, it can exist on its own as a beautiful expression of form without the necessity of context.

Tight shots are often botanical portraits, isolated from the rest of the space through selective focus or even shot in the field against a neutral backdrop. They can also be small elements in the garden that can be graphically isolated—a decorative latch on a gate, a potting bench with crockery and tools, a rustic basket filled with harvest, or a pair of muddy boots against an old door. Anything to do with the garden and its care are possible subjects. The photographer's job is to choose subjects that are somehow compelling and frame and compose them well.

For these images, I would use a 50mm 1.4 or an 85mm 1.4 lens if you have them. Any medium to long lens, even a macro lens, will do, and the faster the aperture the better. You will want to isolate your subject from its background and other distractions that are beside the visual point you're trying to make. The faster and longer the lens, the more your subject will be pulled out in the frame. If you're using a zoom, extend the lens to its farthest telephoto setting and step back. With this narrow field, your subject will isolate and stand out. Be sure to set your camera to aperture priority in the program mode, and take numerous shots of the same setup, dialing up from the widest aperture (say, f/1.4) to one with more depth of field, like f/8. This way you will have choices in postproduction should you decide a little more focus is needed. You can subtract focus later (see page 159), but you cannot add it. If it's out of focus in the camera, it's out of focus forever.

Beyond selective focus, compose with an eye toward color harmony or repetition. A brick-red pair of garden boots, for example, isolated against a weathered green door, with a climbing 'Blaze' rose in the background is a start. But selectively focusing on the boots and a bit of green paint, while allowing most of the door and the rose to fall into impressionistic blotches of red and green, creates not only pleasing color harmonies, but color pattern and repetition between the boots and rose. Paying attention to, and creating, these subtleties will make your images stronger.

If the early light has passed, and you're into the hard glare of a rising sun, an important tool to have on hand is a diffusing scrim. Many companies make these collapsible, translucent disks that will soften hard light when held over a subject. They're usually rated as cutting down on the available light by ½ to 2 stops, a stop meaning an aperture setting. For example, an image without diffusion might meter at f/8, but a full stop of diffusion would mean a reading of f/5.6, the next stop down on your lens. By having a scrim on hand, you allow yourself the freedom to shoot tight details at any time of day. A stand is helpful to hold the scrim if you're alone, but it can always be floated above your subject on other plants or branches since scrims are considerably light.

If you've come across a lovely inflorescent hydrangea in full bloom, or a vast sea of bee balm, choose a long to medium lens, or fully extend your zoom, and isolate one or three specimens from the crowd. (I follow a loose Rule of Three in composition: When three objects triangulate in the frame, they offset and play against the right-angled image plane of the photograph, making it more provocative.) Keep the rest of the group in the frame, but let them fall

The curves of these climbing and hybrid summer squash are softened by the inclusion of deep yellow blossoms in the shot. This scene may have been set up, but the artistry makes it more memorable.

Tight images in the garden include many details besides plants. A basket of fresh eggs hung against a red barn door tells you something about the nature of this farm garden; a collection of sundials creates a strong pattern; a leaf pattern sets the mood on an iron garden gate; and copper plant tags and tiny terra-cotta pots are wonderful objects in themselves.

out of focus. Find a blossom that is exemplary, and have it speak for the rest of the plant or planting. This blossom may be right up front in the frame, with the background falling off, or it may be midway through the image, so the eye has to travel across an unfocused expanse in order to get to it. Remember that the eye wants to be intrigued and entertained. Also, keep the paths you lead the eye down in your images as diagonals in the rectangular frame. Don't have a foreground or midground subject dead center, where it stops the eye in its tracks. Instead, crop it to one side or the other. This will force the eye to travel obliquely across the rectangle and give the visual cortex some pleasing exercise.

As a rule, I always shoot the tight and macro shots of plant portraits and details vertically. Whether this is a subjective habit, a rule of photographic syntax from centuries of plant portraiture, or the simple physiology of the plants themselves, most of which tend to be taller than they are wide, is no matter; the vertical format somehow pleases for the plant detail. It could also be conditioning from how most of us experience individual plants in books, magazines, and catalogs. Above all, the tight shot is meant to be intimate, a revelation of form, and a calling out of a single, special plant from the garden. This is their moment to shine.

The Macro Shot

The macro shot is an isolated detail, captured using a macro lens or a macro setting on your camera. It is a coming-in on the most intimate of plant parts: the delicate, secret uncurling of a fern; the pollen-dusted throat of a daylily; the crimpled, pink saturation of a hibiscus; or the showerhead crown of a lotus pod. Most of the details in the macro image are unavailable to the human eye because we just can't focus that close. And so they intrigue us with their magical investigation of form, with their powers of revelation.

These are images to make at almost any time of the day, as the closer in you get, the less the light is a controlling factor. You may still want to seek out plants that have retreated to the shade, but those in bright sun can easily be shaded by a scrim or even a thin piece of paper. You will need to set your camera to macro mode in order to get in close (usually indicated by the tulip icon on compact cameras), or use a macro lens. A standard length for a macro lens is 55–60mm or 105mm, allowing you to get in close enough to isolate detail.

With a compact digital, usually the only way to get in tight on macro mode is to have the lens at its widest setting (around 35mm or less). This has to do with the internal optics of zoom lenses, but the results are more or less the same: You're able to get in closer than humanly possible.

Macro images are led by the camera more than others. It's by looking at plants through the macro lens that their potential beauty will be revealed. Sometimes a rather ordinary plant,

The macro shot gets in tight on the marvel of botanical form: A teasel shows off its intimidating armor of thorns and spines; the radial pattern and rich hues of a wide-open tulip; shooting this annual from above reveals its whirling petals and starlike flowers; this pink Rudbeckia's *outsize pincushion center makes a strong photographic statement.*

Making the Macro Shot

TECHNIQUE: These images will require a compact digital setting at macro mode (the tulip icon) or a macro lens on a DSLR. With the compact digital set to macro, you'll need to shoot with the lens set at its widest angle in order to really get in tight. Remember that you can always crop in closer later, in postproduction. Be sure to shoot at varying apertures to alter depth of field. Because field is so dramatically narrowed with a macro lens, you'll want to make sure the parts you care most about are in focus.

ASSIGNMENT: Pick out plant specimens in the garden that have interesting internal architecture, or are somehow compelling up close. This is about the whole plant, not just its blossom; stems, leaves, thorns, and vine tendrils are all worthy of attention. Let the camera lead some of your discovery by examining as much as you can through the macro lens. If there is backlighting to use, by all means use it. Though less critical up close, beautiful light is still a tonic for the eyes.

Blossoms are not the only subject for macro scrutiny in the garden; leaf patterns, tendrils, and fronds are all worth considering. The pattern of ribs on this two-toned leaf makes a graphic statement; a multicolored leaf up close takes on the look of textiles; and unfolding fiddleheads on a woodland fern are always beautiful.

when scrutinized under a macro lens, reveals itself to be infinitely complex and magical. Or, conversely, a stunning bit of bloom will dull when taken in too close.

The macro image is an opportunity to let the camera off the leash. After you've worked your establishing, medium, and tight shots, now you're free to explore the fine points of natural form and botanical design. Often, the macro image is abstract and impressionistic, its parts rendered so closely that they're hard to place. Here the sum of the parts is often only suggestive of the whole, although the form-generating power of the gestalt effect on our senses often allows us to organize pieces into whole forms.

A plant form's gestalt (German for "essence or shape of an entity's complete form"), therefore, can be implied; the mind will shape the rest. It is a helpful rule to remember when photographing in the garden. In essence, it argues for implying over telling—and revealing versus showing. The macro image, by singling out parts from the whole, engages the mind in the pursuit of form filling. I am convinced the brain is like a Labrador retriever, always excited by the possibility of discovery and play.

The suggestive power that's unleashed by the exploration of detail, along with the attention the macro image focuses on the marvel of botanical structure, make macro images in the garden a pleasure to make. Just be sure that you're not always in so close that beauty is sidestepped by botany: Some macro images end up saying a lot about parts and not enough about *essence*. A beautiful face is beautiful because of how the features balance and relate, not for the features themselves.

You may find some particularly telling element of a plant that speaks to a larger idea. A sea holly, for example—after losing its slate-blue summer coloring—takes on an air of medieval menace. Its razor-sharp defenses are all points and spurs. By isolating it against a neutral background, and amplifying its hooks and macelike thorns, that idea comes to the fore. Converting it to black-and-white takes the graphic threat of this plant to an even higher level. If you like to get physical with your garden, this may be one to leave out of the group hug, but it makes a great macro image.

On assignment once in a tropical estate garden in the Caribbean, I found that the whole property pulsed with color, exotic form, and lush abundance. Gardens in the southern latitudes are inherently louder and more richly chromatic (think Rousseau and Gauguin in Tahiti). With so much plant life screaming for attention, the dense, riotous flora can easily overwhelm. Here, coming in close can reveal even more complexity and sensuality, and edit the noisy scene down to a single subject. This sort of simplifying applies anytime you come in close. The lens will optically limit focal length the tighter you get, and the subject will be reduced to a few beautiful, miraculous parts.

Left: The upturned tendrils of a squash, with their whorls and hairlike spines, are graphic and intriguing.

Right: Allium christophii, with its massive, star-clustered blooms, is a botanical wonder. If you see this in a garden, shoot it!

Narrative Dimension

Every photograph should tell a short story. And like any story, some are more captivating and successful than others. In order to infuse your image with narrative, you need to have something to say about your subject that will engage the eyes and imaginations of others.

Before you shoot, even, there's a story unfolding in front of you: A garden may feel mysterious and secret or loud and flamboyant. It may embrace you with its lush abundance, or implore you to stay on paths and keep within bounds. It may boast about its rarefied plant collections and horticultural oddities. It might ask you to come in close to ground-hugging diminutive plants, or crane upward into a canopy of remarkable flowering trees.

Every garden is as unique as its proprietor, with a personality all its own. Finding the story of a place or a single plant specimen is a collaboration between the subject and your narrative imagination. Your photographs will be far more interesting if you have a point of view and are intent on telling us something.

The dialogue that takes place between you and a location, between your interior experience and your outward exploration, needs to be a revelation and not just a record of what's there.

I once shot a garden in Seal Harbor, Maine, for *House and Garden* magazine that was very thoughtfully designed by a well-known landscape architect. It faced the ocean on a ragged slope of land. The house was modern and minimal, and the garden was equally minimal, to the point of not being there at all!

What to do? Here was a non-garden garden. Its conceit was that it was designed to look entirely un-

designed. Between low, undulating waves of granite were subtle rills of moss, lichen, and lowbush blueberry. Except for the austere house looming above and a few sentinel Lunaform pots, the garden looked like a completely naturalized, indigenous Maine landscape—until it registered that the entire site had been cleared and was, until recently, covered by a thick spruce and fir forest. Every plant on the site had been brought in and artfully placed to create an undisturbed, natural habitat. It was remarkable.

But how to translate that subtlety with the camera? How could I best tell the story of this garden without it looking like a landscape shot for a coastal Maine calendar? After some deliberation, I decided to include an element of domestic life in each frame, but only enough to suggest that someone had moved in (the

The story of this farm garden was as much about the style and energy of its owner as it was about the place itself. The camera is always looking for a story to tell, not just to make a lot of pretty pictures.

This minimalist Maine garden was composed of granite, moss, lichens, and lowbush blueberries, all carefully placed to look as though they had always been there. The challenge was to convey some sense of human design played out in the landscape, which the outdoor seating areas and Lunaform pots did.

large urns came in handy). I also shot quite low to the ground with a wide lens, letting the groundcovers dominate the frame while minimizing the human footprint of house and home (the persistent early morning fog played its obscuring part as well). This place was meant to look untouched after all, under the spell of sky and sea and granite. The garden story was about a collaboration with indigenous land, not dominion, and the photographs spoke to that idea.

There's another garden in nearby Northeast Harbor, Maine, that I shot for *Traditional Home* magazine, whose story and tone is entirely different. Thuya Garden is modeled on a traditional English estate garden, with long herbaceous borders of looming delphinium, Asiatic lilies, and perfectly edited perennials. Walking through its hand-carved gate transports you across the pond to the English countryside, but here incongruity is the story; rugged coastal Maine meets orderly, temperate England.

Just shooting Thuya's great bones and flower beds would certainly make for beautiful images, but somehow getting the looming, indigenous pines and mossy forest floor of Maine encroaching on this unique patch of orderly horticulture was more interesting and more to the point. So I opened gates and allowed the wildness of the perimeter forest to enter into the frame. I climbed up onto tile roofs and shot through the evergreen canopy to the immaculate borders below. I allowed the one local reference in the garden—a massive, lichen-dusted Lunaform pot—to take center stage while the borders stood in the wings, as though deferring to the wildness beyond.

Adding this sort of thought-through storytelling to your images, this sensitivity to not just planting but to place, will give your photographs meaning beyond their inherent beauty. The goal is not loveliness alone, but loveliness filled with something deeper that informs and lingers in the mind's eye. There are countless pretty garden pictures out there, but far fewer that carry a deep narrative dimension as well.

Beauty alone is certainly a wish.

And adding beauty to the world with your camera is nothing to scoff at. But why not try for even more? Why not look for the more profound possibilities? Surely this is the goal of meaningful art. Great art isn't in pursuit of a facile expression of the beautiful. Where would the Mona Lisa be without her esoteric, unknowable smile?

It's not always what you see, but what you know is there. The Cubists understood this and exploited it fully. The reductionist boxes of Braque or Picasso are an effort to get to the essence of physical form in order to reveal something more provocative and truthful. The small towns of the French Pyrenees carry very little resemblance to their Cubist paintings, and yet their canvases say more about these domestic clusters of life cut into rolling hills than any objective rendering ever could.

Painting and drawing are certainly freer from the empirical constraints of the camera. But the camera should be after the same vital essence as the canvas. At its most fundamental, the camera is a box for recording images (the word

camera comes from the Latin *camera obscura,* meaning "dark chamber"), but at its most profound, it is a protean tool, able to alter and deepen our perception.

Photographing only to record the given fact is fine and useful. But those are not the aspirations of an artist. If you find yourself flat-footed in the garden, clicking away like a copy machine, you will get a record of what's there. But you won't get art. Art asks that you invest your work with idea and desire. It is interested not only in the thing itself, but in its essential nature.

A botanical portrait of a flame-red Asiatic lily can be taken any number of ways, depending on your intentions. If you're shooting to make a record of its petal form, color, and overall habit for a garden catalog or plant file, that's one thing. But if you are after its essence, that's a bigger investment. You need to have something to say about this plant that's subjective; it's your idea of its essential nature. You may feel she's a horticultural harlot or a velvet trollop in the garden, flaunting her flame-hot colors. If so, a mere objective shot

This garden's cultural mix is a story in itself. Set high above the sea on an island in Maine, the long English borders of herbaceous perennials are surrounded by deep coniferous forest. The garden emerges out of a clearing, like paradise.

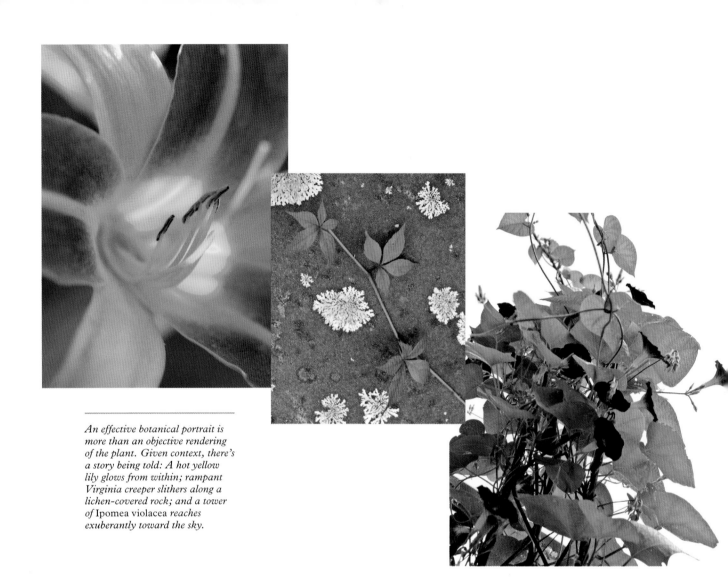

An effective botanical portrait is more than an objective rendering of the plant. Given context, there's a story being told: A hot yellow lily glows from within; rampant Virginia creeper slithers along a lichen-covered rock; and a tower of Ipomea violacea *reaches exuberantly toward the sky.*

How to Create Narrative Dimension

TECHNIQUE: Great storytelling, at its best, is about universal ideas drawn from specific content. Use all the technical tools your camera has to offer to say something true about a place. If the garden is hidden and quiet, your camera should be, too. Shoot a quiet garden in diffused light and indirectly through—as though revealing secrets. If the garden is loud, saturate the colors, or shoot in high-contrast light for more bling. Shoot botanical portraits with a clear point of view. Always work with narrative intent.

ASSIGNMENT: Find a garden that seems more quirky and original to you than others, one that stands out because of its botanical specimens, or hardscaping, or unique design. Shoot this garden with a narrative in mind—a story you want to tell—and find a way to convey the garden's singularity. Remember that it will be your story as well because your eye and camera are part of the narrative. Remember, too, that though this is a specific place, your photographs of it need to carry something with them that will be true.

won't do. You need to get the light moving through her petals and her open throat, turning up the heat; you need to come in tight on her provocative crown of pollen-dusted anthers. If this plant is as sexy as it gets in the garden for you, then show that. Have a point of view. Her portrait should bear no resemblance to her shade-loving and demure cousin, lily of the valley, whose virtuous, nodding white flowers say something different altogether.

A botanical portrait is a life study, but it is a story of two lives—the plant's and yours. Your photograph of a particular cultivar should say as much about you as it does about the plant. They are self-portraits as well.

A few years ago, I self-assigned a shoot in Charleston, South Carolina, in an old city cemetery that was as much garden as it was graveyard. Gothic vines had climbed their way over tombstones, ragged drapes of wisteria clung to wrought iron fencing, and night-blooming magnolia and moonflower loomed over the upper reaches of walls and crypts. There was something botanically haunted and nocturnal about the place. I decided to shoot at night in black-and-white, using bright flash, in order to catch this nightlife in the act, like a paparazzo. The resulting images were precisely what I was after: They captured the stars of this garden seducing the night with their perfumed, moth-pollinated blooms. To this day, it's the only garden I've ever shot at night, with flash. But for this place, and for my sensibility, it seemed to work.

I always want the photographic experience to differ from the day-to-day, to allow it to expand and illuminate. The best photographs are contemplative of time and place, sensitive to stillness, conscious of loss, and intuitive about the human condition. They engage our wonder

and they propose meaning in our lives. Though not always a successful effort, the photographer's job, at its most elevated, is to communicate something essential and beautiful about life in all of its permutations.

The objective is beauty with meaning and metaphor. For the naturalist/romantic, to riff on Gertrude Stein, *a rose* is not *a rose*, is not *a rose*, is not *a rose*. A rose, rather, is the beginning, a form that can be an infusion of metaphors and ideas that are bigger than itself.

You may think that this is a lot to ask of a botanical portrait of a rose, and most of the time the bigger question never comes up; it's just a beautiful rose portrait and that's that. But the desire for something more should always be a part of your photographic ambition. It's what separates good from great. Remember that the garden is a human idea; it is our effort to beautify and order the world. But we're very aware of its fragility—that it needs our constant care, that it is impermanent, and that it is a living thing. Its care and cultivation give our lives meaning and joy. Photography in the garden should serve all of those ideas and more.

The story of this Canadian garden is its towering hollyhocks and mounds of colorful phlox, framed by a pleached lime alleé and punctuated by quirky sculptural pieces.

Black-and-White

While most digital cameras have black-and-white or sepia settings, I prefer to shoot in Adobe RGB color and convert to black and white later in postproduction. The advantage here is that you will have all of the color information in the image if you change your mind and prefer the color original. You can easily make black and white from color, but not the other way around. So shoot in color, and make a black-and-white duplicate later.

A monochromatic image has its own singular power: It immediately alters reality, appealing to our visual brain's need for inquisitive play. We don't see the world without color, so its absence in a photograph intrigues us and compels us to pay attention to form and light, to tonal range, and to shadows and highlights. A photograph without color is more graphic, removing the chromatic distraction and changing the world we know.

Black-and-white also alludes to photographic history, to 100-plus years of imagemaking before the onset of color. By converting images to black and white, they may not only gain in their graphic appeal, but they can also take on a kind of historical legitimacy. Whether consciously or not, historical archetypes affect our understanding of, and attraction to, contemporary work. Iconic images from the past have entered our collective visual DNA; we know them in our blood. We've seen them in museums and galleries, in art history classes, and in fine art books. They have an elegant austerity and truthfulness that can be lacking in the full-color visual noise of contemporary life.

The broad view of the garden in black and white, however, has limited appeal to me. With black and white, the strokes of evocative color along perennial borders or the warm pink wash of early sunlight are lost. Gone, too, are the graphic repetitions of green-on-green, or the hot translucence of a purple beech. All of these color elements that can define and animate the larger view of the garden will disappear. You will have form and hardscaping, but no warmth or radiance and no invocation of a garden's magic.

Black-and-white serves the garden photographer best as a technique for the botanical portrait, particularly of a plant whose power lies in its form and design, not its color. The term *black-and-white* is something of a misnomer, as monochromatic images are mostly tonal variations of gray. Sepia (a warm, brown-toned image) and cyanotype (a blue-toned variation) are both single-color processes that can add dimension to basic black-and-white. They also carry historical allusions to early botanical photography, which was often toned to add archival stability to prints. The word *sepia* actually comes from *Sepia officinalis,* a cuttlefish found in the English Channel that was used to produce the warm pigment!

When considering subject matter for the black-and-white botanical portrait, try to choose plants whose strengths lie in the graphic complexity of their form and habit, not in their color or color gradations. Fiddlehead ferns, magnolia and lotus pods, teasel and sea holly stalks, and white *Phalaenopsis* orchids—these are all worthy subjects for exploration. Their graphic beauty and structural complexity will be heightened in black-and-white.

The portraits you make will need to embody one critical element above all: a passion for the beauty and complexity of botanical form.

The image of these sunflowers was converted to sepia and altered in Photoshop to create a hot, solarized print, which adds a sense of summer swelter.

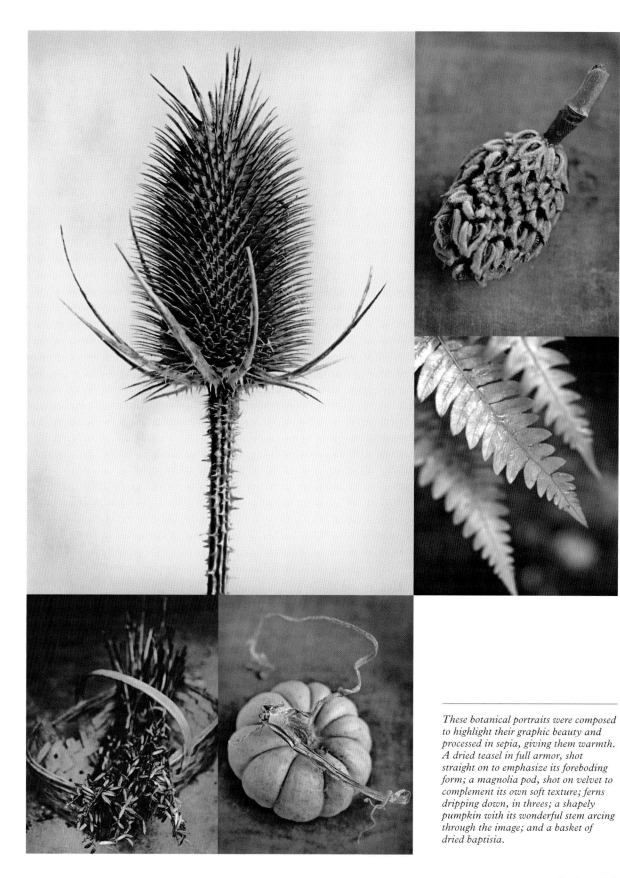

These botanical portraits were composed to highlight their graphic beauty and processed in sepia, giving them warmth. A dried teasel in full armor, shot straight on to emphasize its foreboding form; a magnolia pod, shot on velvet to complement its own soft texture; ferns dripping down, in threes; a shapely pumpkin with its wonderful stem arcing through the image; and a basket of dried baptisia.

Depending on the image, the conversion to grayscale (black and white) eliminates the distraction of color and shifts the focus to the graphic form of the subjects. Processing your photographs in digital postproduction opens unlimited toning options. Both sepia and cyanotype toning allude to early processes and create historical depth.

Your passion will lead you to explore, while your wonder will lead you to discover. "Without passion, men are mere milk, incapable of deeds," said Nietzsche, and passionate intensity is a prerequisite for artistic exploration.

You'll find that the black-and-white still life will help you to see plants from a wholly different perspective, and you may find yourself thinking in black-and-white while shooting, making images with reference to form alone. If necessary, you can sample a photograph in monochrome in the field to see if it has all the information you need to complete your image later in postproduction. Just make sure to take a few shots in color as a backup should you change your mind.

Black-and-white images also seem to benefit greatly from diffused, overcast light. The subtleties of midtone variation (all the shades between deep black and bright white) are brought out when highlight distraction is reduced. Because your eye is also drawn to, and to some degree distracted by, the brightest point in an image, more neutral light means less distraction in the highlights and

more attention to variations of tone.

It's a common practice to shoot botanical still lifes against a white background, creating a bright surface against which the plant form can pop off the page. This can be quite effective in adding graphic dimension to your image. The subject's form and habit will be emphasized, and the eye will be compelled to thoroughly explore the subject without distraction.

This technique was employed by some of the most brilliant early botanical artists. One of the best, Basilius Besler, illustrated the early 17th-century botanical masterpiece *Hortus Eystettensis,* whose life-size plates are stunning to this day. He artfully arranged his more than 1,000 species on white backgrounds, printed in both black-and-white and hand-colored, setting the standard for plant portraiture. That standard is in our aesthetic DNA, consciously or not, and referencing it in your work will add a certain level of artistic credibility.

What made *Hortus Eystettensis* one of the most remarkable botanical works ever was not only the color and detail of the rendered plants, but the compositional care taken in their arrangement on the page. There was as much design going

into placement within the frame as there was to the illustrated specimens themselves. This is your goal as a photographer as well, to explore not only the subject, but the balance and composition of form within the rectangular frame. In Besler's artful placement of tulips with their root-tangled bulbs, his ornamental pepper stalks, and his full-page explorations of the structure of artichoke and sunflower, patterned graphicness is at the fore. He knew how to arrange objects in space. He was not only a genius illustrator, but a genius designer as well.

While a white background serves to define the subject quite well, it can seem a bit clichéd and overdone. Instead, you can use neutral background (anything between deep black and bright white) and allow the eye to profit from a more nuanced consideration of tone and form. Nineteenth-century naturalist photographer Peter Henry Emerson put it like this: "It cannot be too strongly insisted upon that strength in a photograph is not to be judged by its so-called pluck or sparkle, but by its subtlety of tone, its truthful relative values in shadow and mid-day shadow."

Remember, any color range between white and black will register as gray tone, so when you're out in the field and want to neutralize the background for a botanical portrait, your effort can be as simple as having someone hold a sweater or jacket behind the plant subject, no matter what the color. The goal is to isolate the plant from its surroundings, and to draw the undistracted eye in.

One of the marvels of horticulture is the complex form and pattern that plants inherently contain. This is why we, and the rest of creation, are

Making the Black-and-White Botanical Image

TECHNIQUE: You can either set your camera to record in black-and-white or sepia, or keep it at its normal color settings and convert your images later in postproduction. I would recommend the latter, so that you will have a color version of the image. It will be simple to convert color to monochrome, but impossible to add color after the fact. Keep the light on your subject relatively flat, avoiding deep shadows and highlights. The beauty in black-and-white is the tonal values in its grays, so overexpose your image a bit to bring out shadow detail. If you need to soften the light, use a collapsible scrim over your subject, wait for cloud cover, or shoot in the shade. Avoid high-contrast midday sun.

ASSIGNMENT: Find specimens that are more about plant architecture than color, that have a bold shape or dynamic form, and shoot these in both black-and-white and color. Look for images where the subject is texture or evocative shape, and where light is secondary. Once you've found an appropriate subject, shoot it at a wide range of apertures to vary depth of field. Then try to isolate your subject in the field by setting up a backdrop—something that will read as neutral gray in monochrome.

Shoot the details of ornaments and nonflowering elements in the garden: the carved design on an urn or plinth, the curls and tangles of grapevine or a thorn-armored climbing rose, and the geometry of an armillary or sundial. Bring cut flowers indoors for a black-and-white still life arrangement. Reference all the classic floral still lifes you've seen in museums and art history books and explore your own ideas. Create at least one still life every time you shoot in a garden.

These creatures were found in the garden and brought into the studio to be photographed in stark, graphic silhouette. Their secret lives are lived in and around the garden, and photographing them formally in sepia reveals their graphic form. They were placed on mixed media and shot against a lightbox to blow out the background.

so drawn to them. They are miracles of expressive design, at once highly functional and beautiful. Their beauty can be delicate or bold, towering or tiny, and intricate or simple. The black-and-white portrait explores these ideas free from the distraction of color, revealing new aesthetic discoveries and meaning.

Sometimes botanical portraits don't only involve plants. Early naturalists and botanists would often include insects and small creatures in their renderings, creating a more comprehensive view of plants and their connections with other living things. Consider shooting beyond plants alone, exploring their broader relationships with insects, birds, and other creatures.

Selective Focus

One of the critical distinctions of the camera—and its strength as a compelling, alternative view of the world—is its ability to selectively focus. The human eye has no such ability. Whatever we look at, our eyes (whether prescriptively corrected or not) will focus on. While what's in our peripheral vision may be physiologically out of focus in the eye, our brain's visual cortex only allows us to perceive or "see" objects in focus. So the camera, with its capability to render both what's in and out of focus in the same view, engages the brain in a kind of visual play and a game of focal intrigue.

What is it about selective focus that makes it so appealing? It's the power of intimation, of what's suggested. We don't want it all spelled out. We want to imagine and fill in the visual blanks. It's so much sexier than the outright telling of things. Your goal as a photographer should be to engage viewers with images that invite their imaginations to roam free from the constraints of the literal.

There was a movement of naturalistic photography in the late 19th century, championed by photographer Peter Henry Emerson, that was based on the Naturalistic School of painting that predated and anticipated Impressionism, where sharply rendered, literal scenes were superseded by more subjective content.

Emerson believed in naturalistic focusing, what we now call selective focus, because he thought it to be more physiologically true to how the eye sees; namely, only one field of view is sharp at one time.

What Emerson didn't anticipate was the backlash from the photorealists (who thought of the camera as a tool for creating a literal facsimile of life), and even the pictorialists (who played with overall soft focus for aesthetic effect). Both camps thought selective focus was neither optically accurate (they were right), nor aesthetically compelling (they

Selective focus suggests rather than tells, and leads the eye seductively into the image: A planting of Monarda didyma, *left largely out of focus except for a few blooms, is suggestive without being too literal; and just-pulled onions in a row.*

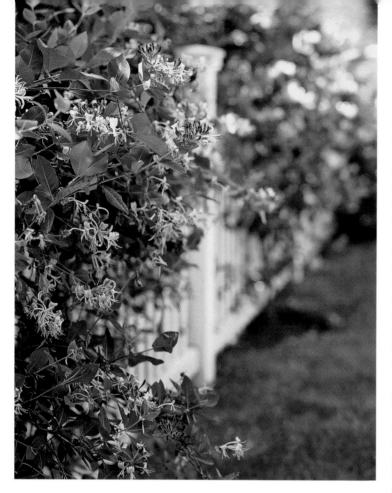

A fencerow leading through this image is softened by abundant, colorful honeysuckle, selectively focused in the foreground.

reality every day and get numb.

By choosing your point of focus, and allowing the rest of your image to soften into a gauze of blurred form and hue, you are directing the eye of the viewer. Your selective focus creates visual hierarchies in the image field and, I am convinced, has a seductive psychological effect on us. By selecting only one, sometimes very thin, focal plane in an image, we play with the brain's perceptual disposition. That narrowly focused view mimics what happens when we look intensely at something, or care about it deeply; nothing else seems to matter. This view implies intimacy and warmth, and we are entranced.

Emphasizing the camera's "otherness" is captivating and uncommon. We are intrigued by its ability to do what the eye alone can't, and seeing *like* a camera is always a seductive place to start. A specimen plant isolated from a mass of others becomes an intimate spokesperson for the species. The texture of bark separated out from its background focuses our attention on its remarkable ridged patterns. And the silver gray of *Stachys byzantina* tightly focused against soft blotches of perennial color is more compelling as an image if the background is a color wash instead of a distractingly detailed composition.

were wrong). Even Emerson soon abandoned his ideas. But the contemporary ubiquity of the photographic image, which wasn't the case in the 19th century, has made the altering of reality—whether through camera functions such as selective focus or through image manipulation in postproduction—a viable aesthetic approach. We see too much

Using Selective Focus

TECHNIQUE: If you're using a fixed lens, set it to its widest aperture. On a compact digital, set the dial to "A" for aperture priority. At these settings, the camera will vary only the shutter speed and ISO, depending on the amount of available light, in order to render the right exposure for your aperture. Setting the compact's zoom to telephoto or using a longer fixed lens will also limit depth of field.

ASSIGNMENT: Shoot the same scene or setup and vary the aperture on your lens. Using a tripod will ensure that you maintain constant framing for each image. Also shoot macro and telephoto images, varying the aperture in each frame. Notice the falloff in field as the lens is opened up. With a DSLR, practice shooting both in manual focus mode as well as in autofocus. Make note of which setting gives you the most consistently sharp results.

Selective focus, while keeping only what you want sharp, takes the literal eye-to-brain relationship and makes it more subjective. Objects in the visual world articulate themselves as much by what they are as by their relationship with their environment. And the softness of the unfocused environmental foreground or background has its own compelling beauty, particularly when set against something sharply focused. That quality of softness is called *bokeh,* and higher-end lenses with fast apertures are often rated for the quality of their bokeh.

I have a number of prime (non-zoom) lenses that open to very fast apertures (f/1.4–f/1.8). These are remarkable not only for their ability to isolate extremely thin focal planes, but also for the quality of their *bokeh.* And with current shutter speeds reaching the 0.005 to 0.006 of a second range, bright daylight shooting at midrange with highly selective focus is now possible. When I shot gardens with a 4 x 5 (inch) field camera with bellows, I could tilt and swing the front lens board to shift focal selection, which—besides the beauty of the camera's large, seamless film plane—meant I could correct architectural distortions and play endlessly with focus. Now those bulky cameras are less critical. And the fast lenses allow me to shoot handheld most of the time, even in the earliest or latest light of the day, freeing me up even more to enter a fluid imaginative state. No heavy camera, no tripod, no loading film, and no reading meters—just creative flow.

The basic technique of selective focus is to shoot with your lens set to its widest aperture, and the faster the lens, the wider the aperture you'll be able to choose. For compact digitals, you'll need to set your camera to aperture priority ("A" on the dial) and open up to the widest possible setting. The set aperture of your compact, with the fastest (or widest) being the most desirable, will determine not only how much latitude you have when shooting in low light, but the selectivity of your focal plane. The reasonably fast (f/2.0) compact that I carry with me is always set to aperture priority.

A DSLR with interchangeable lenses frees you up to choose from a wide selection of lenses, with varying focal lengths and apertures. Zoom lenses, while incredibly versatile and practical (I have two), are usually not as fast as prime lenses, due to the complexity of their optical elements. A few very fast fixed focal length lenses (I have 24, 55, and 85mm primes, all with apertures of 1.4), though adding to the bulk of your camera bag, have such incredible focal discretion and are capable of capturing the most delicate,

These ripening blackberries in soft, early light are far more evocative when shot with a shallow depth of field, with focus set on the ripest of the bunch.

magical light that I'm never on assignment without at least one of them in my rig.

Expense is usually the reason cited for not owning a fast prime lens, as they can cost almost two to three times as much as slower models. But for what you gain in photographic latitude and creative possibility, the cost seems negligible. Remember that it's the quality and versatility of your lenses that makes the most difference.

Besides a fast lens set at its widest aperture, longer lenses—medium to super telephotos—will drop depth of field more significantly than wider lenses, as will zoom lenses set to the deepest telephoto setting. If you're working in the garden with a zoom, by getting as far back as possible from your subject and zooming all the way in to frame it, you'll notice a considerable drop in field compared to wider or medium lenses. That zoom at its widest aperture will also go a long way toward isolating and flattening your subject. This is why portrait lenses are often medium telephotos (105mm to 200mm)—all the better to isolate and enhance with *bokeh*.

On the other optical end is the macro lens, capable of extreme close-up work. Like the telephoto, the macro lens renders a pretty shallow depth of field when it's in close—again a function of its optical design. For that reason, macro images often have an aesthetically compelling drop in field, allowing you to isolate the pollen-dusted thighs of a honeybee or the capillaries of a petal without the distraction of rendering the whole subject in focus.

There have been movements in photography that have championed deep, highly detailed focus as their mantra (Group f/64 was a 20th-century San Francisco school of photography dedicated to shooting at the smallest possible apertures in order to capture razor-sharp detail and depth), and much of their work is of remarkable quality. Practitioners like Ansel Adams, Imogen Cunningham, and Edward Weston were interested in what they called straight photography, a reaction against the pictorialist, or aesthetically infused, photography that had preceded it. Though the grandeur of Adams's images of the American West is undeniable, and the graphic beauty of a Weston pepper or nautilus is beyond doubt, I'm partial to the "non-straight" school, where subjective perception is championed over the literal artifact. I suppose I'm a loyal member of Group f/1.4.

Selective focus was used extensively on this shoot at an organic farm in order to evoke the warmth and beauty of the crops and their connection to small, sustainable farming. The imagination is more fully engaged without the snapshot realism of complete depth of field. The focal point alternates between the front and middle of the frame, depending on the subject, but rarely falls at the back.

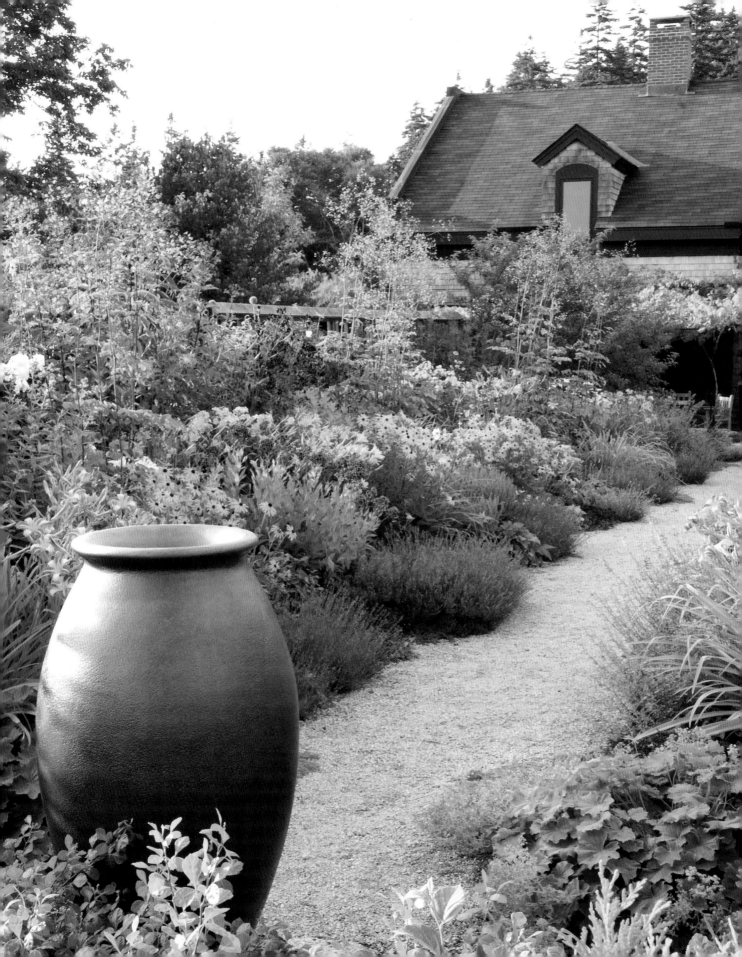

Garden Ornament

Many gardens have, in addition to their axes of paths and varied mix of annuals, perennials, shrubs, and trees, ornament of some kind to punctuate a particular spot in the overall design. Garden ornament, whether in the form of statuary, fountainhead, or pottery, can be very useful to visually anchor an image and give the eye a place to start or end its course as it looks at a photograph.

A long view through a garden, or a path making a diagonal swath through the frame is served well by an ornamental form in the immediate foreground, or as a destination. It tells you where to intuitively begin and end, and often marks a transitional point in the landscape.

Ornament, if it suits your visual idea and its form appeals to you, is also an excellent cue to the viewer that this is a cultivated place. The type of ornament will indicate the overall tone of the garden as well, whether it's a period garden, cottage garden, woodland garden, or modernist garden.

Use ornament as a midrange shot, filling the frame with it if you think it deserves that much attention. Or come in close on an intriguing detail of a statue, on the ironwork of a gate, or on the reflection of water in a birdbath. Use ornament in the large overall view as an anchor and an indication of scale.

At a 6:00 a.m. photography workshop in Bedford, New York, the formal garden at first looked like many small period gardens I've photographed. Its formal parterre and requisite shrubs and perennials were lovely but nonspecific. It was only when I clambered up to higher ground that the garden and its peculiar soul emerged. There, on a low foothill, sat an enormous bronze boar, slouching toward the house. Behind it were rare specimen trees and a few benches for observing the garden below. It was from this vantage that early sunlight began to spill through the trees, backlighting the parterre and throwing the boar into stark, brooding silhouette.

This was an opportunity to shoot

Use garden ornaments to anchor an image and to indicate that it is a cultivated place: This Maine garden, with its lush borders divided by a long axial path, is anchored on one end by an ornamental Lunaform urn; blue spheres lie in a wooded glade; blown-glass toadstools punctuate a carpet of ferns; and a birdhouse made from a watering can hangs off a tree trunk.

Garden ornaments can be subjects in themselves: Antique garden tools, arranged here in a potting shed, have timeless beauty; a weathered millstone against a tree appears like a found object.

something dramatic and specific, with the ornamental beast in the foreground, his bowed haunches mimicking the garden's curvilinear shape. I shot toward the rising light, using both wide angles—taking in not only the boar and lower garden, but the house as well—and tighter shots, framing in only parts of the garden and the bronze. The mythological boar, with backlighting creating a glow around his form, almost came alive, as though Artemis herself were present. Because I knew this opportunity would be short and that the soft light would soon turn to hard contrast and overwhelm the garden, I shot with abandon, filling at least 500 megabytes of storage in no time. Carpe diem.

Think of garden ornamentation as punctuation, a way for the garden to exclaim itself. Whether it alludes to classical mythology, to local design history, or to something quirky and personal, find a way to include it in your images. Ornamentation is an indication of a garden's idea of itself, and it will give your images a stronger sense of place.

Sometimes there is more orna-ment than garden. If that's the case, then that's the story: plants crowded out by possessions. I shot a well-known designer's farm garden recently for a shelter magazine, and you almost couldn't see the flower borders for the busts and clutter of ornament. He was a collector first and a gardener second. There's no rule, of course, that says that plants have to be the stars of the garden. If gardening is the cultivation and ordering of place, then one can cultivate objects in the landscape to the same ends.

I've shot gardens that were so plant populated that you lost any sense of order or design, and instead found yourself in a riot of color and form all screaming for attention. This may work for the most impressionistic images, ones that are mostly about light and color, but not as well for a camera that hungers for pattern. The best gardens have struck a harmonic balance between the botanical and the man-made, between organizing nature and imposing ornament. I once shot the garden of a literature professor that was strewn with classical allusions,

Ornaments that lie hidden among plantings can softly illuminate a garden's character. Here, a Buddha looks out wisely from a planting of hydrangea and cedar, while a gargoyle-like monkey holds up a spray of roses.

references to Blake and Shelley and Coleridge, and to mythology, but it was so artfully balanced with beautiful horticulture that all the high-minded references didn't dominate. Your images, too, need to strike a balance between the garden itself and its decorative punctuation.

At its best, ornament in the garden is a harmonic note, accenting the tone and feel of the design without dominating. Most often, garden-ers err on the side of abundance, with ornament everywhere like too many points of exclamation, or they scatter the borders and paths with a succession of homespun plaques bearing garden verse; nice for the first few, but cloying after a dozen. A successful garden doesn't need its beauty to be subtitled. If the design is strong and the plantings are thought through, the ornament is a seamless part of the whole.

How to Use Garden Ornaments in Your Photographs

TECHNIQUE: For most of these shots, you will want enough depth of field to render both the foreground ornament and the background of beds and borders sharply, so a stopped-down depth of field will serve you best. At a wide setting, anything after f/11 will work; for the medium shot, you will need to be at f/16 or higher. You may also decide that a tripod is needed. If you want either the foreground or background to soften, open up the lens a few stops. To ensure that the foreground ornament stays in focus with a compact digital, point your lens to it first and depress the shutter halfway, then reframe your view to include the garden beyond. This will lock focus on the foreground object after you reframe.

ASSIGNMENT: Find an ornament in the garden and practice shooting it at different apertures to change your depth of field. Also, try to lock in focus on either the foreground or background. If you're shooting with a DSLR, simply shift to manual focus. If you're working with a compact digital, use the focal lock technique. Try setting your zoom lens to both wide and medium apertures as you frame the ornament in the foreground of your shot.

The Sensual Garden

Though all of the senses are engaged in the garden, it is the visual that prevails over all others. In order for your images to awaken other senses, they need to evoke touch and smell and sound and taste without the benefit of literal experience. They need to rely instead on the viewer's sensory memory. And photographs that conjure more than the visual will always hold sway over those that don't.

As Jim Nollman wrote in *Why We Garden:* "We are visual creatures. Our visual sense is our most insistent sense; it rules our perception of the world and dominates our consciousness. . . . For instance, scent in the garden comes into consciousness only fleetingly. To experience it at all, we usually need to locate our nose very close to a bloom, and when we do, we often feel a need to close our eyes in an attempt to reduce the dominance of the visual sense."

Photography, literally defined, is visual. It is a flat, two-dimensional medium meant only to be looked at, not listened to or smelled or tasted.

But it is our perception of photographic content that engages the other senses. Because we experience the world perceptually, and our perception is informed by previous experience, a photograph informs by alluding to the sense memory of the viewer.

A person who has never been in a garden or hasn't experienced the perfume of flowers or the softness of an unfolding fern would have no conceptual sensory knowledge base to draw on, and a garden photograph—though perhaps intuitively pretty—would fail to evoke much more than the visual. But because most of us have an empirical, sensory understanding of the natural world, the flat photograph is able to conjure so much more than sight.

With that in mind as you shoot, look to create images that evoke multisensory experience. Shooting in the rich, warmly lit hours of early morning and late afternoon, for example, not only amplifies and saturates the garden's visual beauty,

but it also allows you to—almost—feel the soft warmth of the sun on your skin when you look at the image. If the camera picks up the sparkle on dew-moistened petals or on tall grasses lining a path, your audience should sense that dampness brushing against them.

Coming in close to the folds of a damask rose with your camera, particularly one still glistening with dew, will evoke both the perfume and the sensory viewpoint you experience when taking in a rose's scent; when inhaling a rose's essence, you're always nose-deep in petals, after all. Top-heavy peonies, photographed from a low angle, can seem almost burdened by the sweet weight of their own fragrance. The same visual cues will hold true for a backlit photo of an arbor dripping with honeysuckle, taken from underneath, or an early evening shot of night-blooming jasmine draped over an entry. The photographic goal is always to create a powerful evocation.

Touch is everywhere in the garden,

and your skin is the largest of your sensory organs. The leafy fuzz of lamb's ears or a peach, or the armored intensity of a prickly pear can be a point of focus. A hand brushing across a planting of lavender or rosemary will evoke both touch and smell, and hands holding anything will allude to touch memory. Even bare feet in a photograph can play an evocative role (who can forget the soft stroke of grass between the toes!).

Sound in the garden comes from many subtle places: the persistence of insects as they flit about the borders, wind moving through the tree canopy, water splashing in a fountain, and birds whistling in the branches. These are all part of the sensual garden experience. Shooting an improbably tall allée of running bamboo on assignment at Jack Lenor Larsen's garden in East Hampton, New York, I found I was having trouble capturing the sensation of being inside all of those clattering, sun-glinted stalks. By manually slowing my shutter speed and shooting up into the top of

Invoking as much sensory experience as you can will make for stronger images: a full bucket of summer berries about to become jam; sandy feet splashing under a tap at a seaside garden; crisp loose-leaf lettuce graphically framed and backlit; a ripe heirloom tomato saturated in red and selectively focused; and frozen fruit shot in cool north light.

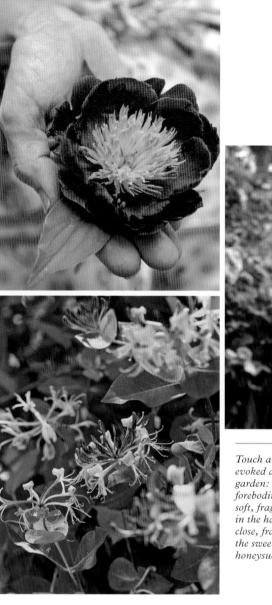

Touch and scent can be evoked as easily as sight in the garden: a Ceiba *tree, foreboding to the touch; the soft, fragrant folds of a peony in the hand; rugosa roses in close, fragrant profusion; and the sweet abundance of honeysuckle.*

Shooting for the Senses

TECHNIQUE: Shooting the sensual garden will engage all of the tools at your disposal. Try working with different lenses and focal lengths to change the mood of the image. Also vary your aperture to shift focus from shallow to deep. In order to convey movement, you will need to set your camera to shutter priority and shoot at $\frac{1}{2}$ to $\frac{1}{8}$ of a second. For the tightest images, such as a dew-splattered leaf, you will need to use your macro lens or a macro setting on your compact digital.

ASSIGNMENT: Find a garden that arouses more than just the visual sense for you and try to capture its essence. Challenge yourself to see with your hands and nose and tongue and capture those sensations with your camera. This is harder than it sounds, but worth the effort. Your photographs will have far more substance and meaning.

the planting, I was not only able to convey a sense of movement, but the sound that movement would make. Similarly, the sound of moving water in a rill or fountain can also be evoked by setting the camera to a slow shutter speed and allowing the water to blur. You may find a tripod useful for these shots, or just a steady hand.

Even taste can be suggested in the edible garden: the warm translucence of currants backlit by the sun, the succulence of a ripe pear or fig, the delicate sweetness of alpine strawberries. As more gardens are mixing edibles into their planting schemes, the opportunity to allude to taste with your images is growing, and the sustainable garden, one that puts out as much as it takes in, and one that not only nourishes the eye but also the palate, is becoming the paradigm. In order to convey taste, think about the plant's habit. Lettuces like a cool, shady spot, so that's where you should shoot them, perhaps spritzed with water. Tomatoes, on the other hand, should be shot in warm, hot light; pole beans are best shot from below, alluding to their climbing habit.

Of course, photography's primary sense is sight, and that holds true for the garden as well. Gardens are, first and foremost, *looked at*. So your objective is always to create something visually compelling. But plants are creatures of habit, and you can speak to their habits by using subtle visual cues in your images. Pale or pastel blooms should be photographed in cooler, delicate light, showing off their inherent tonal values, while deep, loud dahlias or summer wildflowers can take the heat, so they can sustain a more hotly lit composition. Plants with darker petals will absorb bright light, while those with paler colors will simply reflect it and send out a glare of high contrast if shot under the wrong conditions. Coleus, for example, with its darkly saturated, velvet leaves, actually looks better in bright light—all the more reason to plant it for the midday garden, and perhaps to shoot it at lunchtime.

Always look for ways to imply much while telling less. The senses want to be tempted and engaged when viewing photography. The more your photographs create context and meaning beyond the literal image, the more they please our perceptual subconscious. Remember that garden photography is a sensorial act, meant to arouse our longing for beauty and pleasure.

When the hands are involved in an image, touch is present, and in this case so is taste. These organic vegetable crops have rich, sensuous beauty, and shooting them in sepia gives them an archival presence.

The Garden of Compromise

Many of the world's most esteemed gardens are open to the public, which provides for great photographic opportunities. These open-gate policies do come with some caveats, however. The first is people, *everywhere*. The second is light. By the time the garden opens to the public, the good light has passed and the sun is blazing down with unsightly glare and contrast. An overcast day at Sissinghurst or Hidcote, which seems the norm for English gardens, will give you workable light, but the National Trust busloads may be there as well.

There are several ways around these obstacles. The first, and most effective, is to arrange for private access to the garden through the conservancy or trust in charge, with the understanding that you are working on a book, magazine piece, or PR campaign. Better yet, actually *be* working on a book, magazine piece, or PR campaign and there's no need for embellishment. Great gardens, in order to maintain themselves, need to remain in the public eye, and you are a means toward that end. There is always someone in charge to convince that your intentions are worth considering.

Getting access very early or late, when the sun is right and the garden is closed and unpopulated, is your goal. Barring that, you can shoot during business hours by paying close attention to the sun's path and planning your shots accordingly. You can also diminish the distraction of people milling in and out of your composition by stopping your lens down to its smallest aperture, putting the camera on a tripod, and shooting long, slow exposures. The crowds will blur into a muted wash. Alternately, shoot at a very shallow depth of field with a fast lens, say 1.8, so that the crowds simply fall from focus. You will have to be resourceful in order to get the shots you want and be flexible with your shooting plan. Once I set my mind on an image, however, I'm not easily thwarted. I just assume there is always a way. Being patient, resourceful, and persistent will ultimately pay off.

Access to beautiful private gardens, often made possible through garden clubs or Garden Conservancy

Getting around Obstacles

TECHNIQUE: Tight cropping and postproduction editing will help to salvage your images from compromise. Private gardens aren't usually open to the public except for occasional annual garden tours, so finding a way to see them on your own time and terms will make an enormous difference. Public gardens will be suffused with others, so try to work around them and plan your shots accordingly.

ASSIGNMENT: Pick a very public place and shoot it both with and without foot traffic. Find an attractive person, couple, or child and have them interact with their environment. Make a personal statement about our relationship to gardens. What makes them meaningful? How do they affect people?

tours, is another way to shoot and refine your garden photography. I often go on garden tours and only scout the location with a small compact digital, usually in bad light with others underfoot, planning to make an appointment to return on my own to shoot under ideal conditions. You don't need credentials of some kind to do this, just a professional manner and permission from the homeowner. Sometimes the offering of a nice print or even an e-mailed JPEG from your shoot is appreciated. Most gardeners are more than happy, and often flattered, to share.

If you do schedule a day to return, make sure that the garden's proprietors know the ungodly hour in the morning you plan to show up, and that the sprinkler and alarm system will be off, and all pets restrained. I've been on more than a few garden assignments where I found myself dodging irrigation pulses at 5:00 a.m. to the howls of sirens and hounds. If you do enter undisturbed, remember to return the courtesy to the homeowners. Your morning may still be their night.

Besides issues of access and foot traffic, some beautiful gardens are compromised by their location (the best overall view slams right into the flanks of an unsightly apartment building, or a telephone pole or wires are in the middle of your shot), by lack of light (the sun rises late because of high surrounding buildings or trees), or by the garden's condition on the day you arrive (it may be transplanting day, or piles of mulch are waiting to be spread, or the *Laburnum* arbor that you scouted dropped all of its blossoms overnight). Regardless of the compromises, and there will always be some, find a way to work around them and get the shots you want. Remain flexible. An *idée fixe* is a ticket to frustration.

Telephone poles and wires can be edited out in Photoshop (see page 153), unsightly buildings can be blocked with branches or other garden structures, and lightless gardens can be celebrated for the loveliness of their bones and succeed even without the epiphany of early light. The only compromise that can't be overcome is a lack of resourcefulness.

I shot a glorious peony garden once that happened to be in a neighborhood burdened by a post-industrial tangle of overhead wires, telephone poles, and unsightly fences, which compromised most of my larger, overall views of the garden. I did as much as I could to crop the mess out of the frame, but I knew there would be plenty of postproduction tweaking to come. Many compromises can be overcome by altering your point of view, though some will have to be resolved later in front of your computer screen. Think of the camera as a tool for creating the information you will edit and develop later on your desktop.

This small suburban garden view was ruined by telephone wires and poles (left). The image was carefully cleaned up later in Photoshop (right).

Photographing the Vegetable Garden

Some of the most beautiful images to be made in the garden are of vegetables—the translucent leaves of backlit lettuce, the glinting and jewel-like dangle of cherry tomatoes, and the graphic succession of a row of kale or rainbow chard. They are not only great subjects for the camera, but also an evocative suggestion for the rest of the senses. The flower garden doesn't excite the tongue, after all.

The industrialization of food has distanced many of us from seeing fruits and vegetables as living things attached to the earth with wonderful stems and trunks and vines, with habits and a culture all their own. As agriculture and food access are becoming more local, though, and as more of us begin to incorporate vegetables and fruit into our own garden plans, they are becoming available and expressive subjects for the camera.

As someone who photographs food as much as flowers, I am always looking at fruit and vegetables in the garden with the same visual discretion: How is the light playing with their color and form; how can I compose an image that is graphic and compelling; and how can I convey meaning?

Let's take the indeterminate sprawl of tomatoes or climbing squash as camera subjects, for example. Both are about lush foliage and vines that carry their abundant fruit skyward in loose, far-reaching tangles. I might lie on my back and shoot up into the vines, backlighting and dropping focus toward the top of the image. I would find a particularly fine cluster of tomato fruit or a perfect squash with its attendant blossoms and make them the stars, allowing the rest to fade from focus. And if those stars need to be born, I'd take my pruners and cut back intrusive foliage to bring them front and center, or cut and wire a few great ones into the frame. I might also shoot an imperfect tomato, one that has perhaps cracked under the sweet pressure of its own swell—that says something about the reality of a tomato on the vine, as opposed to its store-bought cousin.

I've photographed a few organic farms and orchards where the neat marshaling of crops created its own graphic order that the camera loves. One such immaculate setting, Four Season Farm in Harborside, Maine, is a place of color and form-perfect beauty. It seems to have been designed for the camera, with its mist-veiled belts of cutting flowers

Capturing the vegetable garden means capturing the visual "flavors": a maroon head of Italian radicchio shot to show off its folds; grapes sparkle and dangle in a greenhouse; a view through a pole bean trellis; and artfully arranged squash and blossoms.

and colored bands of lettuces and cole crops. Clearly, with a little effort, growing food isn't just about scrappy hoop houses and hog swill. If there ever was an aesthetic argument for tearing up the lawn and planting a micro farm, this place is it.

Approach the shooting of the vegetables and fruit with the same principles in mind that you would use for the garden: Light is where it begins, followed by form. The only caveat with fruit and vegetables is that it is ultimately meant to be tasted, and the intent of your images should somehow convey that sense. So fruit can be cut open and placed on a worn cutting board, or in a beautiful bowl and shot as a still life; it can be held in fruit-stained hands as though just harvested, or carried in an old basket or trug. Be sure your propping is as tasteful as your harvest, however; consider the shape, color, and feel of your props as carefully as your composition.

Rows of vegetables are best shot moving diagonally through the frame, with light filtering through translucent leaves. Leaf vegetables are gorgeous when backlit, particularly colorful lettuces and chards. Peppers, eggplant, climbing squash, carrots, and knobbly heirloom tomatoes have inherently beautiful, sensual forms. The visual story to be told is as much about how the edible garden feels and tastes as it is about its fundamental beauty.

A visit to an organic farm offers great opportunities to shoot not just plants, but animals, too. I photographed these bantam chickens in a makeshift studio on the side of a barn, using a wooden table and fabric hung from a door and secured with "A" clamps.

Making the Edible Image

TECHNIQUE: Because the vegetable garden has ulterior motives besides aesthetics, you may need to snip and prop and style your subjects more than you would in the flower garden. Carry a pair of pruners and floral wire to cut and tie your subjects into the shot if necessary. Think about the fruit or vegetable's form and growth habit and shoot to make that point: Grapes dangle, melons sprawl, and peas clamber. They all have a story to tell.

ASSIGNMENT: If you don't have your own vegetable garden, find someone who does and arrange to visit to shoot. Come very early or late in the day, and bring any props you might need, including someone to pick and hold a harvest for you. Visit a farmers' market and ask if you can shoot their produce, or get permission from a local organic farm to come and shoot. The promise of a few images in return will usually open the door (or gate) for you.

The Water Garden

Opposite, clockwise: Water can animate and highlight the garden image: A fern leaf in fall reflects in a rustic pool; a high canopy of trees is captured in a scalloped birdbath; a simple pool in a modern landscape brings a circle of sky into the garden; and a rock, thrown into this pond just before clicking the shutter, adds some energy to this quiet image.

Most dimensional, satisfying gardens incorporate water as a decorative element. Water is an animating force: It captures and reflects light in glinting highlights; it mirrors the sky and the sweeping canopy of trees; it's a refuge for birds and insects; and it gives a garden voice with the gurgle of a fountain or the wet chatter of a creek.

The camera loves to play with water. The colors of a warm, outstretched sky at daybreak can seem infinite when mirrored in a still pool. You can bring the sky and tree line down into the garden view when they're reflected in a birdbath or rill, and mist rising from a pond on a cool morning will add beautiful atmosphere.

If the garden you're shooting has a water element, consider it the way you would the rest of the space. Backlighting, for example, will work the same magic with water as it does with plants, and even more so. If the garden has a formal water feature, place it in the frame so that it is a focal point, drawing the eye in with its brightness and movement. You might even set the camera on a tripod and slow the shutter down so that the moving water blurs and comes to life in the still image. I've thrown pebbles into an otherwise still pond to create graphic, concentric ripples, wetted down garden paths to saturate their colors, and

even moved small water features into better light to enliven a scene.

Water can also animate your photographs in less conventional ways. I once shot a garden where the children, who were an important part of the story, were self-conscious and bored until we brought out the sprinklers. They went from lifeless to buoyant in a matter of minutes.

Without water, there is no garden, no lushness or life. So water is as central to the idea and metaphor of gardens as the plants themselves. Some of the earliest cultivated gardens were all about water. The Persians channeled water from snowmelt through their ancient gardens in quadrants, symbolizing the four rivers of paradise, that fed pools and purled sweetly in fountains, soothing the hot and dry desert atmosphere. These gardens revered water as a life force in their hostile climate. And water has continued as both ornament and metaphor throughout garden history, from the Italian Renaissance gardens that celebrated water as a symbol of fertility and natural abundance to Japanese gardens that only allude to water with their symbolic raking of sand.

By the inclusion of water, your images will come to life. Even if it's just the splash from an Evian bottle on a maidenhair fern, or the splatter over the rim of a fountain, water completes the garden story.

Working with Water

TECHNIQUE: Water will reflect light and trick your meter, so you may need to use exposure compensation in order to get the right reading. If you slow down the shutter in Shutter Priority mode, to at least 1/8 of a second, moving water will take on an evocative motion blur.

ASSIGNMENT: If a water feature is still, such as a pond or pool, try to find an interesting reflection from the garden in its surface. Shoot the reflection with the lens wide open and shut down for more field. Create motion ripples on a still surface with the tossing of a stone. Try to capture the sound and feel of water with your lens by setting up a tripod and shooting at a long exposure to show movement.

People and Pets in the Garden

The garden portrait is either
pulled back, where the
gardener is part of a larger
environment, or tighter, where
the subject's surroundings are
merely suggested, and the
emphasis is on light, posture,
and expression.

Gardens, unlike wilderness, are cultivated places. They are designs in the landscape made *by* people *for* people to enjoy. While the garden photographs that appeal to you most may be solely about horticulture, there will be occasion to photograph people in the landscape, either using the garden simply as a backdrop for an appealing portrait, or showing that person in a direct, working relationship with the space.

The first rule of portraiture in the garden is the same one that applies to plants themselves: Shoot into the light, early or late in the day. While people are not translucent, like petals and leaves, they will benefit from a shimmering backlight because it will add depth and radiance to their form, and set them apart from the plant material. The key difference when shooting the garden portrait is that you will need to "bounce" light back into their faces—and into eyes, in particular—in order to bring the portrait to life. The "catch light" or specular highlight in the eyes is crit-

ical to drawing our attention to the subject's face; it is the animating force in portraiture. Without it, the portrait falls flat. Modigliani deliberately left it out of his portraits, turning them into simple cutouts, while the great portraits of Rubens and Vermeer are all about the glint of the eyes.

With the light behind your subject, you have two options to create a catch light. One is to use the built-in flash on your camera to create a specular glint. You will need to set the flash to fill only, so that it doesn't dominate or alter the portrait's ambient exposure. Cameras have different ways of modulating flash, but a search through the manual or the manufacturer's online technical support links should provide an answer. The downside of flash fill early or late in the day is that the color temperature of flash is roughly 5,200 Kelvin, or bright daylight, while the ambient light of your portrait will be closer to 3,400 or less, which is much warmer. I find this mix of color temperature distracting. Flash also creates a very sharp, flat light, unlike the soft diffusion around the subject. The photograph looks "lit."

A better approach is to reflect, or bounce, the light coming at you back into the subject's eyes with a reflector. It will have a color temperature that's balanced with the ambient light, the subject's face and form will lighten, and their eyes will come alive. Reflectors are collapsible, and open up to more than three times their size. They can be mounted on a small stand with an A-clamp, leaned against your knee, or propped against an herbaceous clump. Be sure not to overpower the subject with your bounce, as too much light will cause your subject to squint (not a good look). Set the reflector to the side and at least 10 feet back, so the

lit face has dimension. You need only a small amount of feathered light to do the trick. By turning the reflector at an angle to your subject, you'll reduce the amount of light reflected. Most reflectors have both a silver and a white side; the silver will add a more specular light, while the white side creates light that is more diffuse.

The more you work with reflectors, the more you'll understand their strengths and weaknesses. They need to be used with subtlety, only as a supplement, but never as a key light. Occasionally, I find them useful to open up the shadows on a backlit plant or garden feature, but that's the exception. Sometimes, they can be used as a means of creating instant shade for the plant portrait, or as a way of blocking wind for a long exposure on a subject. They are a versatile tool, and I never travel without them.

I've photographed countless people in their gardens, some armed with pruners as though caught pruning, others digging in the dirt or harvesting, and some just pausing or posing on a bloom-fringed path. The most important consideration is having something to say—a point of view—about your subject. A portrait with clear personality will trump a staged or concocted idea anytime.

Some subjects will take to their portrait session naturally; others will be discomfited by the whole exercise. Make sure to give your subjects some options to put them at ease in front of the camera. Humor goes a long way to relaxing others, as does clear direction. Have your subjects look away from you, take a deep breath, then come back to your camera's gaze refreshed. Also have them relax on one hip with one shoulder more toward the camera (this is nothing new, as the classical Greek sculpture of the Kritios Boy, with his pelvis

Anything on two or four legs can animate the garden image and tell a bigger story of the place. Composition and framing are key to getting that story across: A puppy pounces through the frame in low afternoon light; an Australian shepherd, shot low and angled, and in sepia, to accent its beauty; a goose about to charge the camera; and a peacock in full feather fills the frame.

Shooting People and Pets in the Garden

TECHNIQUE: A reflector is the key addition to your camera gear for the portrait. They come in many sizes, and there are some small enough to fit into the back of a medium camera bag. Use the reflector with subtlety. The effect you're after is glint, not glare. Fill flash will also create a specular highlight, but controlling its output can be tricky. You don't want its white, flat light to dominate. Use a long enough lens or telephoto setting on your compact in order to reduce the distraction of a lot of depth of focus in your image. Also set your aperture to wide-open settings, to reduce focal depth (f/1.8 to f/3.5 should do the trick).

ASSIGNMENT: Grab a friend or relative and ask them if you can take their portrait in the garden; give the portrait context and make it environmental because you want your subject to be *somewhere*. Practice using a reflector, first filling in with too much light, then backing off and angling the reflector to reduce its effect. Vary your depth of field, and your point of view. Have your subject share the frame with a pet or other critter and have them interact. Have the subject do something in the garden, and ask them to look at you on command when you're ready to shoot. Take enough images to cover the inevitable awkward smile or closed eyes.

inclined, changed the course of Western art more than 2,500 years ago). Some subjects will stiffen unless given a garden task to preoccupy them, and you need to be accommodating. But steer clear of contrived or forced ideas, where you've burdened your subject with baskets and trowels or other unwieldy garden props; they'll always seem forced.

I've shot garden portraits that have been like pulling teeth, and others that were wonderful and collaborative. Some have come as a complete surprise. A Danish garden designer, austere and octogenarian, turned to me for her portrait after a day of solemn horticultural discourse and began to curse and giggle. She cracked herself up by behaving badly, and it worked. And the art critic Robert Hughes, after a day of shooting his remarkable Shelter Island garden, faced my camera square on and literally started vogueing for the lens. His campy preening seemed ludicrous to my assistant and me, but the results were perfect. What did he care if he made a fool of himself in front of one photographer, when thousands would only see a great portrait?

I had Edwina von Gal throw open the garage-style doors on her modernist home in Sag Harbor for her portrait, as a kind of joyous exclamation of place, and because it seemed to say something about her captivating energy. She went along with the whole idea to great effect. The bottom line is to always know what you want from your subject, but stay open enough to seize any wonderful surprises, and always shoot with humor and sensitivity. Remember that plants can put up with your creative fidgeting all day, but people won't.

Besides the inclusion of people in your garden photographs, pets of all kinds can animate the scene. Dogs are most often out and about with their owners in the garden, and it makes sense to include them in the

Sometimes people in the garden are not there for a portrait, but just to liven up the scene. It's really not about them, but about what it means to be in the garden, whether it's gathering, or pruning, or feeding, or just staring at the sky.

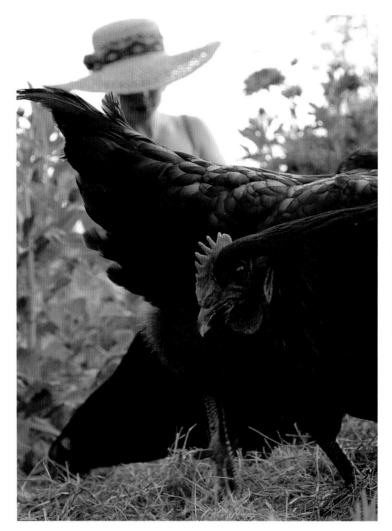

Chickens always make for great subjects in the garden, and getting down on their level makes a more interesting shot; a sheep shot through fencing with focus only on her eye and lashes is a graphic detail.

portrait. Pets also give the self-conscious subject something to do while you take your shots, thereby loosening them up (just keep them away from your cameras—I've laboriously cleaned off my share of dog-licked lenses).

Sometimes a pet just moving through the garden will add life to an image, and adding motion blur with a slow shutter speed will enliven things even more. I once shot a farm garden for *Country Home* magazine in the Berkshire mountains of Massachu-

setts where the reclusive owner had about a dozen or more Australian shepherds bounding around the property unrestrained, as well as two massive Pyrenees sheepdogs that seemed to enjoy taking a good nip at my backside each morning (sheepish I am not, but they weren't convinced). Because the property was so much about animals, and the owner was reluctant to be photographed, the dogs and sheep became the stars. The merle coats and eyes of the shepherds were so beautiful that they became as much the story as the lush garden.

I've worked with other critters in the garden (chickens, guinea fowl, goats, cats, pot-bellied pigs, and you name it), and they all help to tell the story of the place. Cats and pigs are hard to wrangle into doing anything they don't want to, but chickens and goats will enter the frame given a bit of nosh. Just make sure they all sign a release.

Personal Style

As you begin to shoot with growing awareness and skill in the garden, an individual approach will begin to emerge. You'll be drawn to certain plant combinations, and you'll favor a particular point of view, using some lenses a lot more than others. These patterns will become a personal style, a way of seeing and photographing the garden world that is yours.

Sometimes this style will be a product of technical syntax by the cameras, formats, techniques, or printing style you favor. You may decide that deeply focused, saturated colors stir your psyche, or that muted, almost monochromatic tones are your thing. You may become obsessed with macro photography, or with aerial landscapes, or black-and-white in the garden. These don't have to be defining or limiting interests, but rather challenges that can make you a stronger, more versatile imagemaker.

Back in the day when film cameras dominated, style was often defined by syntax. I knew photographers who only shot using 4 x 5 or 8 x 10 box cameras, and their images had a very formal, deliberate feel. Others worked loosely like street shooters with Leica rangefinders, and some shot Polaroid for its punched-up, direct positive colors and square format. These styles were often an extension of personality, a kind of self-portrait. Now, with digital postproduction, the product of these various styles can be mimicked, although the process can't: How you went about capturing an image, the mechanical/chemical process, always affected the kind of images you'd get.

I used to think of myself as a darkroom shooter. Because I loved the process of developing and printing my own work, of transforming the raw material of the negative into a compelling print, my images were "reshot" in the darkroom after they had been captured in the camera. This led to a lot of split processing, heavy cropping, toning, dodging and burning, and solarizing—all processes that I still use today, although now they're in the "lightroom" of postproduction on my computer monitor. I still have rather primitive hunter-gatherer impulses in the field, where I'm out to "capture" and "shoot." Photographs are always taken, never given. And we "take" out of impulse and desire. We are stealing moments of time and covetously taking them back to our computers to play with, to print, to hand over to an editor or gallery, and to proudly hang in the hallway.

Whether or not photography is an art form has been debated since its invention almost 175 years ago, but when there is clear creative intent and investment by the photographer, and when the photographer is interested in infusing content with meaning, then he or she has moved beyond the role of visual stenographer and taken on the aspirations of an artist. Personal style, above all, needs to be *personal*. You need to hear other voices, but listen to only your own. That doesn't mean you must try to reinvent photography in order to develop a style that's yours, but rather that you always search for the images that matter most to you. You need to be your own toughest critic and most passionate fan.

Style is many things—attitude, humor, approach, technique, interest. It's your particular way of expressing yourself with the camera.

"It is better to invert reality

than to copy it."

—Giuseppe Verdi

3 *Postproduction*

Creating with the Computer

If you understand the premise that framing and photographing in the garden alters its reality (because reality is neither framed in the rectangle, nor is it static), then digital postproduction is just another step in the photographic process and a further refinement of your aesthetic ideas.

The tracery of this maidenhair fern's delicate leaves has been emphasized in postproduction. Converting to black and white renders the image in graphic relief, while strengthening the shadow detail brings out its internal architecture.

Postproduction is what you do with all of your pixels once they've been captured and stored in your camera. I create some of my best photographs in front of the computer screen, camera nowhere in sight. Maybe reality is overrated anyway? The cultivated garden, according to the protocols of nature, isn't real. Its linear quadrants and massing together of nonnative, even un-neighborly, species aren't real, and its weedless paths aren't real, so why should garden photographs be so?

If, as Ansel Adams said when comparing photography to music, "the negative is the score, and the print is the performance," then think of your JPEGs as negatives, needing development and creative nurturing, just like the rest of us. The amount of tweaking you do is a matter of choice, just as some *plein air* painters will complete a canvas in the field, while others will only loosely sketch outdoors and finish their work in the studio. But if you think of your in-camera images as a starting point, and of postproduction as a much-improved finish, then imaging software is just another tool available to facilitate your vision. Whether it's you behind the camera or you in front of the screen, it's still *you*, with all of your aesthetic quirks and desires.

Many amateur photographers never hone their computer skills to become thoroughly literate in postproduction software, such as Adobe Photoshop, Adobe Lightroom, Nikon Aperture, or even iPhoto. They will store their thousands of unedited images on hard drives and USB memory sticks, make a few prints, and leave it at that. They still photograph under the old paradigms of print and transparency film, where what you shot was what you got.

But in this age of digital capture, very little is beyond redemption. You'll need new skills, and these will prove to be as critical to your competence as a photographer as basic camera functions are. What you do with the thousands of megapixels on your memory card is as crucial as the pixels themselves. It's okay to manipulate as much as you want in postproduction to create images that weren't there in the camera. In photography, if the end result is a great shot, then the means don't matter.

Image Assessment

The first question to ask yourself after a shoot is "what do I keep?" This is the initial image assessment, the moment where you test your editing skills and your resolve. On average, I might keep a third of what I shoot on any given assignment. Becoming a good and disciplined editor of your work is critical. You will be much happier with a couple dozen undeniably strong images from a shoot, than with an extra hundred ordinary ones. Throwing out all those pixels is surely an exercise in creative confidence, but, trust me, you'll want to avoid the nausea of all those middling images hanging out on your hard drive. Cut, and cut deeply, saving only the best.

The psychology of managing clutter is a critical skill as our lives become digitally saturated. The only way to stay ahead of the digital tsunami is to edit, both time and content.

Where you first assess your images is a matter of choice. I prefer to constantly check my work in the field on the bright and large LCD of my DSLR, quickly deleting exposures or compositions that are off. This is a crucial part of the workflow: You shoot, you check, you tweak, you shoot again. Though my CF memory cards store up to 8 gigabytes of image data, there's no point in filling them up with unusable pixels. And if your

LCD screen is too small or too dark, you put yourself at a disadvantage. When you edit in the field, shade your screen as best you can to get a clear idea of what you've shot. And always shoot more than you'll need; vary exposure, depth of field, and composition. Cover your bases; they're only pixels.

Most of your editing should take place in front of the computer, however. That's where you can really see what you did or didn't get in the camera, and that's where your image management and editing software is. On assignment, I always carry a laptop uploaded with all of my imaging programs so that I can edit in the field or hotel room, or tether to the screen during a shoot for immediate assessment by others (art directors and clients who pay the bills!). Most professional camera bags now have a padded slot for a 15-inch laptop, which comes in very handy. It's critical that you begin to think of your computer not just as a storage vault for your images, but as an indispensable creative tool.

Digital Workflow

Digital workflow is the stream of processes and applications you use to create final images, from camera capture to computer editing, and from storing to printing. Digital imaging technology offers vast choices to help you create the best possible images and meet your creative goals. And in postproduction, software is a moving target; as soon as you've become familiar and comfortable, something new and improved is on the market to entice you. Remember to make a distinction between marketing hype and a necessary upgrade. Which software you choose will be a matter of personal preference, but—for the sake of clarity—I'll detail the specifics of my workflow using Adobe products,

namely Photoshop Lightroom and Photoshop.

Lightroom is a remarkable, intuitive software application, designed by Adobe exclusively for digital photographers. Unlike Photoshop, which is primarily a graphics editing program, Lightroom was developed as an image management program and database, replacing the light boxes, loupes, and storage sleeves of the past with a sophisticated, intuitive tool for managing thousands of digital images.

With the amount of image data we are now creating, a means of managing and making sense of it all is critical. We need a place to put it, to sort it, and to store it; otherwise it's just a tangled heap of ones and zeros. And because Lightroom was developed with input from professional photographers (I contributed to one of the early Beta versions), its workflow modules make sense to its intended users.

I'm going to outline my own personal, perhaps idiosyncratic, steps to using this software. It is by no means the only way, or even the best way, but it is the way that works for me. Everyone will have his or her own preferences in postproduction, just as they will in front of the camera. Remember, too, that these programs cater to the whims of users and offer many ways to get to the same sought-after place.

I think of technology as a versatile tool, and it's there to help me realize my creative ambitions. However, I'm not a tech junkie and I'm not someone who has to have the very latest gadget. I have always been more interested in the image than the process. I want to understand and use enough of technology's power to be able to seamlessly flow from photographic idea to finished image, and that's enough for me. As long as it serves my aesthetic aspirations, I'm on board.

Adobe Lightroom

Lightroom is the first stop for all of my postproduction workflow. Once a digital card leaves my camera and slides into a card reader, or I run a DVI (digital visual interface) to firewire cable from camera to computer, images begin their transformative journey into Lightroom. Once there, I label, edit, and organize them before doing final image finishing in Photoshop.

Lightroom is divided into distinct steps, or modules, that you move through—much the way you might have gone through your images in the past, but with a more streamlined process. There's no physical clutter and no waste, and you get to edit and improve your image content without compromising the original file. The workflow modules are:

- **Library**—Where your images are initially collected, organized, rated, and either saved or discarded
- **Develop**—Where your chosen images are edited for color, exposure, crop, aspect ratio, and dozens of other image-enhancement functions
- **Slideshow**—Where presentation tools, if needed, are chosen for slideshows
- **Print**—Where layout options and print settings are chosen
- **Web**—Where image Web galleries can be created and exported

Of these five modules, most—if not all—of my time is spent in Library and Develop. This is where 90 percent of my workflow happens. You leave these Lightroom modules with a tight edit of your images, tweaked for color and exposure, and ready to move on to final editing in Photoshop.

The first step in importing your images to Lightroom will be to preview your memory card in the Lightroom Import window and decide what you want to import. You'll often have a few different locations or shoots on one card, and now's the time to import and label them sepa-

The Adobe Lightroom home page mimics the traditional lightbox used for viewing slides and transparencies. Images can be arranged, rated, and filed here.

rately. Organization is the goal here. Be sure that the "Show Preview" box on the lower left of the Import Photos window is checked. Then click the Uncheck All tab underneath the previews, choose and highlight the ones you want to import, and click Check All. Only the highlighted images will be checked and imported. After you have imported images to Lightroom and your hard drive, you can erase your memory card.

The second step is file handling. Because Lightroom is nondestructive (meaning the original, imported file is not altered), Lightroom first asks you where you want your original images stored. Because I'm a professional photographer, I keep all of my image files on external, split multi-terabyte hard drives that make two separate backup files of each image. These drives store both the original image and the Lightroom/Photoshop improved version or versions. For storing your personal images, you may find that your computer's hard drive is the only storage system you need, but an external

drive will give you a lot more room and the security of a backup should your computer crash.

In the Import window, choose a location for your imported originals, and save them to folders and sub-folders if you wish. This is the location that Lightroom will access when managing and editing your images. It's also the name Lightroom will assign your folder in its library. The next step is naming the image file. I usually choose a custom name along with the original file number that was assigned by the camera. You can also add keywords and metadata to your images if you want them tagged with more information. The last option in the Import window is your preview size, which I keep at the standard default setting. Once these settings are chosen, press Import and let Lightroom do the rest.

Library

When your import is complete, a folder with the designated file name will appear in Lightroom's Library. The Library module is where you

The Import window in Lightroom is where your images first enter the program. Digital card readers, cameras, and hard drives can all have their images imported here and have new filenames and sequences assigned.

make organizational decisions about your images. Your most recent import will appear as preview images in the Library window. It's here, in the Library module, that I make my most comprehensive edits, assigning a ranking to each of the recent imports, and saying *sayonara* to at least half of the shoot. Images, for me, are love at first megabyte. If I'm not smitten with them now, I don't expect to take a weird shine to them later. It's the digital equivalent of speed dating. Be confident in your choices; otherwise, you'll never get through an edit.

I use a star system to assign rankings to the images. Under the lower far right option arrow, you'll need to check Rating in order to assign star rankings. I use a three-star system when reviewing images, and I eliminate any images that don't earn three stars. Once you're in Library, go through the images from your shoot and give everything you want to keep three stars. You can increase the size of the thumbnail previews with a slider if you want a larger view, or simply double click on a thumbnail and it will fill the screen. If you can't decide between several versions of the same image, there's a feature called Survey View, which I use quite a bit. It fills the viewing window with only the images you've chosen to survey, and makes comparative editing much easier. The icons for these functions are very readable and clear (Adobe is great at creating pictograms), and there are several possible viewing modes.

By clicking the small arrow points attached to the function windows, you can open and close them to increase the viewing template. You can also have Lightroom fill your screen with a click of the "F" key, or drop the whole program out to focus on a single image using the "L" key, which highlights your selection against a black screen. These are aids to help you make strong editing choices and to see what you've got, undistracted by any visual clutter. Stand back from your screen and scrutinize each image. As you hone your editing skills, you'll learn to make tough choices more quickly. What you decide to let go of (and why) will make your next shoot stronger.

Once you've gone through the shoot and given each image the star treatment, go to the drop-down menu under Edit and click Select by Rating, and choose None. All of the images from your shoot that you rated as expendable (no stars) will be highlighted. Click Delete. A pop-up window will ask if you want to delete the images only from Lightroom, or from your disk. This is your call. I always delete them from Lightroom and from the disk. If I don't think they're worthy of cataloging in Lightroom, then I don't think they're worth keeping at all. If you're skittish, just delete them from Lightroom for now.

After that first pass in Library, I've usually reduced my image load by more than half, and I'm ready to get fussy with my three-star choices. I go through the edit again and assign four stars to the standouts, but this time I leave the three-star images in the folder. Those three-star images have made the initial cut and will serve as backup. The bottommost box of the Lightroom window contains a tab with a slider showing small thumbnails of your images in a horizontal bar, as well as a series of filter options (such as flags, stars, and colors). I keep it simple and just use stars, and, at this point, filter my edit to four stars. The filter leaves only my four-star choices visible in the Library window, and ready for the next module, called Develop.

Develop

The Develop module is where color and exposure are managed and corrected, where images are cropped and aspect ratios (a constant relationship between width and height, such as 5 x 7, 8 x 10, or 11 x 14) are assigned, and where tone curves and histograms can be manipulated. There's a lot in the Develop module that can either be useful or get you into a heap of trouble. One of the reasons I shoot in high-res JPEG and convert to TIFF for print and publication is that shooting with Raw is the equivalent of working with a completely neutral, unbiased film with no filters on a film camera, which I never did. I shot with Fuji Velvia for its saturation and always used filters. So I allow the camera and its settings to have some role, and always have.

Remember that by trying to please everyone, from the most unsophisticated shooter to the wonk working with digital algorithms, Adobe has given Lightroom far more horsepower than most of us will ever need or know how to use well. I stick to some basic but critical Develop functions, and leave the tweaking of tone curves to those so inclined. Most of what you can do here can also be done in Photoshop, but I find Lightroom's layout and flow a pleasure to work with, and I want to stay in Lightroom as long as I can when I'm processing my images.

My first move in the Develop module is to crop my image. Because many DSLRs capture a traditional 35mm aspect ratio on their sensor, which is too narrow and wide for my tastes, I first go into the Crop function and choose an aspect ratio that fits my needs or the client's print parameters. If you're planning to print your images, choose an aspect ratio that will fit a standard mat board window. It will save you time and money later to use precut boards when framing your work.

Cropping is a chance to reimagine your image, so pay close attention here to balance and form, and to compositional line and effect. You can turn the crop in any direction if you want to change the image angle, or take just a piece of the image. If

The Lightroom Develop page is where chosen and cataloged images are tweaked for color, exposure, crop, or conversion. This lotus has been duplicated and converted with a preset sepia filter.

you want to get an uncluttered view of your shot, you can reduce the screen to black by pressing "L" twice on the keyboard. Always crop first because there's no point in editing parts of a larger image that you'll be cropping out later.

Once I've decided on the crop, I open the Basic functions tab on the right and first adjust the white balance. Because I shoot with my white balance uncorrected, I often want to adjust the temperature and tint of my images depending on the scene. I like my garden images to be on the warmer side of the spectrum, with a boost of magenta and yellow added. (I used to accomplish this with my medium-format film cameras by using warming filters, or fluorescent daylight filters, but now I can do it all in Lightroom.) The Temp and Tint sliders won't need much movement to get your image where you want it. You can also get your color-shifted image to neutral by letting Lightroom auto-adjust the white balance, then tweaking it from there.

The next stop is Tone, where I spend a lot of time. This is where you can control all the nuances of exposure, including a Recovery slider to retrieve any blown-out highlights, a Fill Light function to bring up the midtones, and a Blacks function to deepen your dark areas. I find these Tone tweaks incredibly useful and versatile. With light being such a fickle and critical issue in the garden, being able to salvage images that are less then ideally lit is a godsend. If an image is too hot and con-trasted, for example, I would reduce exposure (by bringing down the highlights), add some Recovery, add a lot of Fill to even out the light, and maybe add a click or two of Black. Of course, the image is changing in front of you, so you're immediately aware of what is or isn't working.

Presence is the next function down, and it is equivalent to value or intensity. You can play with an image's saturation and vibrance here or with its clarity. I generally only push the clarity a bit if the highlights are too blown out or I've lost detail that I'm trying to recover. If you go too far with your image in any direc-tion, you can press the Previous but-ton to remove the last adjustment, or reset the image to its original status when you imported it.

There's one other development function, under Presets, that's quite handy in Lightroom, and that's the presets for simulating the varied qualities of film and printing tech-niques, found on the left-hand side of the viewer window. Some of these include Antique Grayscale, Aged Photo, Cold Tone, Cyanotype, Direct Positive, Sepia, and Sele-nium. If I think an image would look good converted to Antique Gray-scale, for example, I will first make a duplicate copy of the shot (click on Create Virtual Copy, under Photo in the tool bar), then adjust it in the basic settings. You can also create your own custom presets that can be batch-applied to images (meaning applied to all with one click), so that your conversions are universal.

It may seem strange and unsuit-able to some to simulate these effects, because to purists it disre-gards the discipline of process, but many of these techniques are labori-ous and involved in their original form. Selenium and sepia toning, for example, was a 19th-century warm-tone process meant to improve archival stability of images. Dark-room photographers, including me, used selenium toners for years to render a warmer print, converting metallic silver to silver selenide. We bathed our prints in noxious chemi-cal baths, watching over them like fussy nursemaids, until they emerged. Now it's just the click of a button on a camera or a preset mode in imaging software to achieve the

same results, without mess or chemical concerns.

There's no question that a background in traditional darkroom technique is helpful in digital postproduction, as is a sensitivity for and understanding of photographic history and process. Many of the icons and functions in Photoshop, for example, use pictographs drawn from darkroom technique, such as the Dodge and Burn icons, or the Crop tool. But ultimately, whether your training and knowledge were gained through traditional or digital means, postproduction processes rely as much on aesthetic awareness as on technical know-how. You're going to make choices about which images to convert, and those choices will come from your own references and vantage point. If images are altered randomly, and without much discretion, the effect will feel forced. You have to use your insight to decide if an image would work better in an alternate process, to choose which shots to convert to sepia or cyanotype, and to decide which ones are best left in contemporary color.

Once you've developed your images in Lightroom and are satisfied with their basic crop and tone, it's time to export them and add finishing touches in Photoshop. You can either export directly to Photoshop from Lightroom (under the Photo tab in the toolbar), or you can export them to a folder on your hard drive using the export function in Library. I like to export them as TIFFs to a subfolder in my existing import folder on my hard drive, and then open them in Photoshop from there. A TIFF file is a preferred image format for most photographers, graphic artists, and the publishing industry. TIFF files allow you to work in a lossless format—unlike JPEGs, which lose pixel quality each time you open and work with them—meaning you can manipulate, edit, and resave your images without any compromises in quality. And since you'll soon be putting your images through all sorts of contortions in Photoshop, a lossless format is key.

On the lower left in Library, you'll see an Export tab. Before you click it, select the images from your folder or collection that you want to export (use Select All under Edit in the toolbar or press Command and click to choose individual images), then press Export. An Export window will appear asking you to select a folder where you'll save the images. Choose the same folder you used when you imported files, creating a new subfolder for your TIFF files. Under File Naming, select from one of several options to name your edited TIFF files (I usually give my TIFFs a custom name, followed by the original file name—such as Favorite Garden-2905.tiff). For File Setting, choose TIFF as the format. For Image Settings, my Color Space is always AboberRGB at a resolution of 350 ppi and a height of 12 inches. This means I'll end up with a high-res, 30 megabyte TIFF file, just right for printing or publishing. You can certainly alter these specs, depending on your intended use, but this is the benchmark.

You can also export lower-resolution JPEGs at 72 ppi from Lightroom, if you plan on going immediately to an e-mail, Web log, or Web site with them, but I usually save that step for after the final editing. Once you press Export, your images will end up at their intended location and ready for Photoshop.

You should use Lightroom and other image management programs as a means toward your specific ends. If you want to play with it more, by all means do. There are downloadable tutorials that are extremely helpful, and FAQ references at Adobe's Web site that are worth visiting.

Adobe Photoshop

Photoshop is to photography what Porsche is to the automobile: fast, efficient, and powerful. We don't need to know all the binary code for how Photoshop gets us there— it just does. Beautifully.

Since its introduction almost 25 years ago, the graphics editing software Adobe Photoshop has defined and revolutionized how we work with digital image content. The word *Photoshop* has even become a verb for image manipulation, or a pejorative adjective, as in "it looks Photoshopped." Photoshop is to the appetites of our visual imagination what Google is to our hunger for information; whatever we can conjure, it will most likely deliver, and then some.

Photoshop is simply remarkable for its ability to transform images. Even after years of working with its tool sets, its capabilities still astonish me. Like any revolutionary product in the marketplace, its sophistication—and

selling points—have evolved as well, to the point where Adobe offers simplified versions for those who may be software skittish (such as Photoshop Elements, and even the freely downloaded Photoshop Express). Photoshop Elements, or PSE, has most of the features of the full version at about one-sixth the price. The editing options are fewer, and simplified, but the intent is the same: to give photographers a powerful virtual toolbox with which to refine or transform their visual ideas.

As this book isn't an exhaustive primer on Photoshop and all of its formidable magic (there are many such books on the market), I'll limit my discussion of Photoshop to the postproduction tools I use most

often. Remember that software, like computers, is deliberate. It follows instructions, but doesn't intuit from a mouse or keystroke what you want. You have to approach using this powerful software with imaginative purpose and direction. The depth and quality of your visual ideas and images are still what matter most. Computer, software, and technology are only the means of getting there.

When using Photoshop, you need to aim for subtlety, not an extreme makeover. Realities that are too altered draw attention to the technique itself, not to the image content. They come across as dishonest and facile. There are numerous filter galleries in Photoshop, for example, that will transform your images into pastels or crosshatched ink or tile mosaics. These are fun to play with, but I never take them too seriously. For the binary wizardry it took to conceive of these virtual translations into other media, you have to be impressed. But more is less here, and turning a perfectly decent garden image into a computer-generated watercolor or mezzotint always reads as a gimmick. You don't want to mess too much with basic photographic DNA when trying to showcase a garden's true story—even though it's possible. However, if an otherworldly view of a garden is your goal in imagemaking, you'll find plenty of smart textures, layers, and choices in Photoshop.

Think of Photoshop as a sort of finishing school for your images—a place where their flaws are recognized and corrected, where their strengths are sweetened, and where they take on a final luster. Remember that many of the remarkable features and image-enhancement possibilities in Photoshop will rarely, if ever, be used in your postproduction workflow. Redundancies are built in to accommodate the most demanding user, and next-generation enhancements and features are always being marketed to sell you on the latest software upgrade. Don't let their presence unsettle or intimidate you. Work with what you need to make the most compelling images. And when you have time to explore and play, get familiar with some of the technological advancements and expand your skills.

My postproduction workflow in Adobe Photoshop follows seven basic functions, which I'll outline in detail in the next section. Though I work in a full version of Photoshop CS created for imaging professionals (CS stands for Creative Suite, a bundle of imaging and design products including Photoshop, Illustrator, InDesign, Version Cue, GoLive, and Acrobat), the core functions I use can be found in both Photoshop and Photoshop Elements.

Working in Photoshop

TECHNIQUE: Photoshop's visual bells and whistles (sirens, vuvuzelas, and air horns) are magical, but you don't need a degree from Hogwarts to master them. Much of postproduction editing is mouse or track-pad driven, so be sure to have a comfortable workstation with a wrist-supported mouse pad. The smoother your tool strokes, the more seamless your results will be. The goal is to have the postproduction work you perform look as though it never happened because your camera skills are just "that good."

ASSIGNMENT: First, take a photograph you want to work on, and under "Image" in the top horizontal toolbar, choose Duplicate. Work on a copy of your original here as you practice these steps. Take the seven tools outlined in the next section and work with each of them, one tool at a time. Use the vertical toolbar as well as the horizontal banner above each tool to select and refine the tool's parameters. Change the brush size, opacity, and exposure. Add new presets and see how they perform. Adjust colors and image sizes. If you make mistakes, open up History (under Window) and undo your steps.

Photoshop Fundamentals: The Magnificent Seven

Though Photoshop has phenomenal power to manipulate pixels, most of its functions lie beyond the basic needs of the garden photographer. While reducing its image enhancement capabilities to seven fundamentals may seem like asking you to drive your Porsche at the speed limit, the core enhancement needs of most images can be met by using the following tools: Crop, Unsharp Mask, Clone Stamp, Adjustments, Dodge and Burn, Layers, and Image Size. I may venture out to some other functions now and again, but for most of my workflow, this is my kit.

The first step in Photoshop is to open the image files you want to work with. Under File in the toolbar, click Open, and select the TIFF images on your hard drive that you want to edit. If you have more than a dozen or so, open them in batches of 10. This keeps your screen from becoming too cluttered and keeps your computer from being slowed down with image weight.

Once your images are open, you'll want to work on them one at a time. On the Photoshop toolbar, you have a choice of three screen modes: standard, gray screen (with menu bar for the entire software program), or black screen (with only a toolbar for the tools you use most often in Photoshop). I always work in gray screen, meaning only my one selected image is visible, along with all of the Photoshop tools. This keeps me focused. If I really want to get a critical view, I can shift to black screen. Remember that your eye is always drawn to the lightest part of an image, and this screen view will keep you on task. I also click the Fit on Screen mode under the View tab in the menu bar. This ensures that I'm seeing my image at its largest possible size for my screen.

Once you've opened your image and selected your screen mode, it's time to begin working with Photoshop. And working *with* is a key distinction here. You are collaborating with Photoshop, using its image enhancement magic to make a better photograph, but don't lose yourself in its spell. Stay focused on your visual goals and work methodically—and creatively—toward meeting them.

1 Crop

Though you've likely given your image a crop already in the Develop module of Lightroom, it's important to include it here for images that haven't yet been cropped, or to review those that have. Crop is the first tool to use, as it defines your image size right away. There's no point in enhancing and editing image real estate that you're going to sell off later.

The Crop tool is located in the vertical toolbar on the left of your screen. To use it, simply click on the tool and a Crop icon will appear over your image that can be moved with your mouse. Create your crop by dragging the tool over your image to the dimension you choose and clicking your mouse or trackpad. You can tweak the opacity of your view in the toolbar percentage slider above, and rotate the crop by mousing over one of the six box points. You can also create custom aspect ratios for your crop, depending on the intended use for your image, or use one of the crop presets.

Be sure to check your crop in the black screen mode, where you can clearly see the form and balance of your photograph. Your choices here will affect the success of your image. If you're not happy with the crop, or want to tweak it, you can always crop again. Photoshop has a History window you can open (Windows + History in the menu bar) that tracks all of your moves. If you're unhappy with a recent edit, simply back up in your History window and try again.

The apples in this orchard have taken center stage with the Crop tool, which emphasizes them and plays their form off the distant boxwood and patch of sunlight.

These heirloom peppers have been isolated from the rest of the produce with selective focus. Unsharp Mask brings their fiery color into crisp relief. The change is subtle but effective.

Unsharp Mask is a sharpening filter with a name borrowed from the old print press days, when a screen, or mask, was put over unsharp images to create the illusion of detail. In Photoshop, it is a way to pop detail and sharpness into your image by boosting pixel edge contrast, and it's a great tool to incorporate as a standard step in your image flow.

Open Unsharp Mask in the Sharpen submenu, under Filter in the menu bar. A dialog box will open where you can preview the sharpening function. You'll be prompted to choose a sharpening amount, or percentage, as well as a radius and threshold. On high-res TIFFs, I use 80 percent as a standard sharpening percentage, with a radius of one pixel. I leave the threshold slider at zero, unless there's intolerable image noise, in which case I'll slide it to the right to raise the levels. Your preview window allows you to see the effect of the mask on your image before you commit to it, and you can alter the magnification with a plus and minus box.

Unsharp Mask is a general sharpening tool for overall image crispness. If you want a more selective sharpening tool, there is one in the toolbox called Sharpen. It allows you to sharpen small selected areas only. It's useful, for example, if a subject's eyes are slightly soft in a portrait, when the overall image is sharp, or if the selectively focused parts of a blossom need a boost of edge detail. Be careful not to oversharpen to the point where your pixels become ragged and blown out. A little goes a very long way.

As with every tool in Photoshop, you need to evaluate the results after each application. The more you work with Photoshop's powerful toolkit, the more critical and tested your image assessment will be.

The Clone Stamp tool cleaned up the leaf debris in the upper right of this shot of harvested carrots. When the light is changing, who has time to get out the rake?

The Clone Stamp tool is the next step after cropping and sharpening, and it's a way to clean up or remove any imperfections in your image. The Clone Stamp tool is one of those almost preternatural Abobe creations that make you want to make a pilgrimage to Adobe head-quarters in California, like a *hajj* to Mecca, and worship at their corporate walls. It's one of the most essential tools in your kit, allowing you to fix an unsightly tear in a petal, flick away a beastly insect with a mouse click, or do away with the tourist in white socks and sandals who sauntered into your frame.

The Clone Stamp tool works by sampling pixels from one part of the frame and copying them into another—of course, this only happens under your creative eye. To begin, choose the Clone Stamp tool from the vertical toolbar on the left of your screen, and pick your param-

eters: You will have a choice of brush size and style (meaning the size and hardness of the clone circle on your image), as well as a choice of the opacity of your brush. I will first choose a brush size that fits the area I'm working on, and I almost always select the softest brush so that my cloned areas will blend seamlessly. The opacity slider allows you to manage how densely your cloned pixels transfer, and I usually begin at 100 percent for the first few passes.

Like a paintbrush, the Clone Stamp tool daubs pixels of data anywhere you like, and—like painting—it's important to stroke the images using your mouse and to be delicate with your application. Aim for subtlety.

How much you use the Clone Stamp tool depends on how much change you'd like to achieve. Let's take a tight shot of a magnolia blossom, for example. You've cropped

and sharpened it, but now notice a little six-legged critter on one of the petals that you'd rather do away with. In your toolbox, grab the Magnifier (shaped like a magnifying glass) on the lower right, and click on the image where the bug is until you're zoomed in enough to clearly see your work. Now pick the Clone Stamp tool and the right-size brush and choose a sample point right next to the bug that's the color and tone you want the area to be. Hold down the Option key (Mac) or Alt key (Windows), and your brush becomes a target. Click once and release to clone and grab your pixel sample, then release the Option or Alt key.

Next, either click and daub, or click and drag the Clone Stamp tool over the bug. As you do so, he will begin to disappear—unceremoniously flicked off your photograph. You may need to repeat the process several times to get a seamless transfer of pigment over the critter. If your sample area is starting to repeat and look genetically engineered, grab pixels from another adjacent area to create a natural blend. As you clone, zoom out using View + Fit on Screen to assess your work in the context of the entire image. If the cloning looks blotchy or obvious, back up using the History template and begin again. The best

fixes, like the best faces, should never look like they had "work" done.

Once you begin to get the hang of this tool, you'll find yourself using it on almost every image, cleaning up an imperfection here or heightening an effect there. On that same magnolia image, let's say there was a beautiful dewdrop on one of the petals that added a point of moist, specular light that you want to duplicate. I would begin with a soft brush not much larger than the dew and clone it discretely to other parts of the image. Or if I wanted to add some soft repetition of color in an unfocused background, I might use the Clone Stamp tool, or I could clean up telephone wires or an unwelcome car or dead leaf. I've also used it to cover up unsightly mulch with a layer of green or to change the compositional balance of an image by adding points of light or a tree line to the frame. You can also de-emphasize an element that is reading too strong in your photograph by reducing the opacity of your tool and softly cloning over it with the desired sample point. Remember to sit back and assess your image regularly throughout this process to see what's missing, what's been overdone, and what could be altered and improved with the Clone Stamp tool. This tool works miracles.

This lovely Italianate garden was compromised by an unsightly satellite dish on its red barn, which was removed with the Clone Stamp tool in Photoshop.

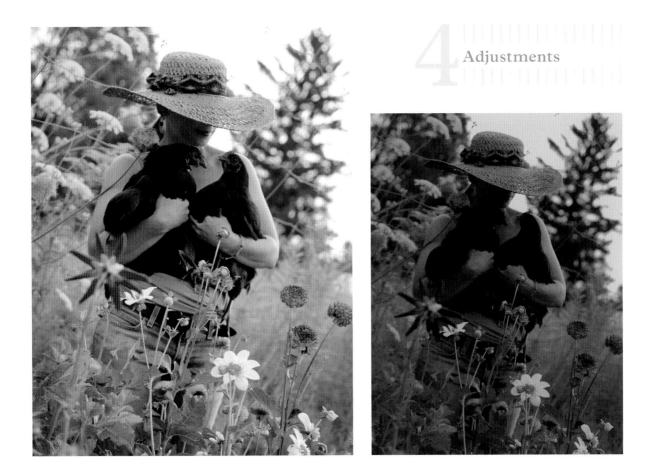

Now that my image is in pretty good shape—cropped, sharpened, and cleaned—I'm ready to fine-tune any adjustments necessary to color values, exposure, and saturation, some of which I began in Lightroom. The ordering and naming of these photo adjustments may differ depending on what version of Photoshop you're working with (there are many), or whether you're in Elements, but the same basic principles apply across platforms.

Under Image in the menu bar, you'll see the submenu Adjustments. This submenu has almost two dozen image-altering options, but for general workflow, I use only two or three. Click on Exposure and a window will appear with sliders, giving you the option to adjust Exposure, Offset, and Gamma. If I feel my exposure is not quite right, this is the place to be. Beginning with Gamma, I'll either brighten or darken the midtones of my image. By adding Gamma, or midtone brightness, I'll often flatten some of the deep blacks in my image. In order to bring the blacks back and add some contrast, I use the Offset slider. An Offset of -0.0050 to -0.0100 is usually enough. Too much offset will block up your blacks, turning them into gobs of density. Go easy. Lastly, I might kick up the Exposure a bit to add contrast that I might have lost by adding Gamma. Once again, this is where your eye is in charge. Every image has different needs and adjustment parameters.

With my exposure where I want it, I may want to tweak the color values in my image. I use the Color Balance

Taken after sundown, this portrait was dark and flat. By adjusting the color balance and exposure, the image became bright and saturated.

tool, but there are many ways to achieve the same results (Photoshop revels in redundancy). With the Color Balance window open, you'll see three sliders with Red, Green, and Blue on the right (RGB) and Cyan, Magenta, and Yellow on the left (CMY). These are what's known as color channels, or color space, and they represent all colors in the known universe. You'll also want to have the Tone Balance box set to Midtones (the default setting) and the Preview box checked so that as you're working, your changes appear on the image. If I want my image to warm up a bit, I may add some red, magenta, and yellow. If it's too hot, it's time for some cyan and blue. This is your chance to set the tone.

You can also use the Color Balance channels to create a sepia copy from a full-color original. In the Image menu, first click Duplicate and save your copy with a "B&W" suffix. Now take that duplicate and under the Mode submenu, click Grayscale. This will discard the color information from your copy and render it in black-and-white. Now convert that copy back to RGB, and open the Color Balance tool again. The sliders will let you warm up your black-and-white with a bit of red and yellow to create a sepia-tone image.

The other Image function I'll use occasionally is the Hue/Saturation tool, under the Adjustments submenu. If I've shot on an overcast day and the colors are muted and drab, or I've shot a hot tropical garden that's popping to the point of distraction, this tool comes in handy. To add depth and richer value to flat colors, simply slide the saturation bar into the plus column until you see improvement. If your image is too loud, decrease the saturation by sliding into the minus. Going far into the minus column will desaturate your colors to the point where they convert to black-and-white (one of Photoshop's many roads to the same destination). Contrast can also be carefully added or subtracted here, using the Brightness/Contrast tool.

It's worth playing around with the numerous image-adjustment tools Adobe offers, some of which you may find more convenient or intuitive for your workflow. Remember that there is really no wrong way to get to the same place. My ways may seem cumbersome or counterintuitive to someone else. The final test is the image itself, not the path you took to realize it. To paraphrase Duke Ellington: "If it looks good, it is good."

This image of harvesting sunflowers has been color- and exposure-adjusted to brighten and warm its late summer mood.

Dodging and Burning selectively in this image of squash creates a more satisfying, painterly image. The edges were burned down to darken them and accentuate the subject, and the folds of the squash's blossoms and ribs were worked on to create more dimension.

Dodge and Burn are some of the most painterly tools in Photoshop. Used well, and with a fluid hand, they can be transformative. They add detail to shadows, they heighten outlines and edges, and they broaden the tonal range of an image, making it more dynamic and rich.

At their most basic, Dodge and Burn are tools used to control exposure on specific areas of a photograph. It's a term borrowed from the photographer's darkroom, where prints were either lightened or darkened using some means of blocking the enlarger's light, or focusing its light on a particular part of a print—it was a way to spot-change exposure. Adobe has referenced photographic tradition by not only keeping the process's name, but by creating icons that come right out of the darkroom. Photographers love that.

When I use Dodge and Burn, I begin by assessing the tonal range of my image to see if there are areas of over- or underexposure that need attention. I then look for shadow lines and areas of detail in the image content, and see where I can darken them for emphasis or add highlights to help them pop. When I worked in a darkroom, I regularly burned the borders of my prints to darken the density of the edges. This not only leads the eye toward the lighter center of the image, but it's a subtle nod to the tradition of *chiaroscuro,* which is hardwired into our collective aesthetic consciousness. Edge burn also alludes to earlier photographic processes where older cameras rendered the edges of prints darker because light had trouble reaching all the way across the image plane.

Choose the Burn tool from the toolbox. It's in the middle right column, shaped like a hand making an "O," along with the Sponge and Dodge tools. If you don't see it (or other tools, for that matter), you need to click and hold on the toolbox icon until all of the tools in that subbox are displayed. Once you've opened the Burn tool, choose a brush size and shape. I usually choose a soft brush to begin, in a size that will give me a large-enough burn to bring down the exposure of the edges. Initial exposure setting, adjusted with a slider, should be subtle, below 50 percent; you want to build up density with several passes. Give the corners a little more. The burn needs to be almost felt, but not seen too literally. You are after the illusion of depth and dimension.

The amount of edge burn will depend on the image and your intentions. On much of my work, the burn is barely noticeable, just a slight increase in density, while on others—black-and-white or sepia, for example—the burn is more evident, alluding to a historic print style. On some images, I may burn one side of the photograph noticeably more to create stronger directional light, the kind of Vermeer lighting that emphasizes dimensional form. As you work, click and drag the tool in smooth passes over the selected area. Keep assessing your progress and building the image up to where you want it.

Still using the Burn tool, I now look for image areas where I want to strengthen or add density. For example, a sepia botanical portrait of a small squash, with its graphic, twisted stem, could use more accent in the creases of its stem and the pleats of its skin. Clicking on the Magnifier tool and coming in very close to the stem, I choose a small (below 10 pixels), medium-hard brush and begin to deepen the shadows along the stem, and then I do the same to the shadow areas on the skin. By selectively deepening these target shadow areas, I've enhanced the tonal range of the image and given it more dimension.

I can use the same burn technique on larger areas of the image with a bigger, softer brush. If I want a perennial border with a long succession of plantings to have more separation, I might lightly burn the shadow areas between the groups in order to have them stand out from each other. Or I might take a portrait in the garden and darken the space surrounding my subject so that he or she stands out from the environment, drawing the eye to the featured area. This takes some

of the flatness out of photography, out of what is basically a height and width object, with no inherent depth at all. In short, you are trying to create as much dimension as possible with the Burn tool, to salvage areas of overexposure, and render as broad a tonal range in your images as you can.

The Dodge tool is the opposite of the Burn tool; it lightens areas of the image that are underexposed, or that you want to draw attention to. I will usually use these tools in tandem, or one after the other, as a way of getting to the right balance of highlights and shadows. You'll find the Dodge tool in the same submenu as the Burn tool, shaped like a wand with a circular tip. Choose your size, hardness, and exposure the same way you did for the Burn tool, finding the right combination for the intended area. On that same squash, for example, I may go over the highlights on the stem to make them stand out more, painting in thin, pencil-like lines at a low exposure until I get it right. Then I might fatten and soften my brush, and run some highlights over the rind between the shadows in order to push and plump the squash's rind. These tweaks need to be subtle and discreet.

For the portrait of plant or person, highlights will draw the eye and push the image forward, while shadows will force it to recede. For human portraits, what captivates most is the eyes; they need to have life and sparkle for the image to succeed. I will often zoom in to a hypermacro place on my subject's eyes and use the Dodge tool to lighten up the whites just a touch, or boost the specular highlight. I've even created that life-giving highlight in the eyes when it wasn't there, because I know how important it is to a portrait's effectiveness, or I've used the Burn tool to add some eyeliner that was overlooked. I've worked with enough makeup artists on shoots to know the drill. Teeth, too, can be lightened (yes, cosmetic dentistry on the cheap).

Dodge and Burn are critical to your photograph's effectiveness. It's this dynamic pushing and pulling that helps to bring your image to life. Boosting contrast has the same effect, but it's generalized and nondiscriminatory: Everything in your photograph gets the same treatment. By selectively choosing areas in your image to accent or diminish, you are in control of the photographic effect. Use the Dodge and Burn tools gracefully and subtly, and they will pay off.

Think of Layers in Photoshop as slices of the same image all stacked on top of each other. These slices can be worked on independently, then sandwiched together to create your final composite image. Layers are like cellophane: As you build them up, new information gets added without obscuring what lies underneath.

Working in Layers can be daunting, but they have the remarkable ability to pull your photographs apart—like an accordion—and let you work on their pieces one at a time, and then you can flatten them again into a whole. There are infinite applications for Layers, from combining image content from multiple sources, to adding text, to creating selective focus. If I use the Layers tool for my garden photography, it's most often to play with the focal plane or move something—or

someone—to a different spot in the image. Because I use selective focus as an essential creative technique when I'm shooting imagery, I'll go through the process I use for creating it in postproduction using Layers. Again, this is one of many means to reach the same ends.

If you're unhappy with the depth of field in an image, or simply want to soften the background around the subject, begin by making a copy of your image, then going to the Menu bar and selecting Layer, then Duplicate Layer in the submenu. A pop-up screen will prompt you to name your Duplicate Layer, or it will simply assign one for you, with each new layer given a sequential name. A Layers palette will appear, showing your source image as Background (which will be locked) and your new layer with its assigned name.

This dew-beaded dahlia was made even more prominent by softening the focus of the other blooms around it, drawing the eye in. The result is subtle but effective.

In the Layers palette, choose the duplicate layer (if you didn't name it, it will be called Background Copy). With the Background Copy open, go to Filter in the menu bar, then to Blur in the submenu, then Gaussian Blur in the next submenu. When the Gaussian Blur window pops open, be sure that Preview is checked. You'll see your image on the upper left. To see more of it, simply reduce the viewable percentage in the minus box.

Gaussian Blur will defocus your image by adding a translucent screen layer on top of it, mimicking the effect of *bokeh*. In the Gaussian Blur window, choose a radius of between 1.5 to 2 pixels to start. You can adjust the slider to any pixel radius, but you're just trying to simulate selective focus here, so err on the side of moderation. You'll see your entire image go soft.

Find the Eraser tool in the toolbox on the middle left and click it. You are going to rebuild focus on your image now only in the areas that you want to be sharp. Begin by choosing a brush size and opacity for your eraser. Use a brush size appropriate to the area you want to bring back to focus, and select an opacity of 100 percent. This will become your select area of focus, and needs to be sharp. Carefully erase away the Gaussian Blur only where you want the sharpest focus. Then set your eraser's opacity at 50 percent, and create a transitional area from sharp to less so, and continue toward the edges of your frame, reducing the eraser's opacity with each outward pass. Your goal is to have a smooth transition from sharp to defocused, without any hard edges between. Zoom in with the magnifier to check your transitions.

This is a simple way to create selective focus in postproduction. There are other ways, of course, but I've found this to be the most straightforward and efficient. Be scrupulous and attentive with this tool. Think like a camera and mimic how it drops focus. Avoid creating focal distortions that don't make sense. The more nuanced your process, the fewer artifacts of digital manipulation there will be. The goal is image integrity, not digital trickery. Once you're satisfied with your focal work, go back to the Layer menu and select Flatten Image. This will compress your pulled-apart composite photo back into one image. You can also save it as Layers if there's more work to do, but this makes for a much larger file.

Another tool to use on occasion in Layers is the Lasso tool, which is great for moving things from one part of an image to another, for transferring and merging content from other images, or for duplicating content. If you have a blossom or plant that you'd like to duplicate in another spot in the garden, the Lasso tool is a useful function, allowing you to follow the exact outline of a selected area and move it. Unlike the Clone Stamp tool, which takes a circular bite, the Lasso is more specific. This is a very tricky process, in part because the subtle variations in focus and light across the image plane are hard to duplicate, meaning whatever you move has to fit in seamlessly in its new spot. But it's also the subtle matter of lassoing itself, which involves very discerning fingers on the mouse or trackpad.

With the caveat that there are certainly other ways to wield the Lasso, begin by creating a duplicate layer and selecting the Lasso tool from the upper left column of the toolbox. Carefully trace the outline of your object to be copied until it follows the entire perimeter and the lines join up. They will turn into a blinking black and white line. Now go to the Move tool on the upper right column and click it, then click and drag your object to its new location. If you want to Lasso and move content from another photograph, simply have both images open and Lasso and drag the content. The images will need to be the same pixel size in order for the scale to match up. Remember to flatten the layers when you have things where you want them. Until you do so, the Layers palette will remain open with all layers visible, and you can work on any one of them individually.

If you're trying to remove content entirely from your shot, like the tour group that just wandered in, begin with an unlayered, flat image and use the Lasso tool to select the group. Go to the menu bar under Edit, then select Cut in the submenu, and your sauntering, straw-hatted group will vanish. You can fill the leftover white space with appropriate content using the Clone Stamp tool. The Lasso also comes in handy when you want to work on one area of your image separately from the rest, to increase contrast or to darken or lighten, or to change the hue. Any part of your image that you select using the Lasso tool will be treated as its own image space, available for editing.

Image size is a routine but critical last step to your Photoshop workflow. Before the final saving of your image, go to the Image menu and click Image Size in the submenu. The pixel dimensions and document size will be revealed. If you exported from Lightroom as 350 ppi TIFF files, your pixel dimensions should reflect the size and quality of your images based on the size of your camera's sensor and the in-camera quality mode you chose. I always shoot at the highest quality mode possible, and on my Nikon D700, a 350 ppi image comes in at about 40 megapixels for a vertical image, and 70 megapixels for a horizontal— plenty of pixel power for high-end printing and reproduction.

If you're going to print your images yourself and you have already cropped them to the aspect ratio of choice, double-check that your image size and resolution are adequate for quality printmaking. If you're planning on using the images online, save JPEG copies of them at 72 ppi (its pixel dimensions will reduce as well), and put them in a separate folder.

If your image's dimensions are not sizing up with the crop of your layout, you can increase or change the aspect ratio of the canvas size under Image, then under Canvas Size in the submenu. You can then clone and lasso content in layers onto the new canvas, and then flatten it to create your new composite.

After working on an image in Photoshop, such as this alpine strawberries shot, save it both as a TIFF file for printing and a low-res JPEG for e-mails, Web sites, and social media.

Photoshop Flow

Once an image makes it to Photoshop, it's already been through some critical vetting in your camera and in Lightroom. While each shot will make different demands on you in postproduction, the basic flow through Photoshop is the same, as is the goal of producing the best image possible. Here is one image's journey through the seven Photoshop steps.

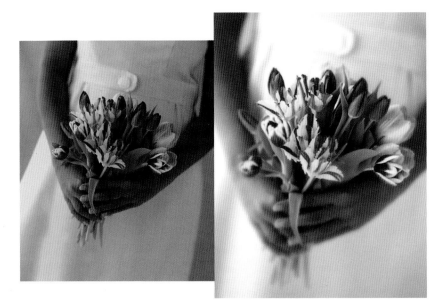

BEFORE: *An image of a woman holding a bouquet of tulips, ready to be altered in Photoshop. The shot has already been through Lightroom. Of the many takes of this setup, this one had the best feel and composition.*

AFTER: *Having gone through these seven transformative steps, this image has gone from good to remarkably better. Every one of your selected photographs deserves a chance to make a similar journey.*

Adjustments: *Any overall changes to exposure, contrast, saturation, and color are made in Adjustments. Changes here will have a significant impact on the look and feel of your image.*

Dodge & Burn: *A classic tool from the darkroom, Dodge & Burn deepens and lightens selective areas, broadening the tonal range and improving the depth and dimension of your image.*

Layers 1: *Begin your work in Layers by creating a background copy. This will be a duplicate of your image that will be modified and superimposed on the original. Here we want to create selective focus in an image with too much depth of field.*

Crop: *The first decision to make is the crop of your image. If you're unsure at this point, leave a little more than you want; you can always trim it later. Compose and crop with even more thought than you put into the original shot.*

Unsharp Mask: *Once you decide what your crop is, use the Unsharp Mask tool to make the image as crisp as possible. The standard for large TIFF files is an 80 percent sharpen with a radius of 1 pixel.*

Clone: *The versatile Clone tool will clean up your images or remove anything unwanted from the frame. Changing the brush size, hardness, and opacity will impact its effect.*

Layers 2: *Select the Filter/Blur/Gaussian Blur tabs and create a blurred surface layer over your original image. This layer will be selectively erased to reveal what you want in focus and left intact where you want the focus to drop off.*

Layers 3: *Select an initial radius for the blur that is below 3 pixels. Then, with the Erasure tool, begin erasing back the blur. Start with the erasure at full opacity, and slowly dial it back so that your areas of sharp and soft focus transition naturally, as they would in the camera.*

Image Size: *In this final step, go to the Image Size tab under Image, and make sure that your resolution is at least 300 pixels/inch, with an image height of 10 to 12 inches. The size of your file should be at least 25 megabytes for a printable, high-res TIFF.*

"The virtue of the camera is not the power it has to transform the photographer into an artist, but the impulse it gives him to keep on looking."

—Brooks Atkinson

4 *Cameras*

The Basics

The camera is where it all begins. In fact, it's been 175 years since French inventor Louis Daguerre created the first permanent photographic print, a fuzzy 1837 daguerreotype of an artist's studio, called *L'atelier de l'artiste*. Since then the camera has gone through countless technological permutations. Its 21st-century form, the digital camera, is a comparative marvel of functional complexity and capabilities, allowing photographers wildly unprecedented creative freedom and expression.

The digital wizardry of today's cameras allows you to think outside the box and takes the guessing, but not the wonder, out of photography. Cameras will show you what you've shot and how you shot it, but never where to look or how to see.

165

Unlike their technological ancestors, digital cameras immediately show you what you've captured on their LCD screens (my assistants and I used to have to "cook" Polaroids on location, waiting for 90 seconds as they developed in the warmest spot possible—usually under someone's arm or *elsewhere*). Digital cameras also store thousands of high-quality images on reusable Post-it note or smaller-size memory devices, allowing those images to be edited and deleted on the spot or on your computer, and offer innumerable image-enhancing beeps and blips (formerly bells and whistles).

In order to think clearly about cameras, though, it's important to cut through the noise of redundant features and get to the essential core of the camera, which is basically its lens (the eye) and its sensor (the optical nerve). You don't want to compromise on these two components, and you'll find that this is where your money should go.

I used to wish, as I stood waiting at baggage claim for another burdensome equipment case to tumble down the conveyor, that I could show up on a shoot with just one small camera, able to outperform all the oversize machines I had to lug around. I needed quality that could meet my standards, as well as stand up to the scrutiny of photo editors and art directors, but I wasn't willing to spend $30,000 on a digital film back for my medium-format system. Then the digital DSLR (single lens reflex) evolved into a high-quality answer for me, with its remarkable sensors and advanced optics, at a price that any pro or serious amateur would be willing to pay. Now I show up to shoot with a much smaller rig and a few DSLRs, and never have to wait at baggage claim for equipment. But more than that, my photography has become more expressive and personal. Without the heavy, time-consuming gear, I shoot more freely and am able to create with much less deliberation and more flow—all great assets for any artist.

This latest generation of digital cameras do more, and do it better, than their predecessors. With so many choices, making a sound decision needs to come down to a few fundamentals.

Camera Shopping

WHAT DO YOU WANT? With the almost numbing amount of choices in the camera market today, the most important requirement is to know what you want. The more specific you are, the narrower the choices get. Decide if you want a DSLR with removable lenses, a high-end bridge camera, or a pocket digital. Begin with a budget, then see what's out there. Always look for the fastest fixed or interchangeable lenses you can get; look for manual options such as aperture priority, exposure compensation, macro capability. Look for quality sensors with noise reduction.

WHERE TO BEGIN? Begin with online research. Read reviews, go to manufactures' Web sites, check out photography discussion forums, talk to friends who've recently bought cameras. Once you're armed with enough knowledge, narrow your list to a few top choices and head out to a decent camera shop to actually handle the cameras. Online images will never give you a sense of what the camera feels like in your hands, if the function buttons are intuitively organized, or if the LCD screen is bright and readable. The camera should seem durable and sturdy in your hands. Feeling is knowing. If you have a quote from an online source, your shop will usually match that price. Otherwise, shop online, but carefully read their return policy in case you're not satisfied, and always opt for the extended warranty. The peace of mind is worth it.

What to Look For

What's the best camera to use in the garden? My advice is always the same: The best camera to use is the one that's with you. That might sound glib, but it's a fact. If you buy an expensive DSLR (Digital Single Lens Reflex) with interchangeable lenses but you find it too cumbersome to take with you, then it's the wrong camera for you. If you think you'll actually go somewhere floriferous and green solely to shoot, or you want to take your imagemaking to another level, then a DSLR might be right. If you want high quality without the bulk, then a "bridge" camera—with much of the functionality of DSLRs, minus a few key features—could be the answer. If you just can't be bothered with choices and parts, a compact point-and-shoot will have to do.

The camera is not a mirror, but a translator, with its own language and means of expression. Whatever camera you work with, you'll need to learn to speak its language fluently.

Sensor Size and Quality

One of the first criteria to consider when looking at cameras is the sensor size. As a former medium- and large-format shooter, it was hard to imagine reducing my image plane from 4 x 5 or 2¼ inches to something the size of a postage stamp. Then that postage stamp got larger and smarter and started to seriously tempt.

When comparing cameras, research and ask about the quality of the sensor. The sensor is the digital "film," where the image is recorded, and it's more important than the number of megapixels. Ten megapixels is plenty if it's a quality sensor, but not all sensors measure up. The larger and more sophisticated the sensor, the higher the quality of your output. Even when cameras have identical pixel counts, some cameras deliver dramatically better image quality than others because they have better dynamic range (capturing a broad range of tonal values, from highlights to shadows), lower image noise, and great low-light performance. Canon's G series of bridge digital cameras have high-sensitivity sensors, as do Nikon's Coolpix. These are sophisticated, well-made cameras that allow you plenty of creative latitude, while being compact enough to be easily carried in a coat pocket.

A DSLR has the advantage of having a bigger body, so there's more room for a larger sensor. My two Nikon D700s, for example, have a 12 megapixel sensor they call FX (meaning full frame), which is roughly equivalent to 35mm film. Nikon's DX sensors, on the other hand, are smaller; cameras with a DX format are cheaper, although some image quality is compromised.

A full-frame sensor has larger pixels, which means greater light sensitivity and lower image noise (or pixel distortion); both of these are key considerations when shooting in the fickle, dwindling light of a garden at dusk. You want to be able to move fast and shoot handheld, unencumbered by a tripod. This would have been unthinkable with film. Fast films were always too grainy for reasonable reproduction. But the latest generation of full-frame sensors outdo the limitations of film, allowing you to shoot sharply at ISOs that would have previously been impossible. These larger sensors, because of their pixel size, also render more nuanced tonal gradations and greater dynamic range, or luminance. So the caliber of the latest sensors, more than anything, has set many of us visual fusspots free.

On more compact cameras, the sensors are compact too, but technology has been advancing here as well. These sensors have been made smarter so that, despite their size, the image quality they render is quite good. And if a photo opportunity comes up, it's better to have a decent compact camera with you than no camera at all. I always carry a bridge compact with me, but on the rare occasion I don't, my iPhone is ready to pinch-hit.

With sensors, size matters, but so does quality. Canon's latest G series actually lowered its megapixel count (which has been worshipped as a false god of quality in the digital revolution) and raised the standards of its sensor, ramping up its image stabilization and noise-reduction capabilities. The reality is that megapixel machismo, while impressive, is no substitute for a quality sensor.

This image of a lush greenhouse on my property can be cropped to create plant details, such as this tropical Epiphyllum, *only if the camera's sensor is large enough to hold the details.*

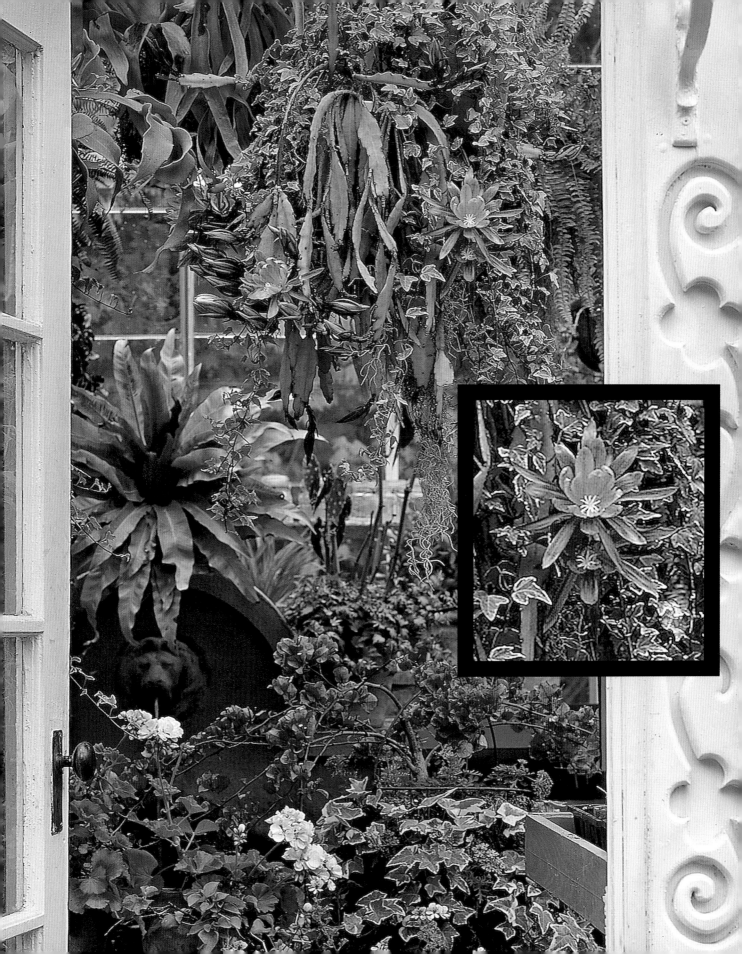

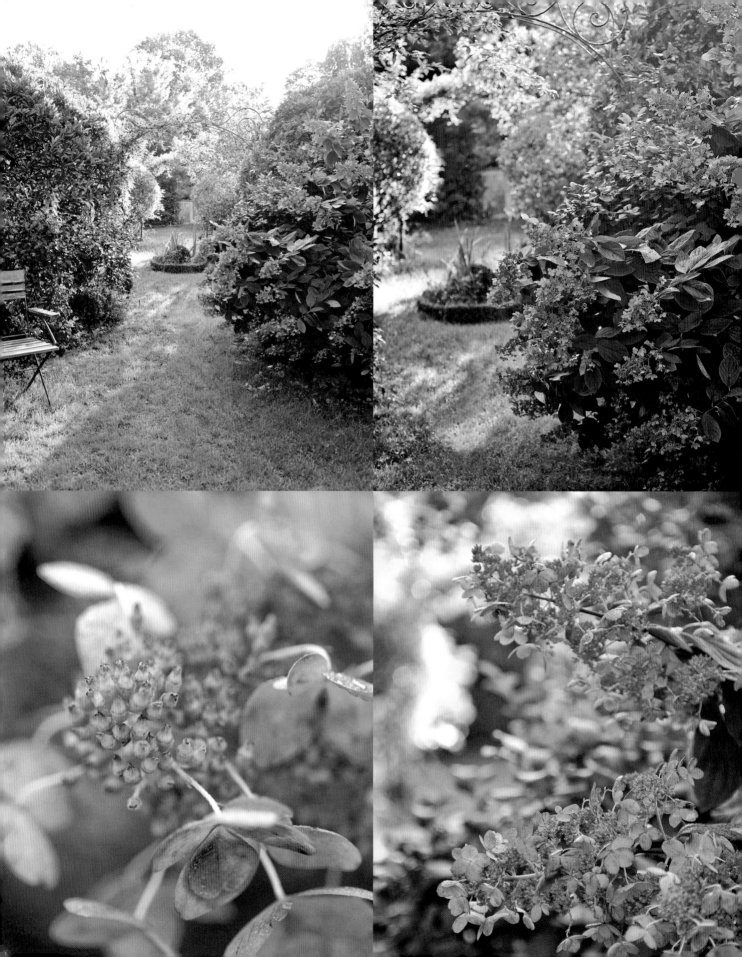

Lenses

The versatility of the lenses you buy for your DSLR, or the one that comes with your compact digital, is critical to your creative freedom and to the quality of your images. It's far more important to invest in good lenses than good camera bodies. In the film days, there were certain lenses that were considered classic, that had just the right combination of glass elements and optical integrity to make them indispensable to the dedicated photographer (the Nikon 24mm f/2.8, 35mm f/1.4, and 105mm f/2.8 come to mind). If you were serious about your work, your lenses were a measure of that commitment.

The lenses you choose to buy for your digital DSLR should first match the sensor size of your camera body. FX bodies on a Nikon should have FX lenses, while DX bodies should have DX, unless you plan to move up to a full-size sensor in the future, in which case you may as well buy all FX lenses, as they can be used in the meantime on DX models as well.

Once you've matched up lens with format, the key consideration is lens speed. The faster the lens—2.8 or less—the freer the creative flow and the more versatile the camera. A fast lens not only means that I can shoot in much lower light, freeing up my workable range, but I can isolate my subjects far more with greater selective focus. A midrange portrait of a perennial border, for example, shot with a 50mm lens at an aperture of 3.5, will render most of the plants with the same predictable, humdrum depth of field. But shot with a 55mm f/1.4 with the lens wide open, the image takes on all sorts of alluring selectivity and beautiful, drop-focused *bokeh*.

A fast lens also means that getting enough light for a decent exposure is less of an issue. At f/1.4, a whole world of possibility opens up, and even f/2.8 starts to seem slow. The one stipulation with fast lenses is that they are usually fixed, or prime (meaning not zoom). It's much more difficult to manufacture zoom lenses, with their optical complexity, that are much below 2.8. The zoom I carry, a 28–75mm f/2.8, is a workhorse with great optics, but it cost me. And fast lenses will cost you, too (usually two to three times the price of their slower cousins). But they're worth the investment and will pay off in opportunities captured.

If you invest in a bridge-type compact digital, such as the "prosumer" Canon G series, or the Nikon Coolpix line, you'll be getting a very sophisticated camera with a fast zoom lens (f/2.8) and enough dazzling technology to never leave you wanting. If there's a consistent mistake made when people buy compact digital cameras, it's not considering the lens speed. A fast lens on a compact won't offer the flexibility and quality of interchangeable DSLR lenses and large sensors, but these cameras are great options for the enthusiast, and if you're willing to get up at 5:30 a.m. in order to click away in a damp patch of daylilies, consider yourself enthusiastic.

On-Camera Features

In order to create on your own terms, you'll need a camera with manual or programmable options. Cameras with only automatic settings are fine for cell phones and the simplest point-and-shoots, but not for much more than snapshots. Most of the newer generation subcompacts are loaded with options, including manual or programmable controls, that will free up your creativity.

Some key functions to look for are Exposure Compensation, Aperture Priority, Auto White Balance, Macro Mode, high ISO capability, a large

Your lenses are the camera's eyes, and the camera body is the visual cortex. Using the right lens, and investing in speed and quality, will pay off in dramatically better images. This fall hydrangea can be fully explored with a range of lenses.

Only by using camera features
such as Macro Mode and
Exposure Compensation
was the photograph of this
dried teasel possible. Its colors
can either be manipulated
in-camera or in postproduction.

and bright LCD (critical in the garden when assessing your images), and ergonomics (a big word for those tiny camera controls—because if a camera is small enough to fit in your shirt pocket, it may not fit your thumbs).

The Exposure Compensation dial on your camera, besides the shutter button itself, will see the most wear when you're shooting in the garden. As you backlight your compositions, you'll need to constantly overcompensate exposure by a few stops in order to fool the camera. The camera sees that much sky light entering its brain and wants to expose for it, while leaving your subject—the beautiful garden—in the dark. Make sure that your camera of choice has this option and that it's easy and obvious to use. Trying to bring a deeply underexposed garden scene up from the dark in postproduction will increase the digital noise in your image and will blow out your high-

lights. Always try to get as close to an accurate exposure as possible in the camera.

Aperture Priority, usually an "A" on your camera dial, will allow you to make your lens's aperture, or f-stop, the function you control, while leaving the camera to make decisions about ISO and shutter speed. This is a critical creative choice because it determines the amount of depth of field you get in your image. If I'm shooting a wide overview of a place, I may want as much field as I can get (f/16 or higher on a DSLR, or f/5.6 or higher on a compact). But if I'm interested in isolating a plant subject in a group portrait, or losing a distracting background, I'll want to set my lens at its widest aperture. This function is an important creative key, with an ability to unlock the powerful visual possibilities of selective focus.

White Balance is the "tempera-

ture" of your images and how they correspond with the available light. An "Auto White Balance" setting means that, no matter what the lighting conditions—sunny, cloudy, interior, fluorescent—your camera will balance the light temperature. White balance simply means that no matter what the light temperature or its source, white objects in your scene will always be white. You can play with this later in postproduction, but it's helpful to have a baseline in the camera.

Macro Mode is an essential feature when shooting in the garden. It allows you to come in close on a plant's intimate parts, to fill the frame with floral incandescence and see as only a camera can. All of the patterned complexity of flowers is revealed in macro. On a DSLR, individual lenses are rated for close focusing and are called either macro or micro. These lenses also focus at normal ranges, and generally have excellent optical quality. I have one lens, a 60mm macro, that is dedicated in my rig for getting in close. In macro mode, you'll have much less depth of field, so focusing accuracy is critical. Be sure to carefully select your focal area in auto-focus mode, or manually focus the lens. On digital compacts, the macro selection is on the camera body, usually right on the rear selection dial, or easily selected in Menu or Functions. Its pictograph is an up-close tulip (how perfect!).

High ISO capability allows you to shoot in low-light situations, and with the vast increases in sensor size and quality on DSLRs, shooting at these higher ISO values (an abbreviation for International Organization for Standardization, a holdover from the film days) no longer compromises your images the way it once did. All decent DSLRs will have a wide range of ISO settings, giving you great exposure latitude,

some even as high as ISO 6,400. At higher ISOs, graininess and noise begin to develop, although the higher-end DSLRs produce remarkably sharp and clear images in very low light. Compact digitals also offer a range of ISO settings, although not as broad as DSLRs, and the smaller sensors shovel out more grain.

I set my cameras (Nikon D700s) to a liberating function called ISO Auto. ISO Auto allows me to set the range I want to work within, and stays inside of those parameters. Most of the time, I want the ISO at the lowest setting possible, about ISO 200, but I give the camera permission to go as high as 800 when it needs more light sensitivity. Once it reaches 800, and there's still not enough light, it drops the shutter speed to a minimum I've also set (usually $\frac{1}{15}$ of a second). This way, as I shoot and play with aperture, my ISO and speed are always adjusting—within limits—to give me the right exposure. The less you have to think about and coordinate on your camera while you're in a state of creative flow, the better.

Along with high ISO options, higher shutter speeds on some DSLRs allow for incredible creative freedom. If I'm shooting with one of my very fast (f/1.4) prime lenses in brighter light, and I want the selective focus and *bokeh* of shooting wide open, I'll need my camera's shutter speed to shoot up exponentially to get the right exposure. (The Nikon D700 shutter is capable of clicking away at $\frac{1}{8,000}$ of a second!)

Besides assessing the available options in a new camera, it's essential to evaluate how the camera feels and functions in your hands. Before you buy anything online, be sure to actually handle the camera in person. I've ordered compact digitals that were much smaller than they seemed on a Web site, or the LCD screen was darker, or the function

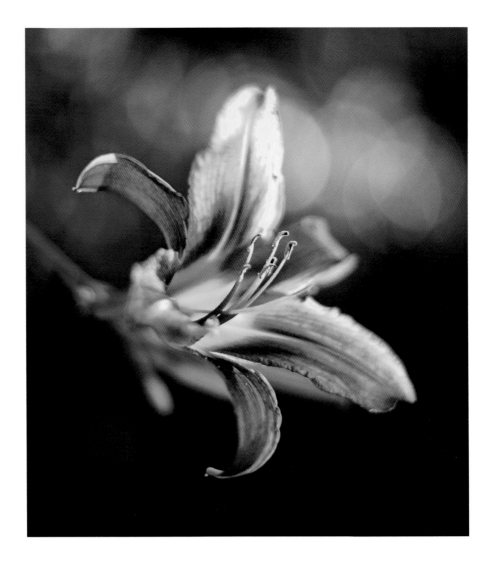

A flame-orange daylily
radiates its own warmth.
It was shot in Aperture
Priority mode, at f/1.4 in
broad daylight—possible only
with a shutter speed exceeding
$\frac{1}{6,000}$ of a second, a
speed now found on higher-
end cameras.

buttons were not intuitive. Head out to your local camera shop and get a feel for different models, play with the function buttons, and feel the camera's weight. And be sure that the LCD screen is large and bright (you'll need this in the garden), or tilts so that you can shoot from high or low or remove glare. The camera needs to be a comfortable, intuitive extension of your arm and eye.

Paying attention to priorities when purchasing a camera will save you an enormous amount of frustration later. In the many workshops I've taught, I've seen too much exasperation with technology while in the garden "moment" to miss making

this point. Don't fall for nonessential functions that flirt with your appetite for the latest gadgetry. Stay focused on what's important. More than half of what manufacturers build into cameras these days is simply marketing bullet points to hype and sell, and not something you'll use frequently, if at all.

A camera needs to follow, to lead, and to collaborate. It can surprise you with its way of seeing, or frustrate you with its technical obstinacy. But its delights are profound, and its outlook on the garden world always a revelation. It should invite you to wonder, to look deeper and longer, and to care more.

Smartphones, iPods, iPads, and Photo Apps

While a pricey DSLR camera will generate the best image quality and versatility, it may not be the camera you have with you. The camera most likely to be with you at all times is your mobile phone or smartphone.

Mobile phone cameras are notoriously compromised when it comes to image quality, although newer models continue to improve on available megapixels, sensor size, and functions. But trying to fit a decent lens and sensor into a package the size of a deck of cards will always be a technical challenge. Smartphones (such as the iPhone) and media players and tablets (like the iPod and iPad) have begun to deliver better image quality, although their technical features and range are still limited when compared to high-end cameras.

Using your iPhone in the garden, for example, will limit you to a small sensor and fewer megapixels of image quality, and there is no way to control aperture or compensate for exposure, two key creative tools for the garden photographer. The answer to some of the iPhone's current limitations is to purchase photo apps from a growing list of third-party iPhone software developers.

Because I save all of my images for editing in postproduction, I'm not likely to buy an app that alters my photographs in a mobile device. The only time I might want to edit on my iPhone is if I'm uploading directly to social media like Facebook or Twitter and need to tweak an image on the go. But otherwise you can do a better job of postproducing and manipulating images on the larger screen of your computer than you can on the LCD of your iPhone.

For basic shooting in the garden, the iPhone wil allow you to choose your point of exposure, so that if you're backlighting, you can touch your screen on a darker part of the foreground and the device will lock that image area in (displayed in a white frame) for proper exposure. You can also zoom for wide, medium, or tight shots, and the macro mode gets in pretty tight. For selective focus, or aperture control, the Tilt-Shift app gives you some control.

Many of the apps out there are fun, playful tools for altering your images, but high-tech gizmos will never prevail over great imagemaking. They draw too much attention to themselves and away from content. As technology continues to develop at breakneck speeds, however, the needs of the serious amateur and professional photographer may come closer to being met, and the garden will beckon.

Smartphones and tablets are getting better at capturing still and video images, although it's hard to imagine they'll ever have the power and versatility of higher-end cameras.

If you're up at 5:00 a.m., camera firmly in hand and knee deep in a damp bed of perennials waiting for sunrise, then this book has been an affirmation of what you already know: that gardens cast a deep, obsessive spell on us.

With the camera, we are bewitched by *wonder*lust, not only by the wonder of the garden itself, but by how the camera shapes and transforms our view of the garden world.

Gardens prevail as a human need because of what they represent to us: beauty, cultivation, the miracle of seed turning into blossom, the marvel of creation itself. The garden acts as both mirror and metaphor, telling us who we are and, perhaps, who we should be.

The camera in the garden compels us to look deeper and see more. It teaches us about color and form. It tells us captivating things about composed space, about pattern and light. With the camera, we are visual predators, stalking the beautiful. "Those who have never been moved to raptures by the tender curve of a blade of grass, the wonderful sternness of a thistle . . . the slender pliancy of a birch, or the enormous tranquility of a canopy of leaves— know nothing of the beauty of form," said designer and architect August Endell. And our cameras inspire us to keep looking: There is always a more flawless blossom to be sought, a more perfect day, a more magical moment in the garden when all of the elements come together.

Gardens will always ask intriguing rhetorical questions: How is this much complexity and beauty possible? Why do such sublime forms exist? Every time you hold a camera to your eye, it's an act of inquiry.

As photographers in the garden, we should be wide open to the flow of visual ideas, and be willing to lose more pixels than we save. The best photographers are always great editors. Remember that the camera is not there to make a literal record; it is there to create. And it composes with light and form, the two central explorations of this book. In order to photograph deeply, you always need to be designing and lighting in your mind.

What you've learned about photographing in the garden will become intuitive in time. Your eye will soon sharpen behind the camera, and you'll begin to see and compose with more clarity and imagination. Even the technical complexity of cameras and computers will be understood. After all, technology and its intricacies pale in comparison to the infinite and almost unknowable complexity of life in the garden.

All of the digital tools at our disposal these days are truly incredible, but their mastery must never be confused with seeing. Just as looking and seeing are as distinct as hearing and listening, developing your eye as an artist is a deeply personal and demanding process. Seeing means knowing when and where to click the shutter. Seeing means reinventing the garden world through your lens. It means establishing a point of view, becoming a storyteller, cultivating meaning. And most of all, it means making something that aspires to the beautiful.

This may seem like a lot to ask of you and your camera, but this book wasn't meant to speak to passive interest. Very little gets accomplished in this world without passion, and great photography is no exception. You must have passion bordering on obsession and be actively, compulsively visual. In the photographic garden, seeing is being.

acknowledgments

I'd like to thank the following for making this book possible: John Shearer at the Columbia Graduate School of Journalism for his contagious enthusiasm and for giving me my first camera; Chris Gangi and Susan Goldberger at Garden Design for giving me work when I didn't know a pea shrub from a perennial; Peter Janssen for letting me write and shoot; Jebah Baum for his years of insight and loyalty; my editors at Rodale, Karen Bolesta and Ethne Clarke, for their hard work and good humor; Kara Plikaitis and Hope Clarke at Rodale for pulling it all together; Kathleen Stradar at the Garden Clubs of America for planting the seed of this book; Lynda Sutton, Karin Lidbeck, JoAnn McVicker, Senga Mortimer, Alison Wilkes, Lauren Hicks, Scott Johnson, Katy Binder, Anne Kerman, Denise Sfraga, Jeff Stults, Brenda Cort, Elvin McDonald, Richard Kollath, Lucy Gilmore, James Baggett, Laura Klynstra, Tovah Martin, Barbara Damrosch, and Christa Neu for keeping the work interesting and fun; my parents for showing me how to live a creative and meaningful life; and my wife and children for constant love and inspiration.

index

Boldface references indicate photographs. Underscored page references indicate boxed text.

Access issues, 126
Adams, Ansel, 117, 140
Adjustments tool, in Photoshop,
 155–56, **155–56**, **162**
Adobe software. *See* Lightroom;
 Photoshop
Aerial photography, 67
Alterations. *See* Postproduction;
 Propping
Analogous colors, 53
Animal portraits, 112, **130**, 134–36,
 134, **136**
Aperture settings. *See also* Exposure
 overview, 15–16
 camera selection considerations, 97,
 172
 depth of field and, 70, 72–73,
 114–15, 121
Art
 essence and, 105
 photography as, 41, 45, 105, 107
 pursuit of, 137
Aspect ratios, 145–46, 151, 161
Asymmetrical balance, 49, 50
Automatic camera settings, 6, 68, 91,
 171

Backdrops, 30, 32, **32–33**, 77, 110–11
Backlighting
 exposure settings for, 4
 for botanical portraits, 22
 for portraits, 132–33
 graphic form and, **9**
 tone and, 51–52
Bad light, working with, 34–36, 37, **59**
Balance, as design element, 47–51,
 48–50, 50, 56
Benson, Diane, 95
Besler, Basilius, 110–11
Black-and-white images
 overview, 108–12, **109–10**
 edge burn on, 158
 graphic elements in, 86, **138**
 postproduction creation of, 108, 111,
 146, 156
Blind sight, 72–73
Blossfeldt, Karl, 27
Blur effects, 16, **83**, 124, 125, 126, 160
Bokeh, 115, 117, 160, 167, 173
Borders, of images, 157–58. *See also*
 Framing, of shots
Botanical portraits. *See also* Still lifes;
 Tight shots
 black-and-white, 108, 110–11

form and, 41, 111–12
light and, 22–24, **22–25**, 24
narrative dimension in, 106
photographer's point of view and,
 105, 107
plant combinations, 93–94
propping for, 74, 77
shooting through technique in, 72
Brightness/Contrast tool, in Photoshop,
 156
Burn tool, in Photoshop, 157–58, **157**,
 162

Cameras. *See also* Lenses
 as creative tool, 176
 buying considerations, 115, 117, 166,
 167–68, 171–74
 capabilities of, 114
 care of, 34–35
 deleting images from, 82, 140–41
 image size settings, 161
 LCD screens, 140, 174
 light control settings, 15–17
 point of view of, 68, 68, **69**, 90–91,
 99, 101
 sensor size, 168
 Smartphones as, 175
Canon G series cameras, 168
"Catch light," 132–33
Centering, of objects in image, 98
Chickens, **3**, **129**, **136**
Clone Stamp tool, in Photoshop,
 153–54, **153–54**
Clothing, 77, 89
Color, as design element, 47
Color theory, 53, 55
Color values
 depth and, 52–53
 in image balance, 49
 light and, 34, 125
 mood and, 11
 postproduction adjustment of, 146,
 155
Compact cameras, 168, 171
Complementary colors, 53, 55, 61
Composition. *See also* Seven Principles
 of Design
 as compensation for bad light,
 34–37
 cropping and, 145–46
 horizontal/vertical, 93, 98
 in black-and-white images, 110–11
 leading viewer's eye with, 47, 60, **91**
Compromise, 126–27, 126

Computers, 141. *See also*
 Postproduction
Context. *See* Environmental context,
 for plants; Landscape context, of
 gardens
Contrast
 as design element, 61–62, **61**, 62
 postproduction adjustment of, 156
Cool colors, 11. *See also* Color values
Crawford, William, 68
Cropping
 planning for, 92
 postproduction, 100, 145–46, 151
Csikszentmihalyi, Mihaly, 86
Cultivated space, garden as, 40, 107,
 140
Cunningham, Imogen, 117
Cyanotype images, 108, 146

Deleting images, 82, 140–41, 144
Depth of field. *See also* Shooting
 through
 aperture settings and, 70, 72–73,
 114–15, 121
 in image balance, 51
 lenses and, 117
 light levels and, **15**
 ornaments and, 121
Design. *See* Garden design; Seven
 Principles of Design
Detail shots. *See* Botanical portraits;
 Macro shots
Developing and printing, of film, 137
Develop module, in Lightroom, 142,
 145–47
Diagonal lines, 98
Diffusers. *See also* Filters
 black-and-white photography and, 111
 botanical portraits and, 23
 in compensating for bad light, 12, 37
 materials for, 28, 97
Digital images. *See* Images
Digital workflow, 162–63
Dimension
 light and, 51
 postproduction adjustment of, 158
Direction of movement, as design
 element, 47
Distance, vs. intimacy, 89
Dodge tool, in Photoshop, **157**, 158,
 162
"Dragging the shutter," 16
DSLR cameras, 115, 167–68, 171
DX sensor format, 168, 171

East-to-west flow, in garden design, 2
Edge burn, 157–58
Editing. *See also* Cropping; Postproduction
 assessing/deleting images, 82, 140–41, 144
 with mobile apps, 175
E-mail file size recommendations, 163
Emerson, Peter Henry, 113–14
Environmental context, for plants, 24, 97
Equipment. *See* Cameras; Tools and equipment
Establishing shots
 overview, 88–92, **88–91**, <u>90</u>
 light and, 11, **11**
 propping and, 77–78
 shooting through technique in, 73
Exporting images, 142–43, 147
Exposure and exposure settings
 as compensation for bad light, <u>37</u>
 backlighting and, 4
 camera selection considerations, 172
 manual control of, 6
 overexposure, 20, <u>111</u>, 158
 overview, 15–17
 postproduction adjustment of, 146, 155, 157–58
External hard drives, 143
Eye level point of view, 67
Eyes, highlights in, 158

Fall light, **18**, 19–20, **20–21**, <u>20</u>
Fast lenses, 171
File formats, 145, 147, 161
File names, 143
Fill flash, 133, <u>134</u>
Film photography, 137, 145, 146
Filters, <u>37</u>, 146, 152
Filter tool, in Photoshop, 160
Finding the shot, 39–41, **40–41**, <u>42</u>. *See also* Point of view
Fixed lenses, 114, 115, 171
Flash photography, 107, 133, <u>134</u>
Flat light, 51
Flow (Csikszentmihalyi), 86
Focal length, of lenses, 92
Focus. *See also* Aperture settings; Depth of field
 as composition tool, 97–98
 contrast and, 61
 minimizing undesired elements with, 126
 postproduction editing and, 97
 selective
 overview, 113–17, **113–16**, <u>114</u>
 in creating emphasis, 16, **17**
 in image balance, 51
 postproduction creation of, 159–60
 shooting through, 70–73, **70–73**, <u>72</u>
Fog. *See* Mist
Foliage patterns, **100**, <u>100</u>, **138**. *See also* Botanical portraits
Foreground framing, 91–92. *See also* Shooting through

Form. *See also* Graphic elements
 as guiding principle, 41, 176
 context and, 97
 cropping and, 145–46
 in black-and-white images, 108, **112**
 in tight/macro shots, 99, 101, **138**
 in winter photography, 19–20, **20**
 light and, 8, **13**, <u>14</u>
 of plants, 111–12 (*see also* Botanical portraits)
Fountains, 119–21
Four Season Farm, 128–29
Framing
 of photographs, 145–46
 of shots, **65**, 80, **88–89**, 91–92 (*see also* Shooting through)
Fruit. *See* Vegetables and fruit
F-stops, 16. *See also* Aperture settings
Full-frame sensors, 168
FX sensor format, 168, 171

Gamma tool, in Photoshop, 155
Garden design
 compensating for, 35
 east-to-west flow in, 2
 emphasizing, 13–14, **13–14**, 64, 67, 95
 formal, 49
 narrative dimension and, 103–7
 sites and (*see* Landscape context)
Garden photography, goals of, 40
Gardens, as human-created space, 40, 107, 140
Gaussian Blur tool, in Photoshop, 160
Gear. *See* Cameras; Tools and equipment
Gestalt, 101
Golden ratio, 56
Graphic elements. *See also* Pattern
 overview, 80–82, **80–82**, <u>81</u>
 backdrops and, 110
 hardscaping as, **9**, 10
 image composition and, 8, **8**, **9**
 in black-and-white images, 86, 108
 in tight shots, **95**
 in vegetable gardens, 128
 light and, **11**, 59
Grayscale. *See* Black-and-white images
Group f/64, 117

Hairlight, 51
Hands, in evoking sense of touch, **122–25**
Hardscaping, as graphic element, **9**, 10
Height
 conveyed in images, **84**
 of photographic point of view, 64–67, **65–67**, 86–87, 101
Highlights, 158
Hipstamatic mobile app, 175
Horizontal composition, 93
Hortus Eystettensis (Besler), 110–11
Hudson River School, 4
Hue, 53, 156
Hughes, Robert, 35, 135

Images. *See also* Photography
 assessing/deleting, 82, 140–41, 144
 file formats, 145, 147, 161

naming/tagging, 143, 147
 organization of, 143–44
 sharing of, 127
 size/resolution, 161
Imaging software, 140, 141, 149. *See also* Lightroom; Photoshop
Importing images, 142–43, 147
Impressionism, 4
Indoor still lifes, 27–28
Insects, portraits of, 112
Internet
 as research tool, <u>166</u>
 image size recommendations, 161
Intimacy, techniques for creating, 73, 89, 93
Intuition, 41, 62, 83–85, <u>83</u>, 88
IPhones/iPads/iPods, 175
ISO numbers, 15, 173
Italian Renaissance gardens, 130

Japanese gardens, 130
Jekyll, Gertrude, 83
Jones, Charles, 27
JPEG file format, 145, 147, 161

Keepers of Light, The (Crawford), 68
Kritios Boy sculpture, 133, 135

Landscape context, of gardens
 as narrative dimension, 103–5
 compensating for, 35, 127
 conveyed in images, 11–12, **11**, **44**, 94–95
 garden design considerations, 10
Laptop computers, 141. *See also* Postproduction
Large views. *See* Establishing shots
Lasso tool, in Photoshop, 160
Layers tool, in Photoshop, 159–60, **159**
LCD screen, of camera, 140, 174
Lenses
 buying considerations, 171
 experimenting with, **170**
 fixed, 114, 115, 171
 for shooting through technique, 70
 macro, 99, 117
 point of view of, 92
 prime, 92, 115, 117, 171, 173
 recommendations for
 overview, 89
 botanical portraits, <u>24</u>
 establishing shots, 92
 portraits, 117, <u>134</u>
 selective focus, 115, 117
 still lifes, <u>32</u>
 telephoto, <u>96</u>, 97, <u>114</u>, 117, <u>134</u>
 tight shots, <u>96</u>
 speed of, 171, 173
 zoom, 92, 115, 171
Library module, in Lightroom, 142–44
Light
 awareness of, 16, <u>17</u>
 bad, working with, 34–37, 126
 black-and-white images and, 110, <u>111</u>
 camera response to, 15–17, 168

changes in, through day, 1–4, **2–4**, **6**, 11, 12, 19, 88
color and, 53, 125
dimension and, 51
direction of, 51–52
for indoor still lifes, 27–28
garden design and, 13–14, **13–14**
importance of, 1–4
in botanical portraits, 22–24, **22–25**, 24
in image balance, 49, 51
lens selection and, 171
overcast, 13, 14, 34, 110
planning for, 4–5, 12
point of view and, 11–12, **11–12**, 86
seasonal effects, 18, 19–21, **20–21**,
shooting into, 3, 6
Lightroom
about, 141
Develop module, 145–47
importing to, 142–43
Library module, 142–44
screenshots, **142–43**, 145
Lines
as graphic element, 8, 82, **82**, 98, 128–29
in contrast, 61
in guiding viewer's eye, 47, **91**
rhythm and, 60
unity and, 62
Lossless format, 147
Luminist movement, of painting, 4

Macro lenses, 99, 117
Macro shots. *See also* Botanical portraits; Tight shots
overview, 99–101, **99–101**, 100, 114
light and, 23
Matting, planning for, 145–46
Mazes, 64, **66–67**
Medium shots
overview, 92–95, 92, **93–94**
light and, 11
planning for, 91
Megapixels, 168
Memory cards, 88, 93, 142
Mendoza, Jeff, 35
Midday light, 2–3, 19
Mist
propping with, 35, 74, 77
working with, 1–2, **2**, 3, 8, 9, 19, 35, 130
Mobile apps, 175
Monochromatic images. *See* Black-and-white images
Monotony, 55–56
Mood, color values and, 11
Morning light, 1, **2–4**, **6**, 88, 90, **91**
Movement
blur effects, 16, **83**, 124, 125, 126, 160
of viewer's eye, 7, 47, 58, 60, **60**, 60, **91**, 119
of water, 130

Naming, of images/files, 143, 147
Narrative dimension, 43, **43–46**, 45–46, 46, **102–7**, 103–7, 106

Naturalistic School, of painting, 113–14
Neruda, Pablo, 83
Nikon 50mm 1.4 lens, 92
Nikon cameras, 168
Nollman, Jim, 122

Objectivity, limits of, 73
Obstacles, 126–27, 126
Offset tool, in Photoshop, 155
Organization, of images, 143–44
Ornaments, 111, **118–21**, 119–21
Outdoor studios, 28
Overcast light, 13, 14, 34, 110
Overexposure
intentional, 111
postproduction adjustment of, 158
snow and, 20

Painting
focus in, 113–14
light effects in, 4
Pano mobile app, 175
Patience, 41, 45
Pattern. *See also* Graphic elements
as design element, 54, 55–57, 57, 57
awareness of, 86
in image balance, 49
in macro shots, **100**, 100
interruption of, **50**
intuition and, 84–85
of light and dark, 52
ornaments as, 120
People, in images
as obstacle, 126
hands, evoking touch with, **122–25**
portraits, 132–35, **132**, **134–36**
propping and, 77
putting at ease, 130
Perception
flow in, 86
subconscious aspects, 58, 62, 72–73, 83–85
Persian gardens, 130
Personal vision
development of, 90–91, 110, 115, 117, 137
intuition and, 62, 83–85
narrative dimension and, 43, 45–46
Perspective. *See* Point of view
Pet portraits, 129, 134–36, **134**, **136**
Photo apps, 175
Photographers. *See also* Personal vision
position of, 64–67, 64, **65–67**, 84, 86–87, 101
purpose of, 107
Photographic syntax, 137
Photography. *See also* Images
as alternate view on reality, 114, 139–40
as art form, 41, 45, 105, 107
digital, advantages of, 64
film photography, 137, 145, 146
history of, 108, 113, 117, 146–47, 165
Photorealism, 113
Photo shoots
awareness during, 22
compromise and, 126–27

establishing shots, 90–92
light shifts, planning for, 12
macro shots, 99–101
medium shots, 92–95
preparing for, 88–90
tight shots, 95–98
tools and equipment for, 88, 141
Photoshop
overview, 148–50, 149
mobile app for, 175
screenshots, **148**, **162–63**
tools in
Adjustments, 155–56, **155–56**, **162**
Clone Stamp, 153–54, **153–54**, **163**
Crop, 151, **151**, **163**
Dodge and Burn, 157–58, **157**, **162**
History, 151
Image Size, 161, **163**
Layers, 159–60, **159**, **162–63**
Unsharp Mask, 152, **152**, **163**
Pictorialists, 113
Picture orientation, 98
Pixels, 168
Place, sense of, 11–12, **11**, **44**, 94–95, 120
Plant combinations, 93–94
Plant specimens. *See* Botanical portraits
Poetry, garden photography as, 41, 84
Point of view
for portraits, 133
in omitting unwanted elements, 127
multiple, exploration of, 46
of camera, 68, 68, 69, 90–91, 99, 101
of photographer (*see also* Personal vision)
as artist, 105, 107
light and, 11–12, **11–12**
position/location, 64–67, 64, **65–67**, 84, 86–87, 101
of viewer (*see* Viewers)
psychological, 86–87
Portrait lenses, 117, 134
Portraits
of animals, 112, 129, 134–36, **134**, **136**
of people, 132–35, **132**, **134–36**
postproduction adjustment of, 158
Position
of photographer, 64–67, 64, **65–67**, 84, 86–87, 101
of portrait subjects, 133, 135
Postproduction
overview, 140
black-and-white images, 108, 111, 146, 156
digital workflow, 141, **162–63**
effects in, 83
image assessment, 140–41
limits of, 36, 46
personal style and, 137
software
Lightroom, 142–47
Photoshop, 148–63
undesired elements, eliminating, 127, **127**
Pottery, 119–21
Presence tool, in Lightroom, 146

Prime lenses, 92, 115, 117, 171, 173
Principles of design. *See* Seven
 Principles of Design
Printing, 137, 145, 146
Print module, in Lightroom, 142
Private gardens, access issues, 126–27
Program mode, 6
Proportion, 56
Propping
 overview, 74–79, **74–79**, <u>76</u>
 backdrops, 30, 32, **32–33**, 77, 110–11
 of vegetables, 129
 ornaments, <u>111</u>, **118–21**, 119–21
 people and, 135
 still lifes, **26–33**, 27–29, <u>32</u>, 33, 129
Psychological positioning, 86–87
Public gardens, 126

Rain, 34–35
Rating systems, 144
Ratio, golden, 56
Reality, alternate views of, 114, 139–40
Reductionism, graphic elements and,
 80
Reflections
 from water, **8**, **21**, **45**, 130, <u>130</u>, **131**
 techniques for capturing, 27, 35, 74,
 77, 158
Reflectors, 28, 133, <u>134</u>
Rembrandt effect, 52
Repetition
 as design element, 56–58, <u>57</u>, <u>58</u>, **59**
 in conveying movement, 60
 unity and, 62
Resolution settings, 147, 168
Resourcefulness, 43, 45–46
Rhythm, 58. *See also* Movement
Romanticism, 13–14
Rule of Three, 61, 97

Sameness, 55–56
Saturation, postproduction adjustment
 of, 146, 155
Scale
 as design element, 47
 indicators of, 119
Scheduling issues, 4–5, 12, 127
Screens and scrims. *See* Diffusers
Seasonal light, **18**, 19–21, **20–21**, <u>20</u>
Selective focus
 overview, 113–17, **113–16**, <u>114</u>
 in creating emphasis, 16, **17**
 in image balance, 51
 postproduction adjustment of,
 159–60
Selenium toning, 146
Self-assessment, 82
Sensor size, in cameras, 168
Sensory information, nonvisual,
 122–25, **122–25**, <u>124</u>
Sepia images, 108, **108**, **109**, <u>111</u>, 112,
 125
Seven Principles of Design
 overview, 47
 balance, 47–51, **48–50**, <u>50</u>, 56
 contrast, 61–62, **61**, <u>62</u>
 movement, 60, **60**, <u>60</u>

pattern, **54**, 55–57, **57**, <u>57</u>
 repetition, 56-58, <u>57</u>, <u>58</u>, **59**
 tone, 51–53, **52–53**, <u>55</u>
 unity, 62–63, **63**, <u>63</u>
Shadows, controlling, 2–3, 27, 52, <u>111</u>,
 157–58
Shape, as design element, 47
Sharpening filters, 152
Sheep, 136, **136**
Shooting through, 70–73, **70–73**, <u>72</u>
Shutter speed, 15, 16, 115, 125, 173.
 See also Aperture settings
Side-lighting, 52
Sites. *See* Landscape context
Sketching, 80
Slideshow module, in Lightroom, 142
Smartphones, 175
Smell, conveying, 122–24
Snow, effect on light, 20
Software. *See* Imaging software
Sound, conveying, 122–24
Split frame cameras, 68
Spring light, **18**, **19**, <u>20</u>
Star rating system, 144
Statuary, 119–21
Still lifes, **26–33**, 27–29, <u>32</u>, 33, 129.
 See also Botanical portraits
Stopping down. *See* Aperture settings
Storytelling. *See* Narrative dimension
"Straight photography," 117
Structure, in garden design, 67
Style, personal. *See* Personal vision
Styling, <u>129</u>. *See also* Propping
Subconscious mind, 58, 62, 72–73,
 83–85
Subjectivity, 115, 117
Summer light, **18**, 19–20, **20**, <u>20</u>
Surface, as design element, 47
Survey View, in Lightroom, 144
Symmetrical balance, 47, 49, 50

Tagging, of images/files, 143, 147
Taste sense, conveying, 125, 128–29
Telephoto lenses and settings, <u>96</u>, 97,
 <u>114</u>, 117, <u>134</u>
Texture, 123. *See also* Surface
Thuya Garden, 104, **105**
TIFF file format, 145, 147
Tight shots. *See also* Botanical
 portraits; Macro shots
 overview, 95–98, **95–98**, <u>96</u>
 light and, 11, 12, **36**
 planning for, 91
TiltShift mobile app, 175
Tone. *See also* Value
 as design element, 51–55, **52–53**, <u>55</u>
 in black-and-white images, 108
 in image balance, 47
 postproduction adjustment of, 146,
 156
Tools and equipment. *See also* Cameras
 computers, 141
 diffusers, 12, 23, 28, <u>37</u>, 97, <u>111</u>
 filters, <u>37</u>, 146, 152
 for photo shoots, 88, 141
 for propping and styling, 74, 76, 77,
 <u>129</u>

memory cards, 93
 minimizing, 33
Touch, conveying, 122–24
Tree canopy, light and, 35
Tripods, 89–90, <u>114</u>, <u>121</u>

Unity, as design element, 62–63, **63**,
 <u>63</u>
Unsharp Mask tool, in Photoshop, 152,
 152

Value. *See also* **Tone**
 as design element, 47
 in image balance, 49
 postproduction adjustment of, 146
Vegetables and fruit
 overview, 128–29, **128**, <u>128</u>
 color and, **61**, 76
 form and pattern, **57**, 91
 selective focus and, **115–16**
 sensory memory and, 122–25,
 122–25
Vertical composition, 93, 98
Viewers
 sensory memory of, 122
 visual path for, 7, 47, 58, 60, **60**, <u>60</u>,
 91, 119
Viewfinder
 LCD screens, 140, 174
 not using, 68
Viewsheds. *See* Point of view
Vision
 as sensory experience, 122
 focus and, 113
 intuition and, 83–85, <u>83</u>
 subconscious aspects, 58, 72–73
Visual hierarchies, selective focus and,
 114
Visual path, 7, 47, 58, 60, **60**, <u>60</u>, **91**, 119
von Gal, Edwina
 as portrait subject, 133
 gardens designed by, **8–9**

Warm colors, 11. *See also* Color
 values
Water
 light and, 130, <u>130</u>, **131**
 movement of, 125, 130
 propping with, 35, 74, 77
Web module, in Lightroom, 142
Web sites
 as research tool, <u>166</u>
 image size recommendations, 161
Weston, Edward, 117
White balance settings
 as compensation for bad light, <u>37</u>
 postproduction adjustment of, 146,
 172–73
 snow and, 20
Whitehead, Alfred North, on pattern,
 86
Why We Garden (Nollman), 122
Wide shots. *See* Establishing shots
Williams, William Carlos, 84
Winter light, **18**, 19–20, **20**, <u>20</u>

Zoom lenses, 92, 115, 171

San Bruno Public Library

3 9046 08966504 4

POWER UP with PR

A PUBLICITY GUIDE FOR ARTISTS

BY JACKIE ABRAMIAN

Art Network

POWER UP WITH PR, A PUBLICITY GUIDE FOR ARTISTS

August 2008
Copyright 2008 by Jackie Abramian
Cover and interior design by Laura Ottina Davis
Edited by Constance Smith

Published by ArtNetwork, PO Box 1360, Nevada City, CA 95959-1360 (530) 470 0862 www.artmarketing.com

The author, Jackie Abramian, can be contacted at jaassociates@comcast.net or haleygallery@comcast.net.

ArtNetwork was created in 1986 with the idea of teaching fine artists how to earn a living from their creations. In addition to publishing business books for artists, ArtNetwork also has a myriad of mailing lists—which we use to market our products—available for rent to artists and art world professionals. See our web site for details.

Publisher's Cataloging-In-Publication Data
(Prepared by The Donohue Group, Inc.)

Abramian, Jackie.
 Power up with PR : a publicity guide for artists / by Jackie Abramian.

 p. : ill. ; cm.

 Includes bibliographical references and index.
 ISBN-13: 978-0-940899-90-2
 ISBN-10: 0-940899-90-6

1. Art publicity--Handbooks, manuals, etc. 2. Art--Marketing--Handbooks, manuals, etc. I. Title.

N8600 .A27 2008
659/.02/47

All rights reserved. No part of this book may be reproduced in any form or by any electronic or mechanical means including information storage and retrieval systems without permission in writing from the publisher, except by a reviewer, who may quote brief passages in a review.

Disclaimer: While the publisher and author have made every reasonable attempt to obtain accurate information and verify same, occasional address and telephone number changes are inevitable, as well as other discrepancies. We assume no liability for errors or omissions in editorial listings. Should you discover any changes, please write the publisher so that corrections may be made in future printings.

Printed and bound in the United States of America

Distributed to the trade in the United States by Consortium Book Sales and Distribution